IMAGES
OF OUR TIMES

Preface by William F. Thomas,
Editor

Introduction by Jim Wilson,
Photo Editor

Afterword by Iris Schneider,
Staff Photographer

HARRY N. ABRAMS, INC., PUBLISHERS, NEW YORK

IMAGES
OF OUR TIMES

SIXTY YEARS OF
PHOTOGRAPHY
FROM THE
Los Angeles Times

by the Staff Photographers of the
Los Angeles Times

Editor: Robert Morton

Designer: Michael Hentges

Los Angeles Times Editor: Angela Rinaldi

Library of Congress
Cataloging-in-Publication Data

Images of our times.

 1. Photography, Journalistic. 2. Los Angeles Times.
I. Schneider, Iris. II. Los Angeles Times.
TR820.I44 1987 779'.997949052 87–1227
ISBN 0–8109–1119–1 (HNA)
ISBN 0–8109–1122–1 (LAT)

Published in 1987 by Harry N. Abrams, Incorporated, New York

A Times Mirror Company

Printed and bound in Japan

Contents

The editors gratefully acknowledge the following for the inspiration and generous cooperation they have given to this project:
Tom Johnson, Publisher and Chief Executive Officer; Bill Thomas, Editor and Executive Vice President; George Cotliar, Managing Editor; Cecily Surace, Library Director, and Tom Lutgen, Reference and Research; Mildred Simpson, Glen Potter, Vaughan Rachel, Gay Raszkiewicz, Michelle Rios, and Francine Hoffing, Graphics; Carolyn Strickler, and Craig St. Clair, The History Center; Joan Stern Goff, Research; Jim Wilson, Photo Editor; and the entire Los Angeles Times *photo staff, past and present.*

Preface
by William F. Thomas

All my life, I have dealt with words. They are adequate for many of our purposes, indispensable for most. They can, of course, be immeasurably beautiful and graceful.

But they can't do everything.

This is a book about photographs. Pictures, if you like. Images, as its title would have it. All from the *Los Angeles Times*.

Gathered as they are here, they are a testimonial to the power of the photograph to present a tapestry of California's history, told to the eye, in images that capture each event in the split second of its happening.

Words can't do that.

They can tell us that a popular President took time for a swim off Santa Monica beach and was surrounded by a friendly crowd. But the photograph grabs for us the instant of spontaneous electricity between a charismatic young leader and his clearly genuine admirers.

Here also is a picture whose story needs few words: a forbidding sea, a young man on a beach trying to comfort a despairing young woman, while at the same time looking past her at the waters that have taken their son.

A paragraph or two in the news columns; volumes here.

One more. We've read much about the Ku Klux Klan in California. One picture alone in this collection captures its menace: a line of hooded figures in flickering light, staring out through holes in white coverings, marching toward who knows what victim. Unforgettable.

That word describes a book like this. Unforgettable. A look back through California's rich history through a medium where words are mere grace notes, and the photo is the message.

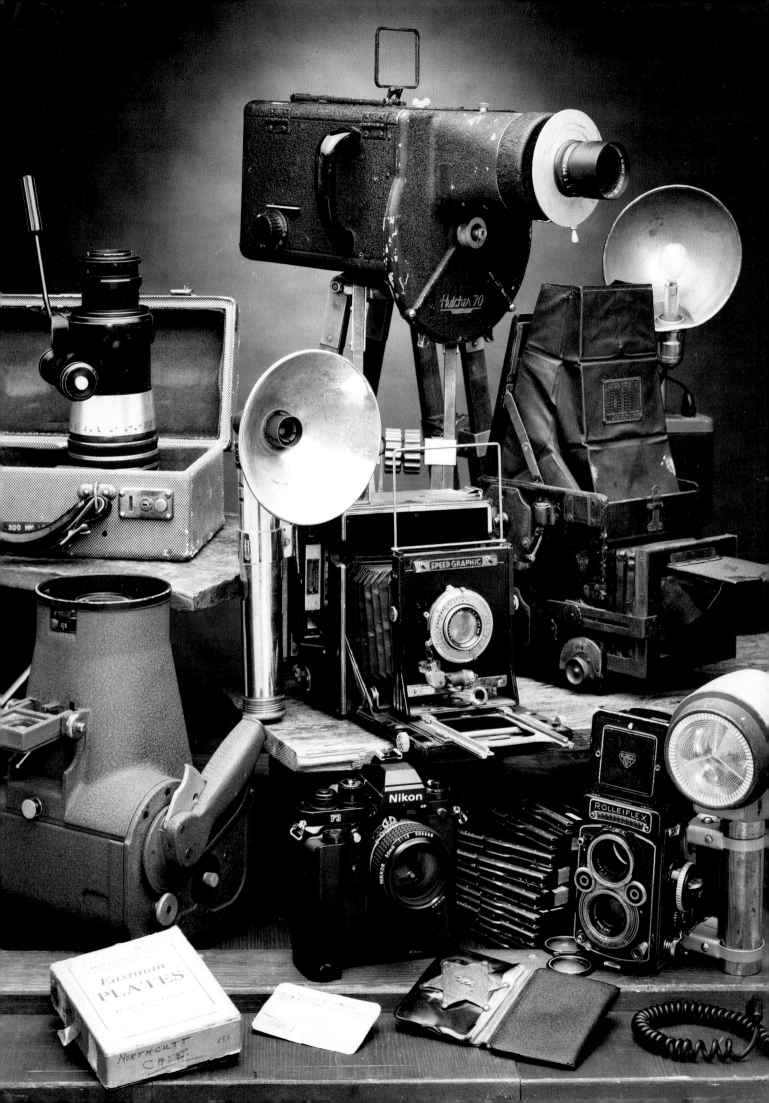

Introduction

by Jim Wilson

Photography has appeared in the pages of the *Los Angeles Times* since the earliest days of this century. Although the medium was then already some sixty years old (photography dates from the invention of the daguerreotype in 1839), the technology of printing wasn't yet up to the task. But once the halftone dot was devised and the continuous tones of a photograph could be broken up into tiny points of metal that could hold ink, the presses roared with a new vigor.

Photography, with its vivid communication of reality, was of course ideally suited to the aims and needs of daily journalism. Events were still described in words, but now portraits of the people who made the news could be shown. When President McKinley was shot in Buffalo on Friday, September 6, 1901, his picture appeared next day on the front page of the *Times* along with a photograph of the President parading in Los Angeles the previous May. Similarly, sixty-seven years later, when Bobby Kennedy was shot in the city, staff photographer Boris Yaro's picture of the dying presidential candidate appeared in the next edition of the paper.

Most of the early photography in the *Times* was gathered from stock agencies or sent over the wires by news services. Most of the pictures appeared anonymously. It was not until the 1920s that photographic credits began to appear, and late in that same decade the appellation "*Times* staff photographer" began to be affixed proudly to pictures. From that moment the photographic credit became as common as the reporter's byline. It is, therefore, from that historic decade that we begin the collection of images that form this book, a collection that celebrates the skills of our photographers, past and present.

In these pages we can see that in most ways the *kinds* of photographs that people made sixty years ago have changed little. The role of the newspaper—then and now—is essentially the same: to provide readers with more information about the world they live in. Thus, in the 1970s and 80s we have pictures of fires, and politicians, and baseball players just as we had them decades earlier. But we may find that the photographs of these familiar subjects are different, that they are better composed, more artful, less like posed tableaux. This is in part because with modern high-speed films and fast lenses a photographer is less likely to have to say, "All right, everybody, hold still please!" But it is also that the photographer of today has greater visual sophistication, is better educated. After all, he or she is standing on the shoulders of those who went before and has their work as examples. But he is also likely to be better trained, not only in technique but also

An arsenal of equipment: from a 1917 Graflex camera at middle right to a 1980s Nikon F3 in the center foreground. To the left of the Nikon is a K-10 aerial camera; at the top is the specially designed Hulcher 70mm high-speed camera with a 300mm lens in its case beside it. Armed with film, the right machine, and a police pass and credentials *(foreground)*, a photographer could go anywhere.

in visual expression. And as there is more competition today in the field of photography those who do finally land jobs with newspapers are very highly skilled and often extraordinarily versatile.

So I would suggest that the reader will find here, particularly in the photographs of the last decade or so (which predominate here), a greater expressiveness, a finer sense of what the great French photojournalist Henri Cartier-Bresson called "The Decisive Moment." Not content with merely recording an event, the modern newspaper photographer conveys a larger meaning, combining information with emotion and sometimes even with comment. Some of the old-timers had this quality instinctively; the new ones have it bred in the bone and polished by training.

Among other differences between the photography of today and yesterday—in the *Times* as in other papers—is a broadened range of subjects. Here at the *Times*, for example, we ask our photographers to spend a day or so every month simply roaming the area for pictures that appeal to them. We call this "Enterprise Day." These photographs, many of them humorous, often find their way into the paper (we call the category "wild art" because the pictures are unrelated to news events or other feature stories), and they make a nice antidote to the hard, sometimes unhappy, news of the day. From the photographers' point of view, these freewheeling assignments provide them with a chance to enjoy the fun of picture-making and to recapture the enthusiasm that led them to become photographers in the first place.

Another kind of photography that's different today from the past is the picture essay, the related group of photographs that afford a rounder, fuller view of a subject than the single shot. More common to magazines than newspapers, this kind of photography now offers readers a real chance for a deep impression to be formed. Examples of some picture essay photographs in this book are Jose Galvez's images of the farm crisis, John McDonough's picture of illegal aliens, and Ken Lubas's photographs of homeless people in downtown L.A.

Though the range of subjects that a contemporary newspaper publishes has expanded since the days when crime, cheesecake, and kitty cats prevailed, today's photojournalist still works against much the same odds as his predecessors. Deadlines are always too short; rain, heat, and dust compound the working problems; equipment malfunctions; and people are sometimes no help at all. Gone are the heavy old cameras and tricky,

explosive flash powders of yesteryear, but in their places have come sophisticated picture transmitters, miniaturized portable darkrooms, and a large battery of lenses and strobe units.

Not too far off, however, is a time when film, chemicals, and the camera as we know it will disappear. Photographers will use an electronic image-capturing device that will both record and store dozens, if not hundreds, of pictures on a small magnetic disk. Plugged into a telephone line, this device will automatically send its digitized information to an editor's console as fast as electrons flow. There the images will be reconstituted (in color or black and white, as desired), edited, selected, and sent again on their way—this time with encoded instructions for layout—to a printing plant. Instead of plates, presses, and ink, that facility will probably be "printing" these images with a laser beam that alters the molecular composition of the paper. For his part, the photographer need never return to the office; he or she can remain in the field, taking and sending pictures all day.

Looking into this future, it is difficult to imagine that the content of photographs for newspapers will change that much. The concerns of tomorrow, like those of yesterday, are bound to stay pretty much the same. What the new technology will do to pictures in papers is more difficult to predict, but I would bet that photographers will have less to say about how images are composed and used. Even now, as we know, photographs are "cropped," or recomposed by an editor or layout person, not only to fit columnar format of the newspaper but to emphasize one or another person or action in the image area. This alteration often dramatically alters the photograph as it was seen by the photographer. I suspect that when visual information is passed along nearly instantaneously—as it will be in the future—it will be treated much more as merely information, that is, as raw data to be employed, than when it is presented as a fully formed image framed by an intelligent photographer, as it is today. The danger is that photographers of tomorrow may become mere collectors of visual data.

But before we get into that era, we should commend to you what we consider to be the real achievements of our predecessors and ourselves, the collective body of work selected for this book that has been formed by a group of singular men and women who, for more than sixty years, have contributed images of our times to the pages of the *Los Angeles Times*.

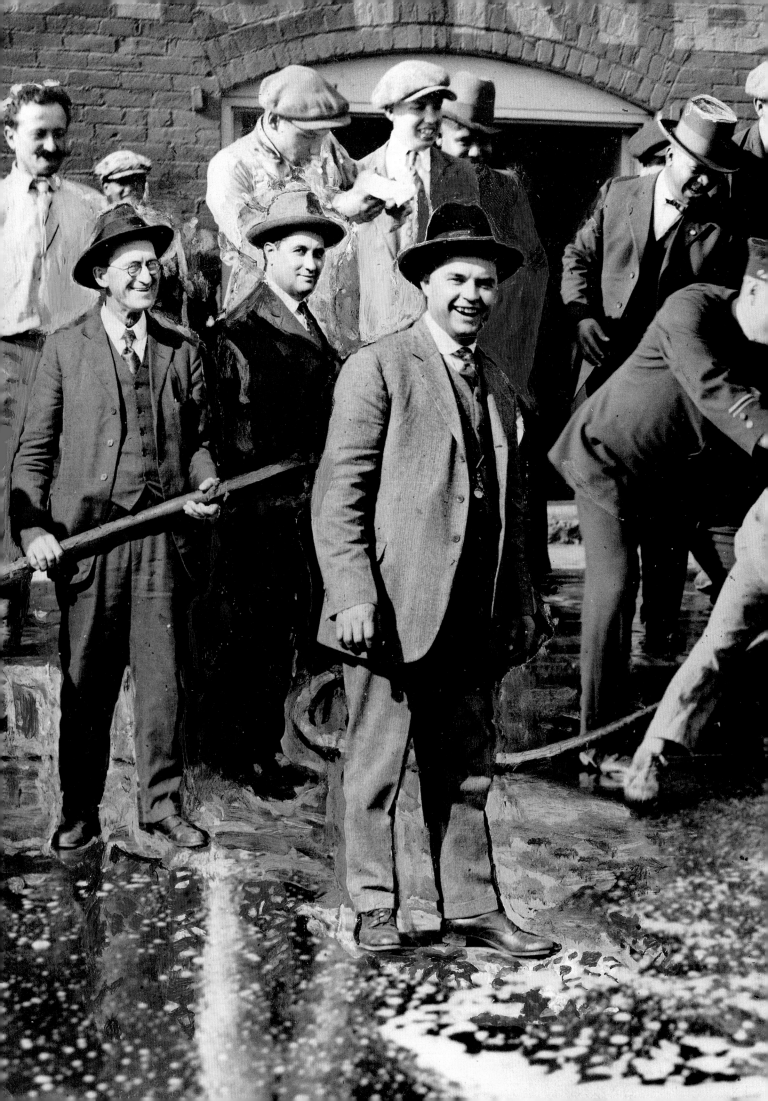

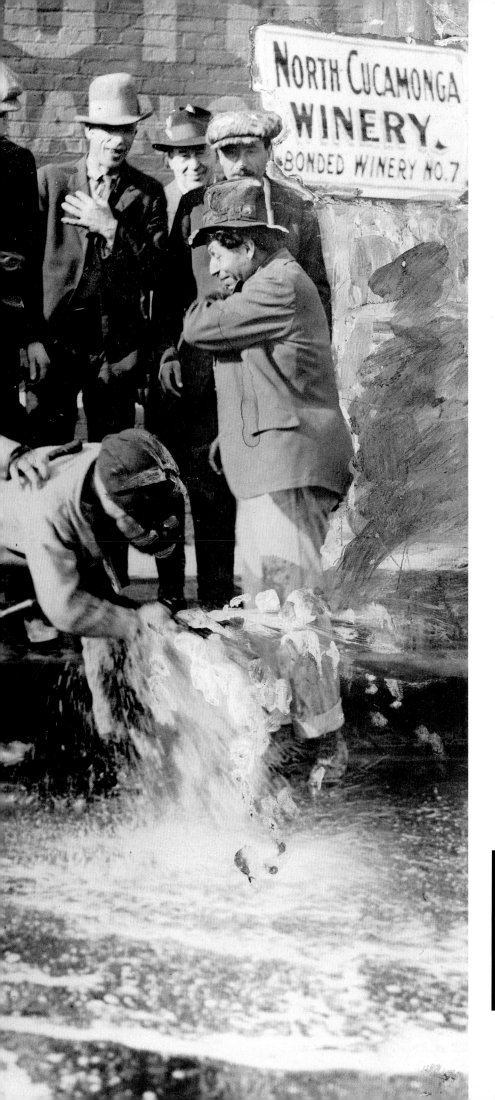

1920s

Prohibition went into effect on July 1, 1919, but it took revenue officers six months to catch up with the North Cucamonga Winery, whereupon they pumped its contents into the street. *January, 1920.* (Los Angeles Times)

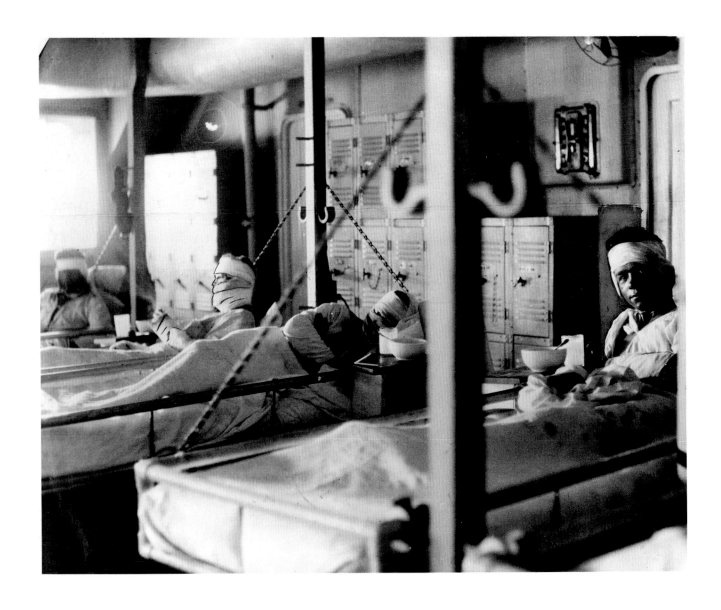

ABOVE AND RIGHT
A mysterious explosion in the gun turret of the U.S. Navy battleship *Mississippi* killed 44 officers and men during a target practice 45 miles off Los Angeles harbor. Four other men were killed when a huge gun was accidentally fired as the ship dropped anchor in the harbor bringing the survivors to treatment. These four tars (Beuttell, Harrison, Whitehed, and Martin) recuperated on a hospital ship. *June, 1924.* (Los Angeles Times)

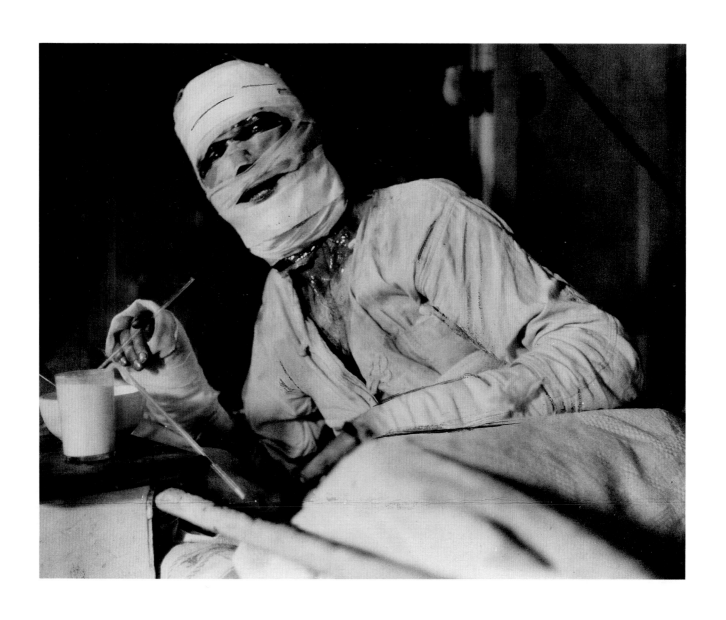

OVERLEAF
Redondo Beach was an unsuitable harbor for
the *W. M. Bowden,* which ran aground in a
winter storm. *February, 1926.*
(Los Angeles Times)

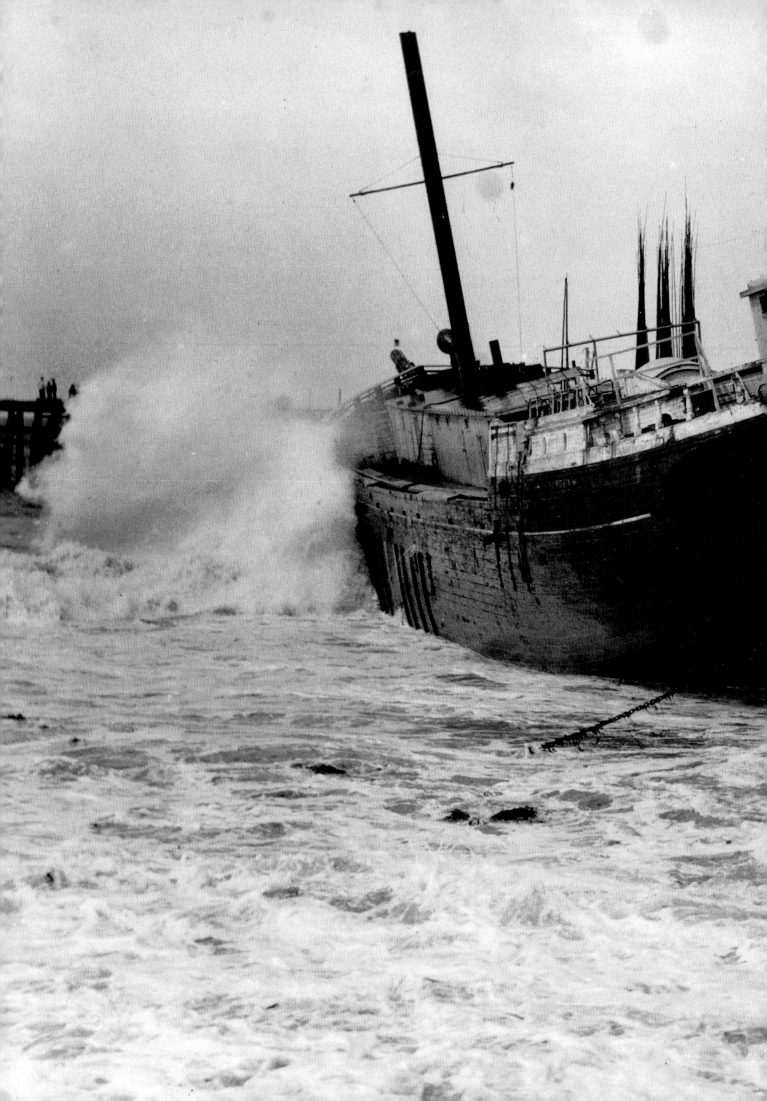

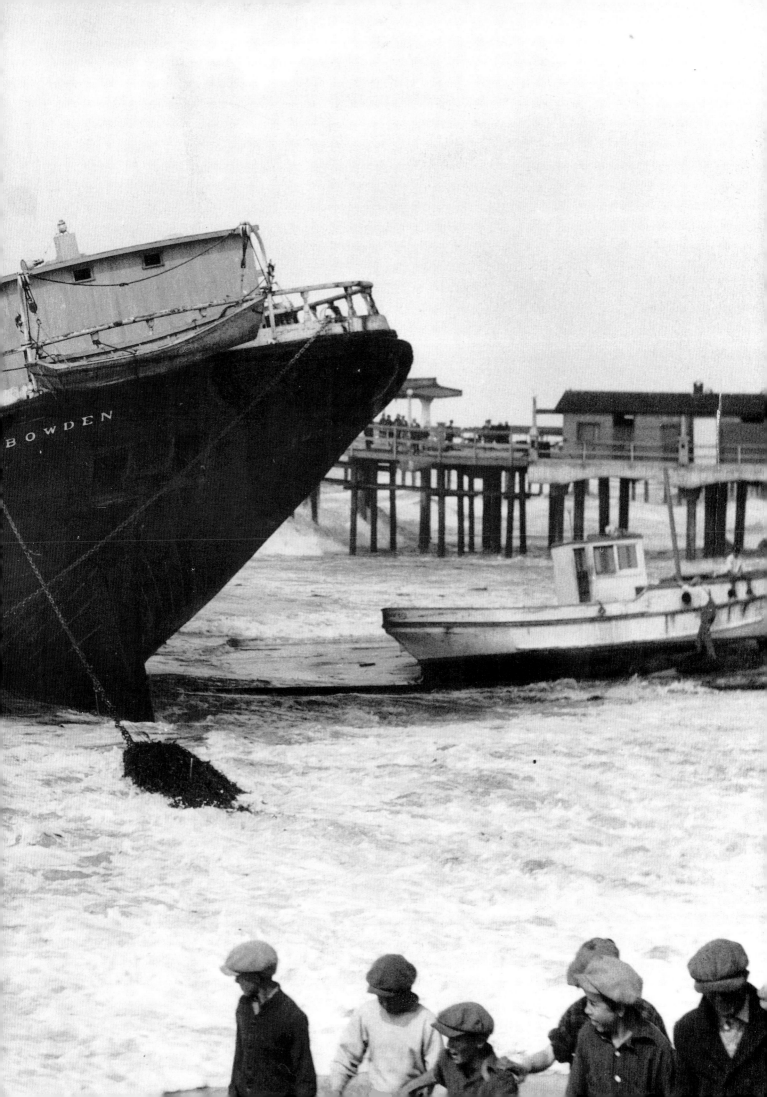

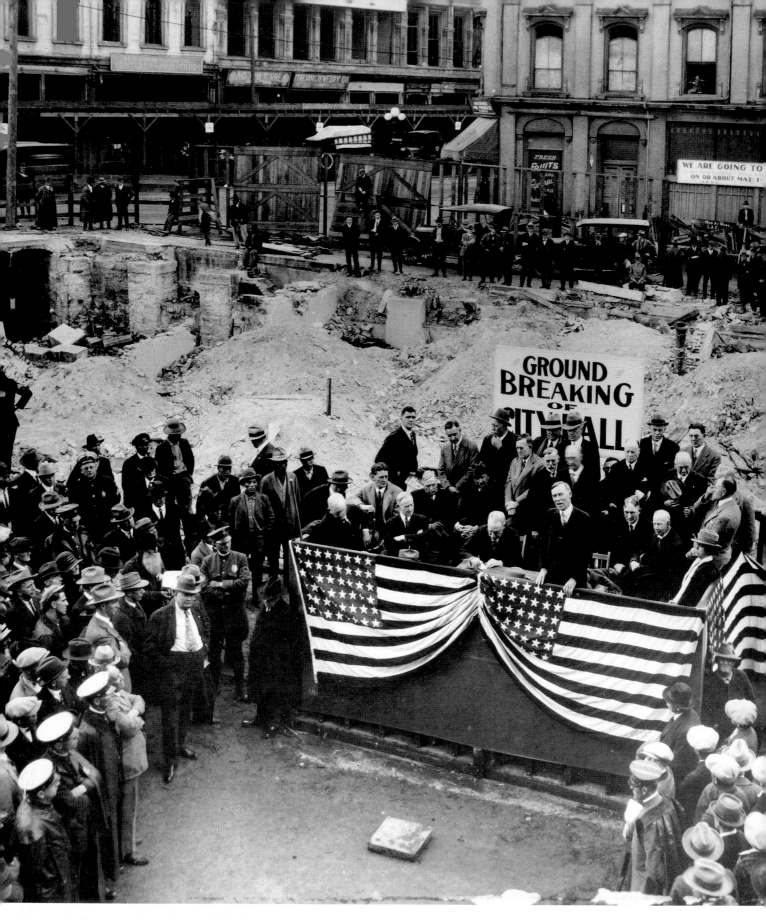

On the ruins of the old Bullard Block,
dignitaries celebrate the ground breaking for
City Hall. *March, 1926.* (Historical
Collections, Security Pacific National Bank/
Los Angeles Times)

A jagged edge of concrete shows where the western wall of the St. Francis dam sheared away, inundating much of Santa Paula and killing more than 200 people. *March, 1928*. (George R. Watson)

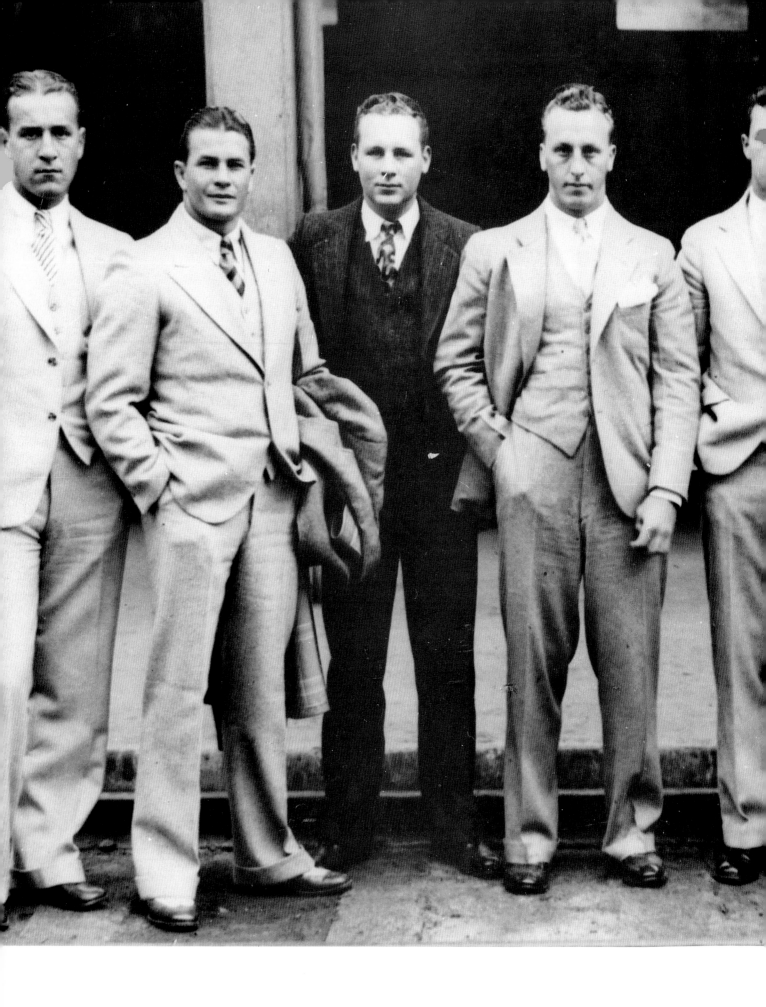

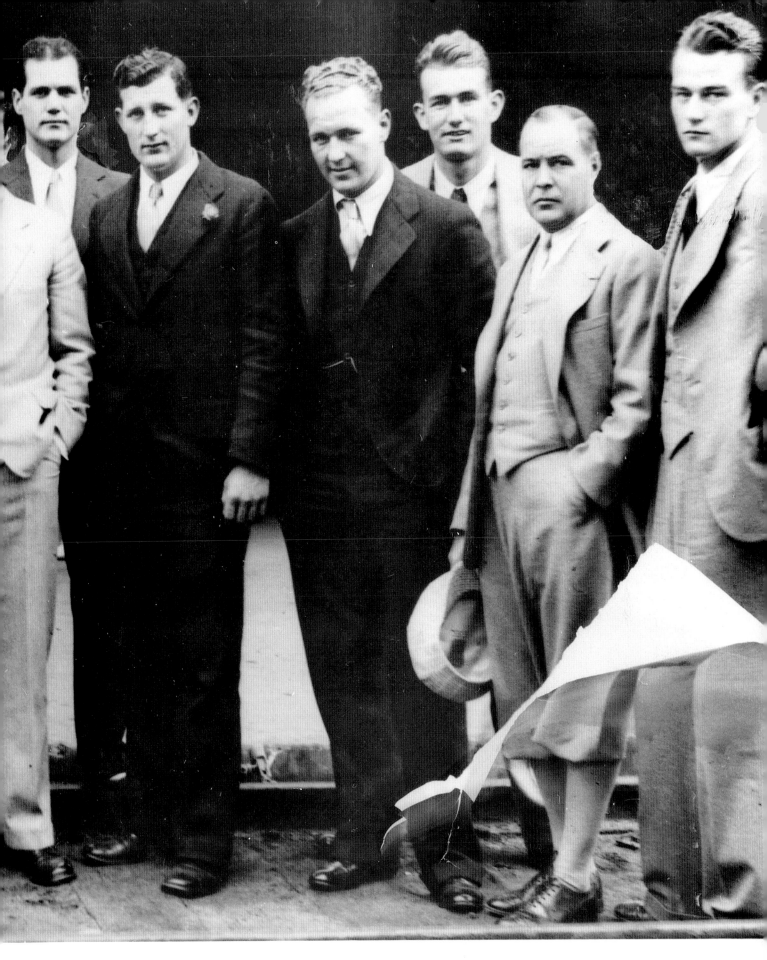

Members of the USC football team about to depart for a playing trip in the East included, at far right, Marion Morrison, nicknamed Duke. The man at his right, a representative of Fox movie studio, knew him as John Wayne. *May, 1929.* (Los Angeles Times)

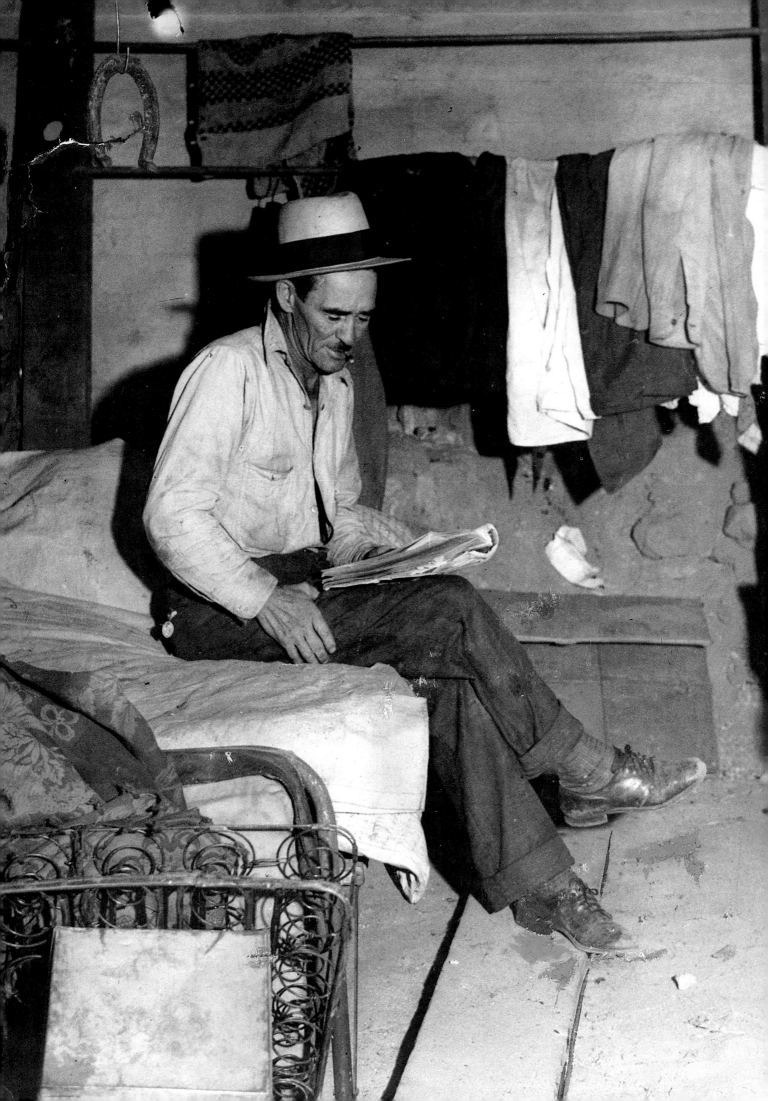

1930s

Two years after the stock market crash, this man found a home under the Dayton Avenue bridge. *November, 1931.* (Los Angeles Times)

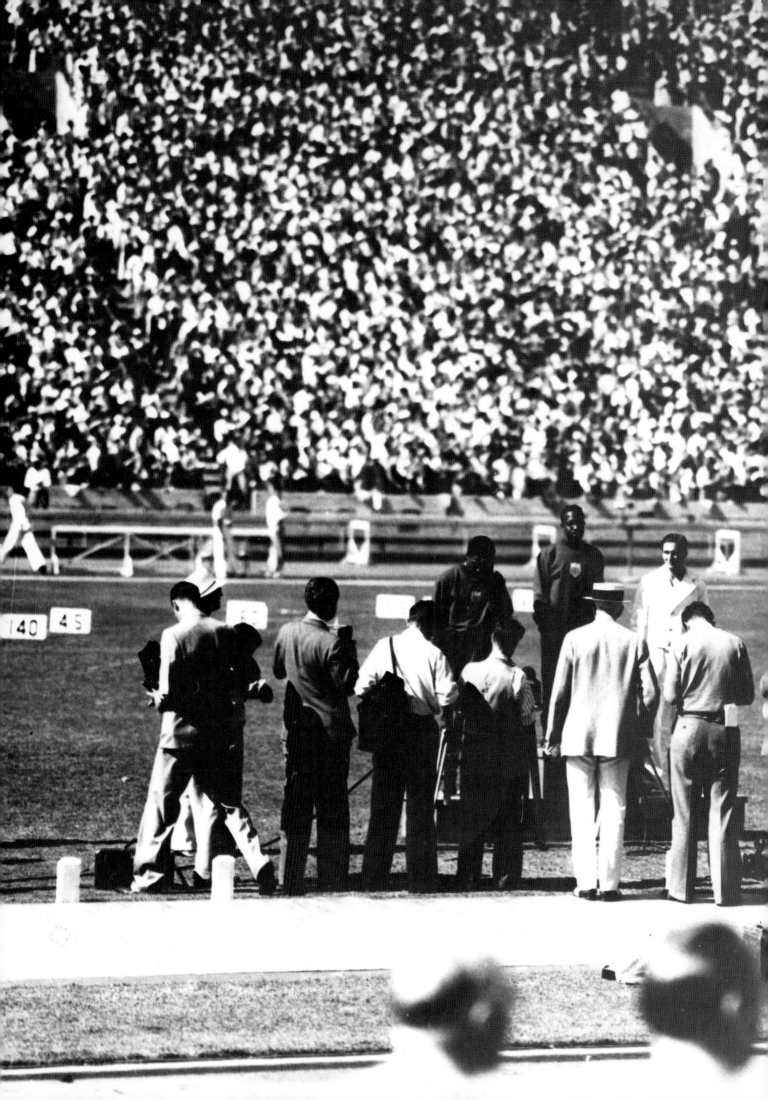

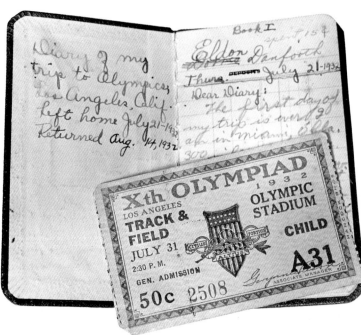

Even as President Hoover ordered federal troops to clear downtown Washington of the 15,000 "bonus" marchers who had been camped there, Vice President Curtis was declaring the opening of the X Olympiad in Los Angeles. Left, two American speedsters Eddie Tolan and Ralph Metcalfe receive their gold and silver medals, having jointly set an Olympic record of 10.3 seconds for the 100 meters. (Tolan won in a photo finish.) *July, 1932.* (Los Angeles Times) Above is the diary and ticket of 17-year-old Eldon Danforth, who hitchhiked from Sedalia, Missouri, to see the Games. The souvenirs were photographed when he returned 52 years later to attend the XXIII Olympiad. *July, 1984.* (Gary Ambrose)

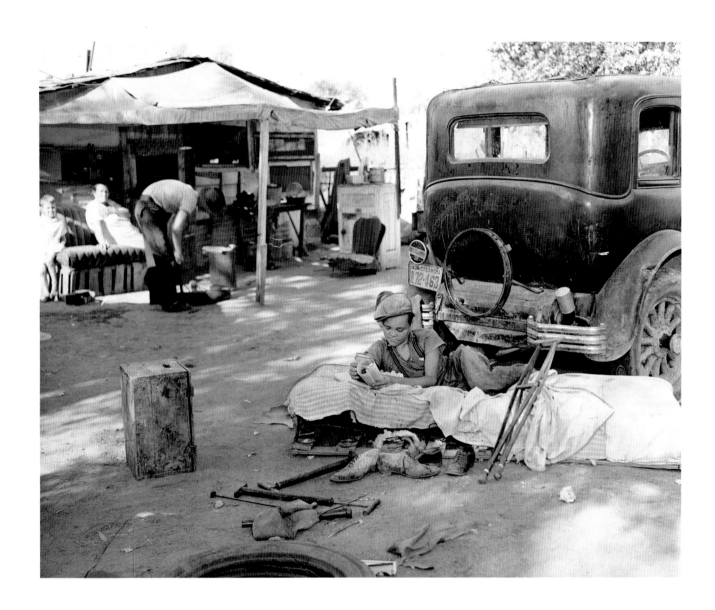

Fifteen-year-old Leroy Norman, crippled in both legs since childhood, makes the best of it in a so-called "jungle" camp in the San Joaquin Valley, home for scores of out-of-work immigrants from Oklahoma and elsewhere. *1936.* (Los Angeles Times)

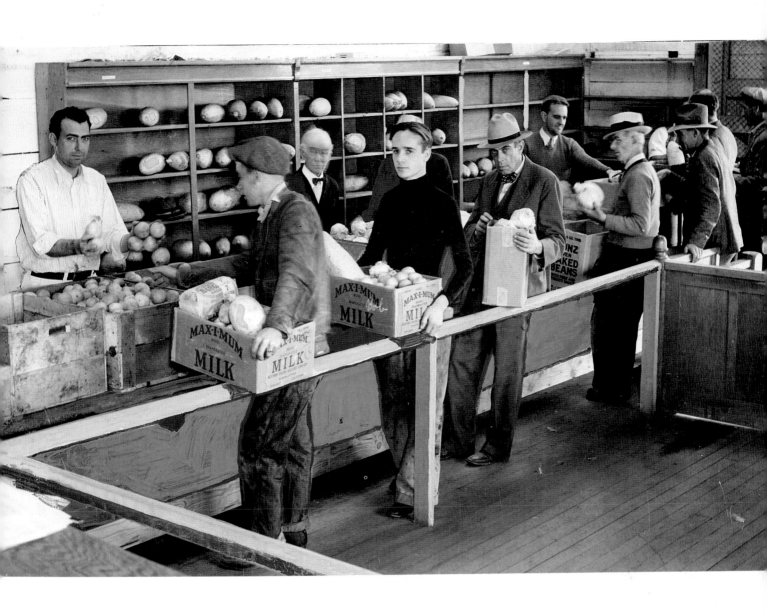

Relief programs that tied welfare to work were in force when President Roosevelt prepared for his inauguration. These men had to show tickets that proved they had been working in order to qualify for food parcels. *January, 1933.* (Los Angeles Times)

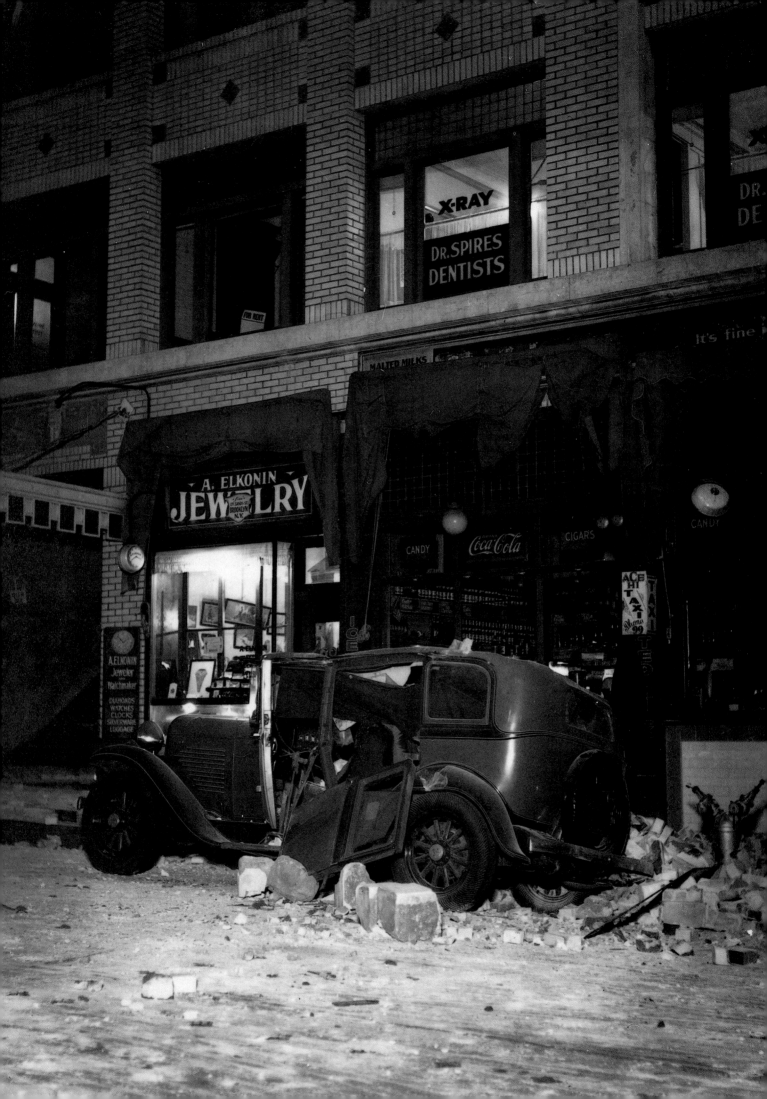

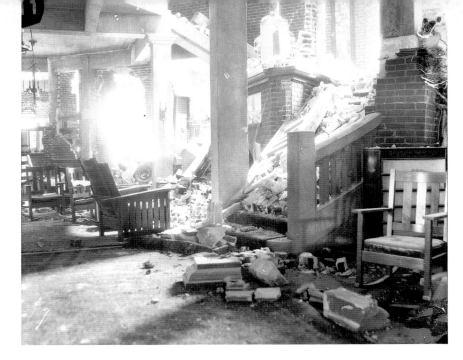

At 5:54 P.M. on Friday, March 10, 1933, a tremendous earthquake "twisted and tore at practically every city and hamlet south of the Tehachapi Mountains. Long Beach, Compton, Watts, Huntington Park, Huntington Beach, and Santa Ana . . . bore the brunt of the shake. But Los Angeles got its full share as buildings shook and twisted, roofs collapsed, walls crashed into the streets, and injured persons began to cry for assistance." *March, 1933*. (Los Angeles Times)

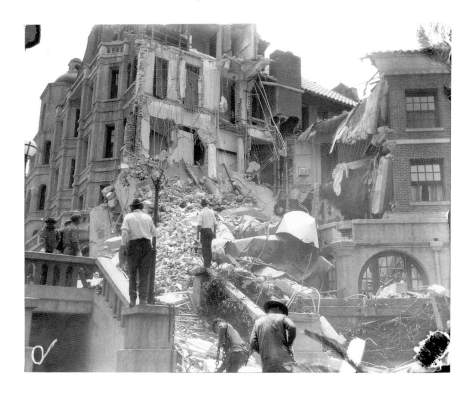

OVERLEAF
New Year hit with a vengeance in 1934 as 8.27 inches of rain fell on Los Angeles in twenty-four hours. Even more water doused neighboring communities; San Gabriel reported 14.86, Glendora 15.40, and Duarte 15.86. In all of 1933 Los Angeles had had less than 2 inches. This mired car on Montrose Avenue became a talking piece for Crescenta Valley residents. *January, 1934*. (Los Angeles Times)

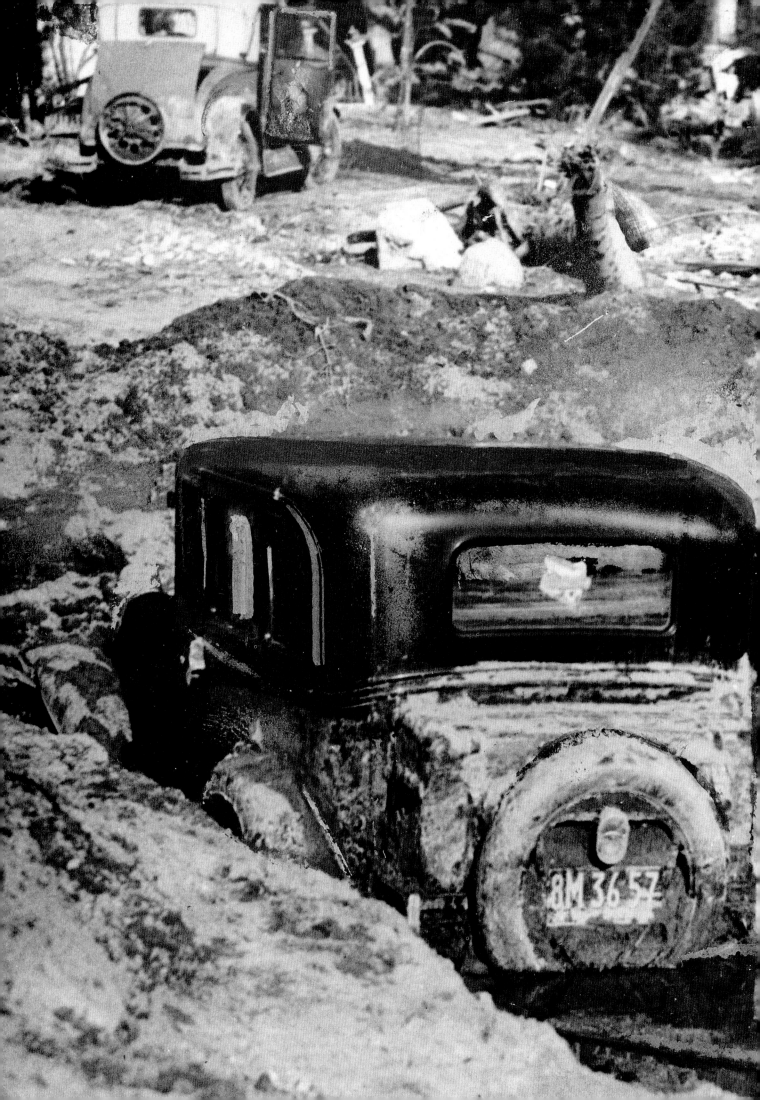

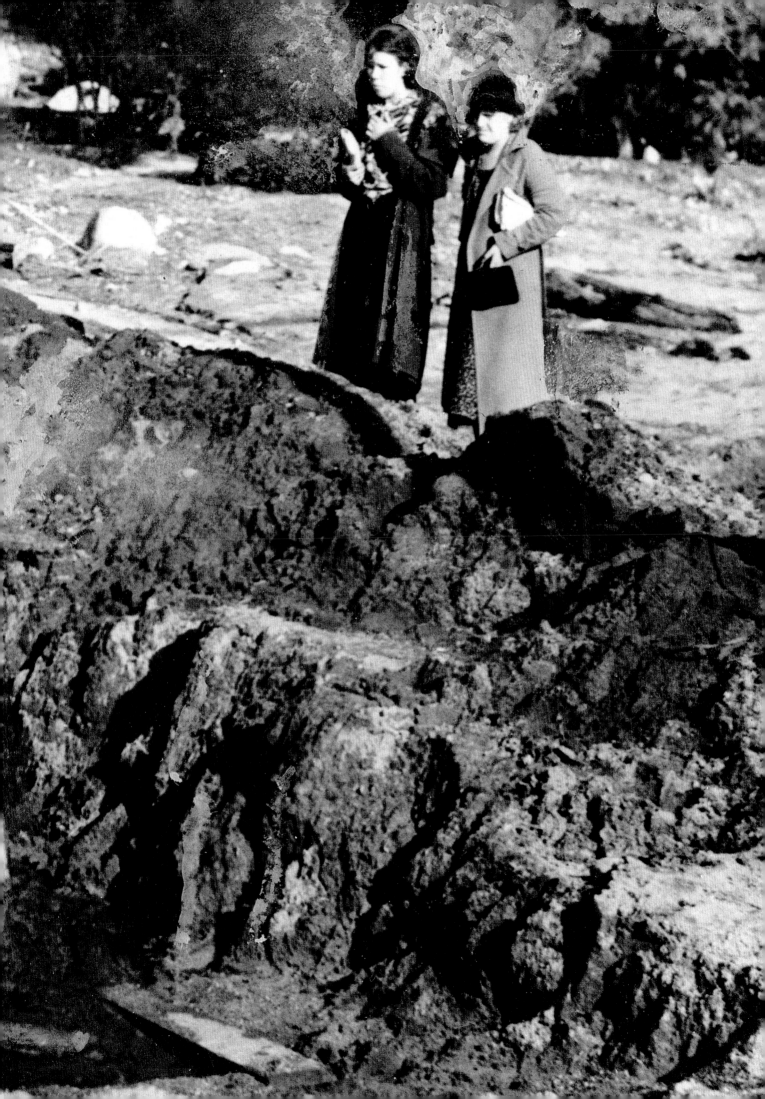

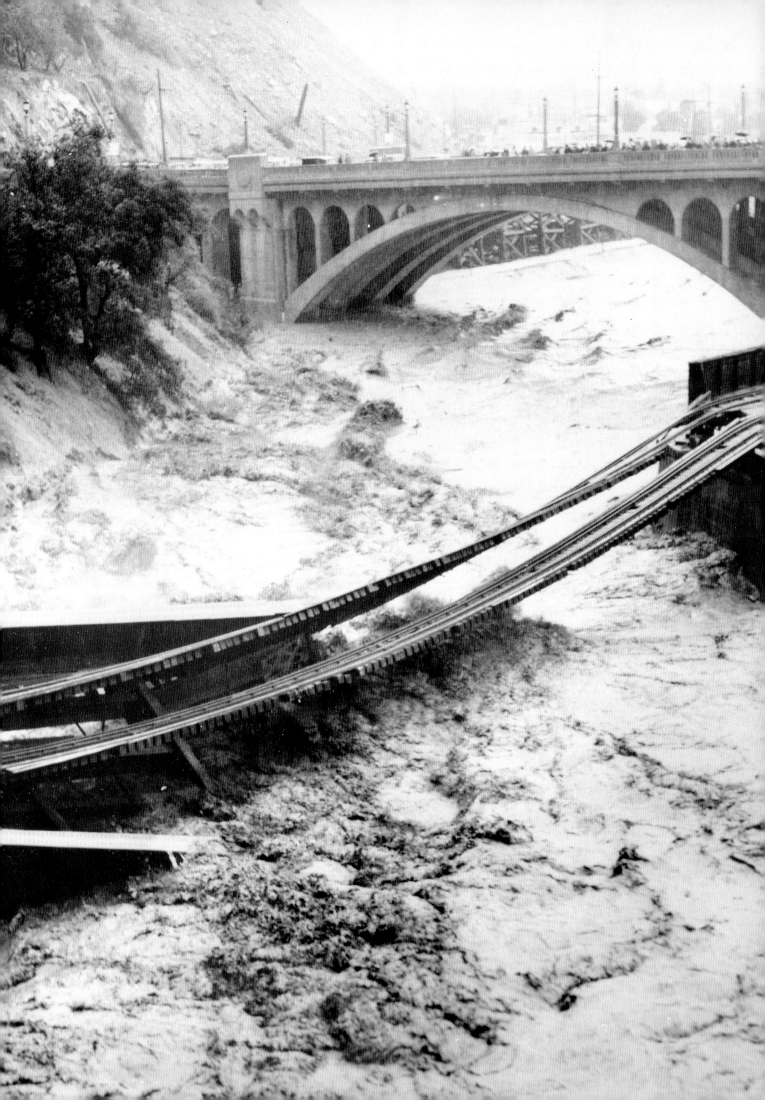

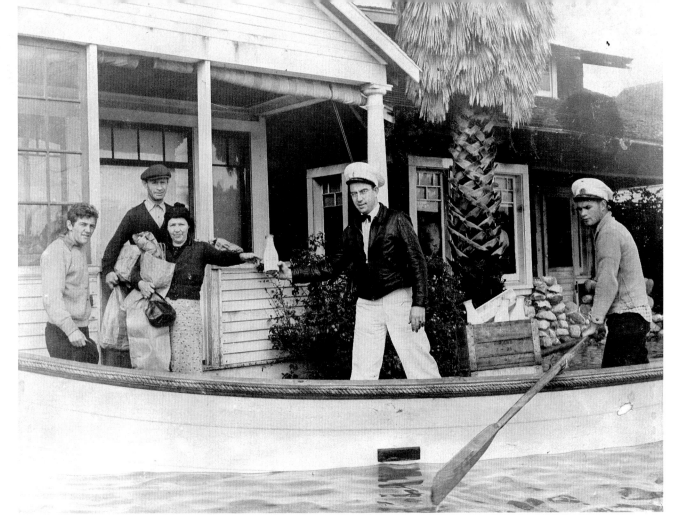

Terrible floods resulted from five days of rain that dumped over 11 inches on the Los Angeles area. A Southern Pacific railroad bridge (seen from the North Figueroa Street bridge) dropped into the Los Angeles River. Elsewhere, milkman Roy Henville improvised his delivery, and on West Forty-third Place east of Santa Barbara the pace of traffic trickled to a halt. *March, 1938.* (Los Angeles Times)

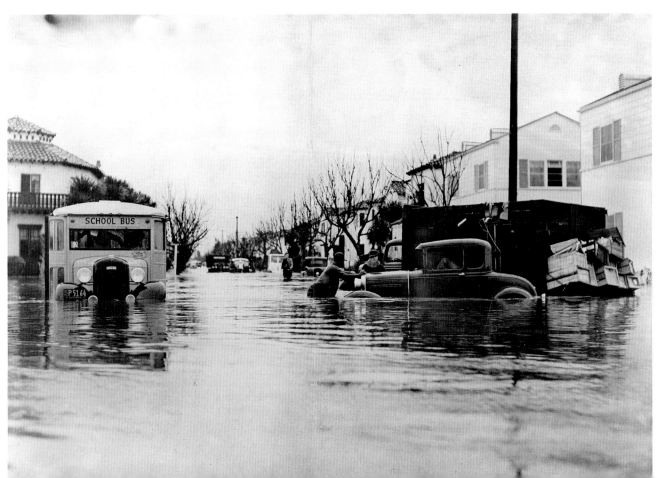

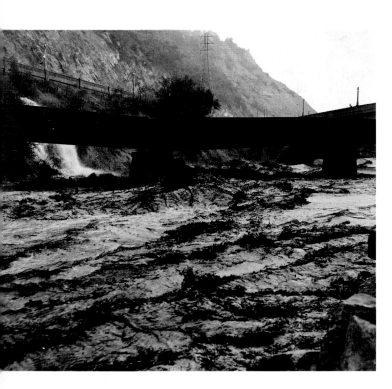

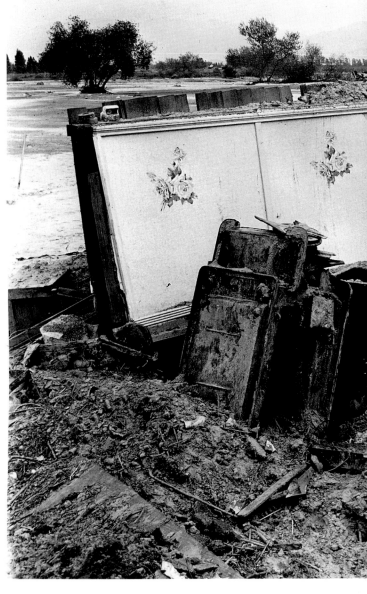

A month after the devastating March floods, the *Times* told the story in the personal terms of J. L. Smith, seen standing with his family in the shambles of their home near the river whose banks could not contain the raging waters. *April, 1938.*
(Los Angeles Times)

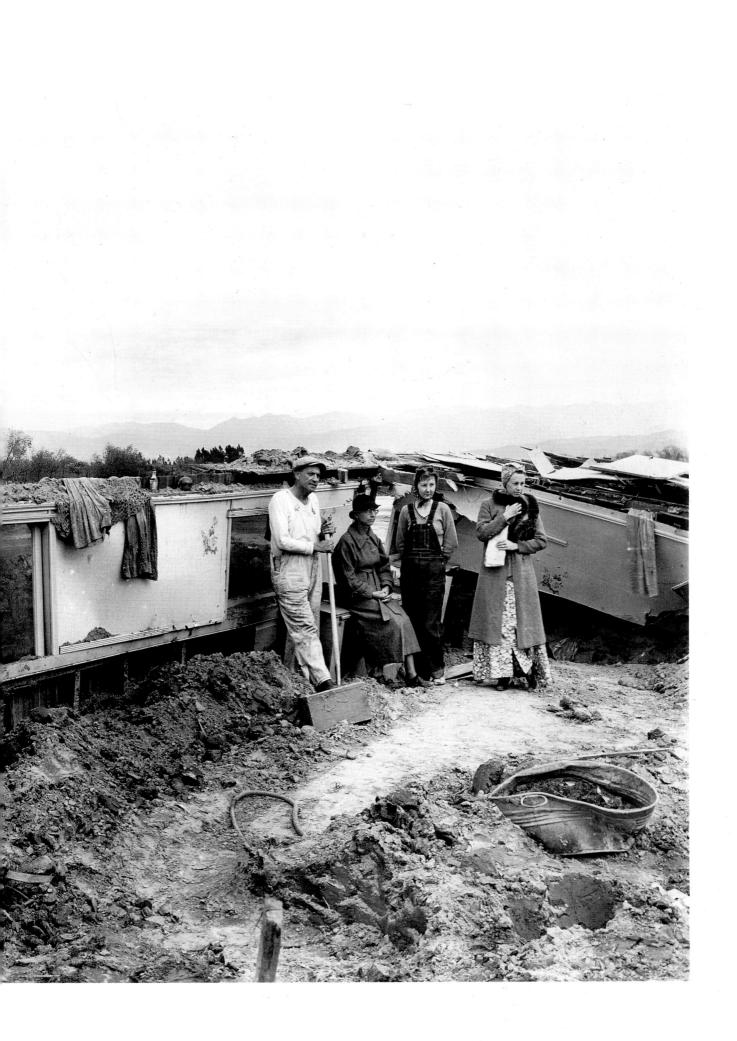

A movie star's welcome was accorded Aimee Semple McPherson, the evangelist, upon her return from a missionary trip to Panama and Honduras. Stepping from the train with "a bouquet of six dozen American Beauty roses in one hand and a bird in a gilded cage in the other," Sister McPherson told the crowd that she was "happy to get home." The *Times* report observed that the only "strange note" in her attire was a single gardenia on her shoulder as "Usually the evangelist of Angelus Temple wears at least a half dozen."

The article further described the general pandemonium of the welcome and indicated that "the tuba player in the band almost had apoplexy trying to attract Sister's attention."

The evangelist, whose reputation survived a mysterious month-long disappearance in 1926 and subsequent trials for fraud and other charges, died in 1944 from an accidental overdose of sleeping pills. *February, 1939.* (Los Angeles Times)

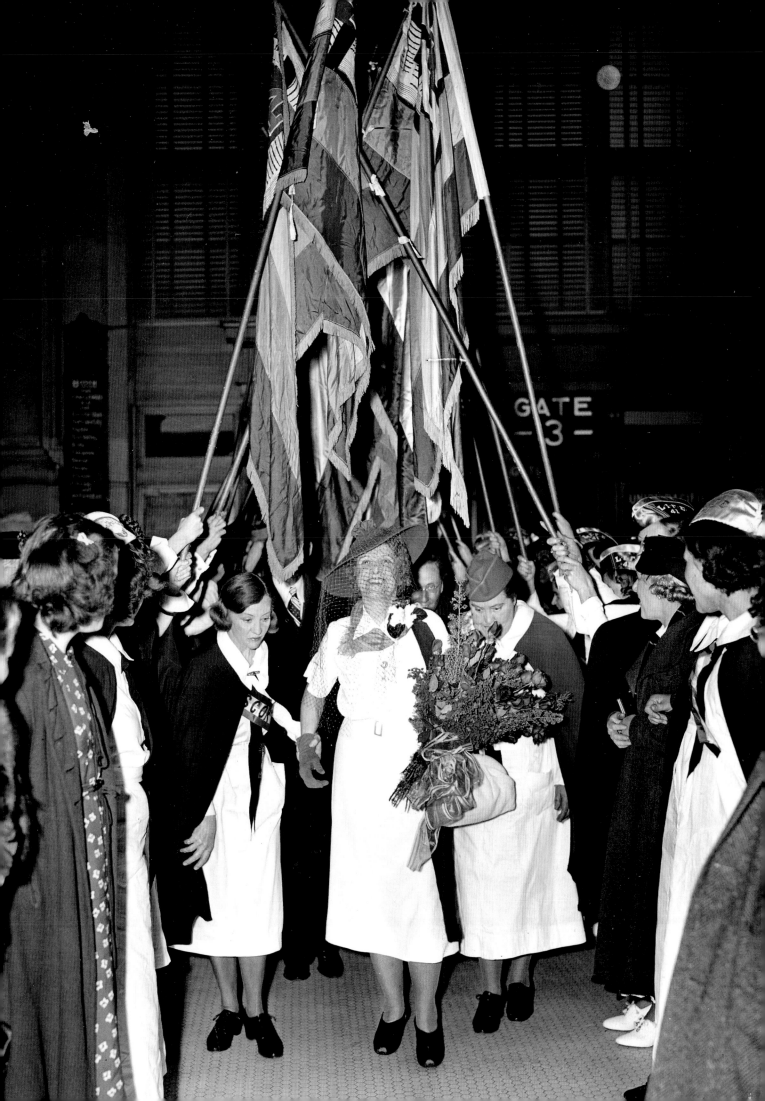

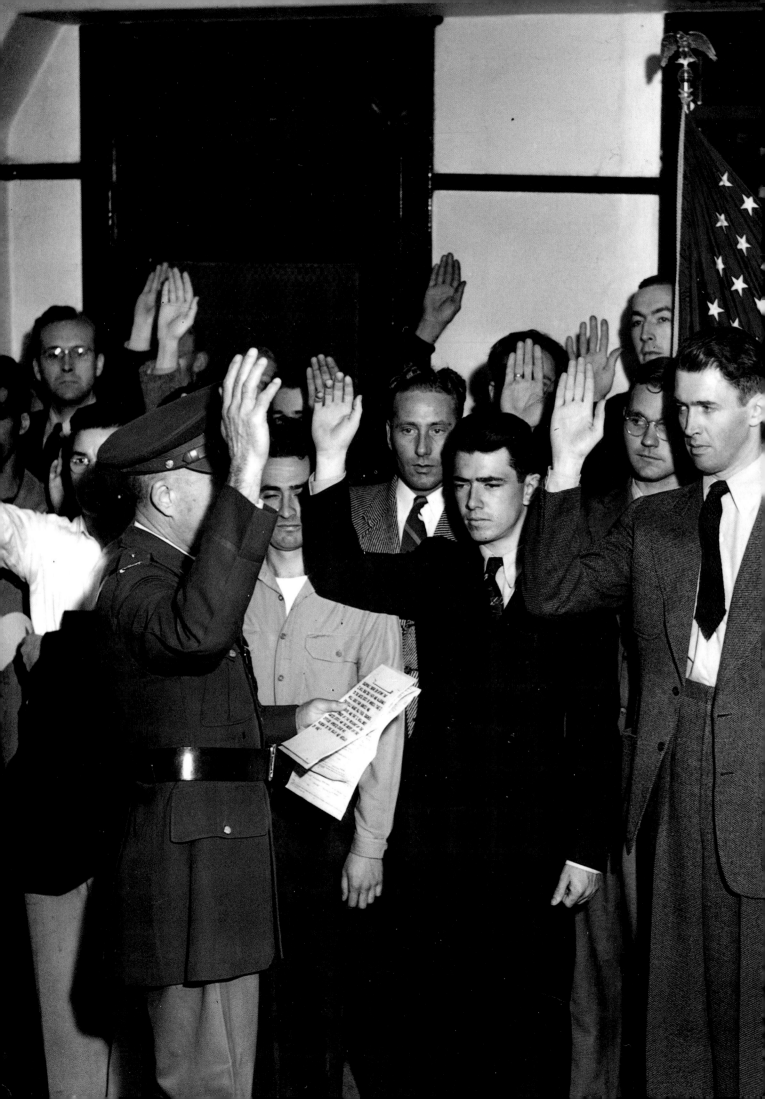

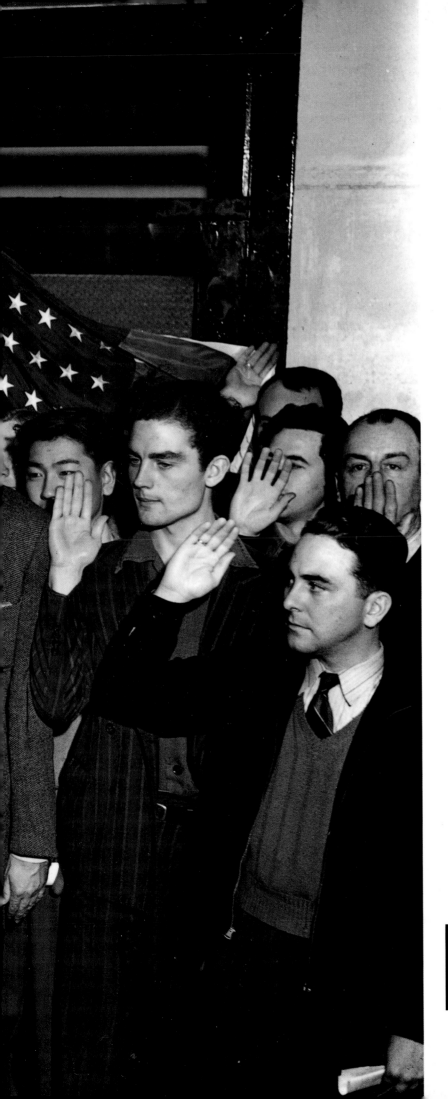

1940s

Among 41 volunteers taking the oath, James Stewart was the first top-rank film star to join the Army. *March, 1941.* (Los Angeles Times)

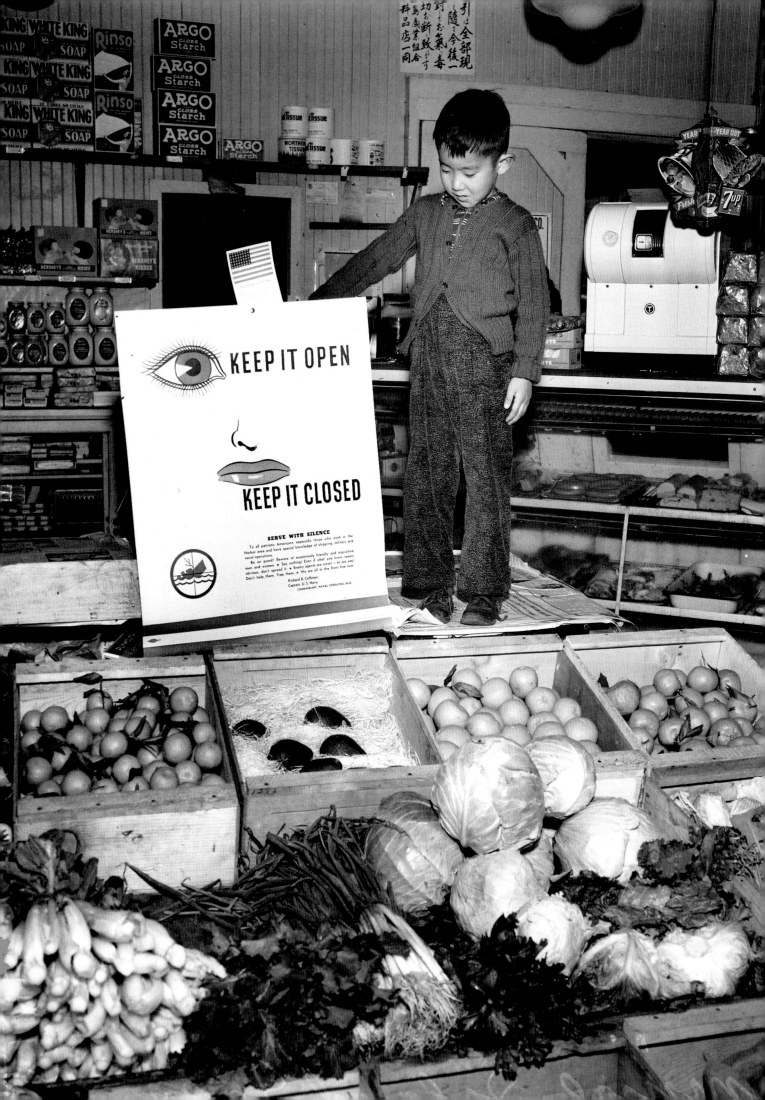

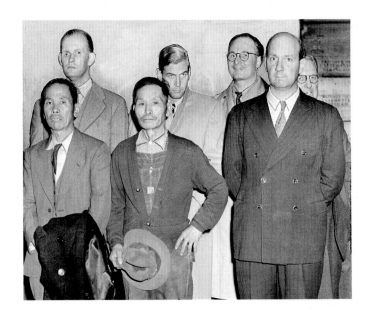

European as well as Japanese aliens were rounded up in the panicky days following Pearl Harbor. Among them was Hans Gebhart, German consul in Los Angeles, the tall man with glasses seen in the second row. *December, 1941.* (Paul Calvert)

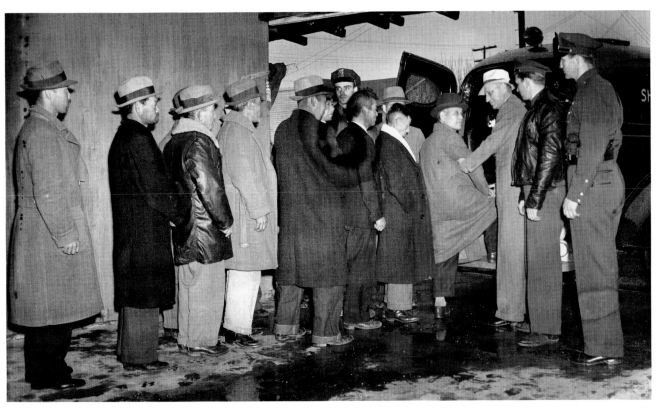

Merchants and residents of the Los Angeles harbor area were advised to keep their eyes open and their mouths closed to guard against information on Allied shipping leaking out to spies. *January, 1942.* (Andrew Arnott)

The roundup of immigrant Japanese and nisei people continued into 1942 as fear of mainland attacks increased. Two days after this photograph was made, a Japanese submarine was reported to have fired 16 shells from a mile offshore into an oil field 12 miles north of Santa Barbara. *February, 1942.* (Ray Graham)

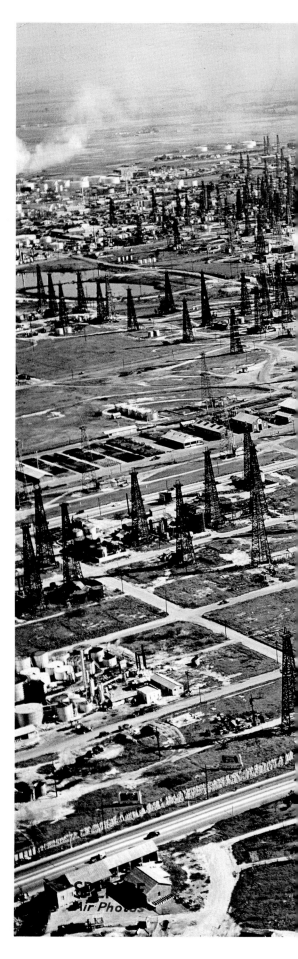

California's oil boom, begun with a wildcat strike in 1921, produced a forest of derricks along the coast by the early 1940s. Above is Huntington Beach. *January 28, 1940.* (Ted Hurley). At right is Signal Hill, where it all began. *February, 1941.* (Spence Air Photos/ Los Angeles Times)

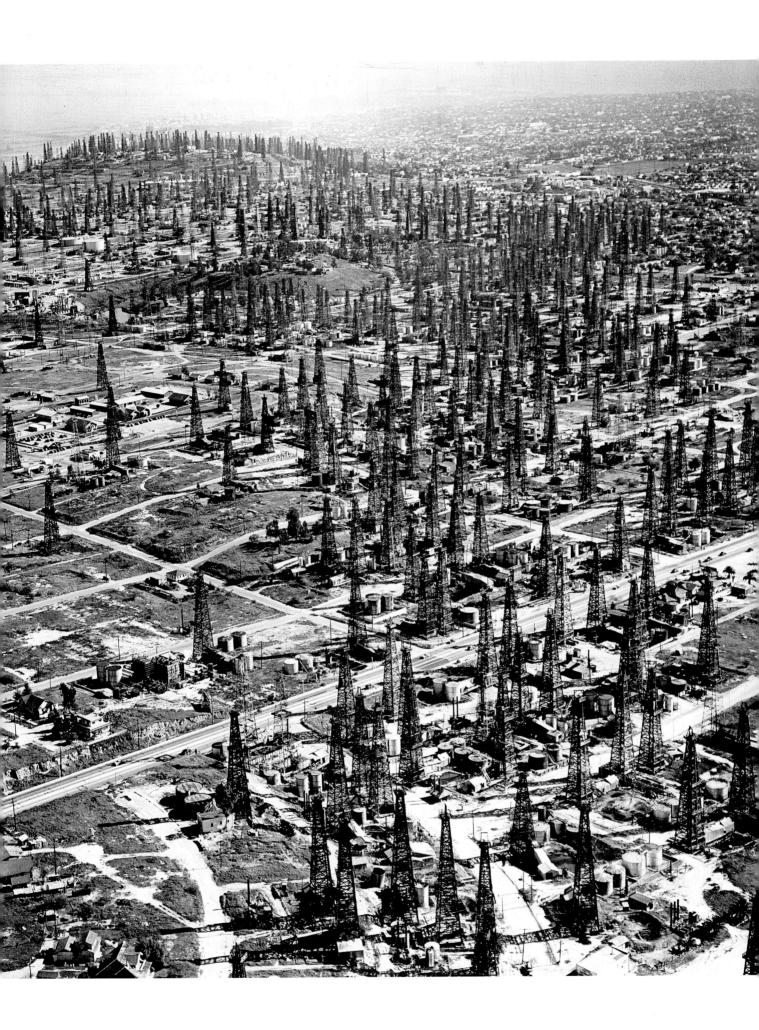

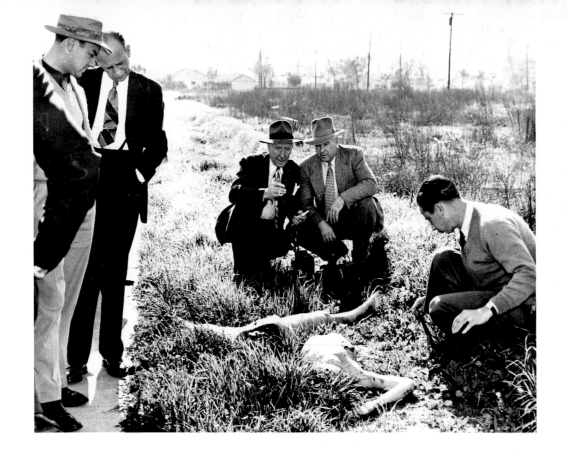

Reporters, detectives, and police crime investigators examine the mutilated body of a woman found in the early morning by children walking to school on Norton Avenue a block off Crenshaw Boulevard. *1947.* (R. L. Oliver)

A police diver offers unheard sympathy to a mother who has just discovered the whereabouts of her missing child. *July, 1947.* (Paul Calvert)

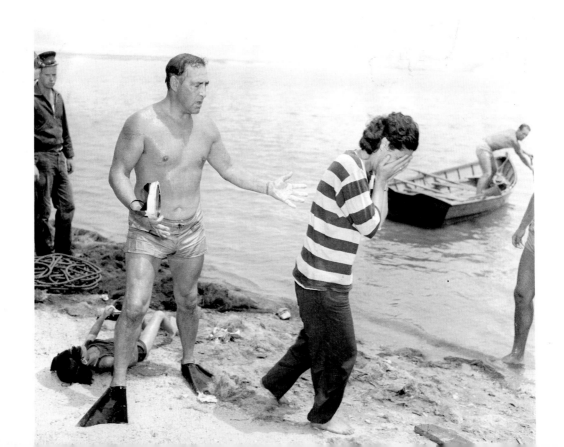

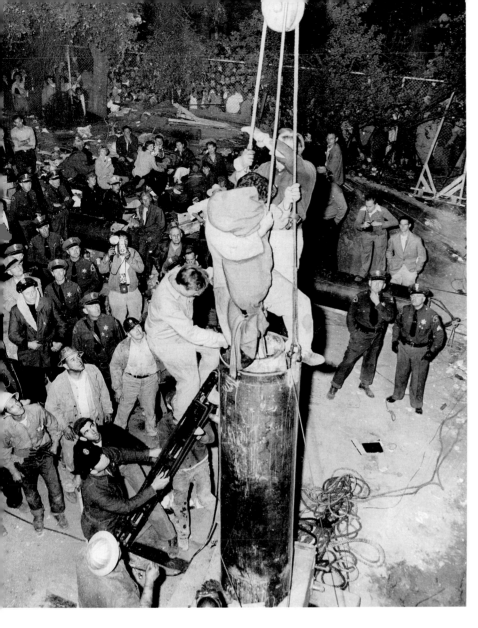

All hope ended, the body of three-and-a-half-year-old Kathy Fiscus is finally removed from the 14-inch water pipe where rescuers had toiled in vain for 48 hours to save her. *April, 1949.* (Ray Graham)

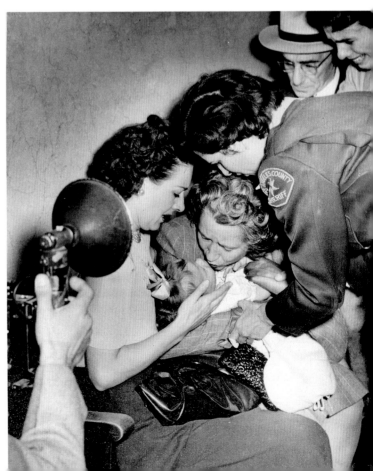

A tearful farewell takes place amid flashbulbs in a celebrated court case in which a natural mother was awarded custody of the baby girl she had given for adoption 16 months earlier. *November, 1949.* (Paul Calvert)

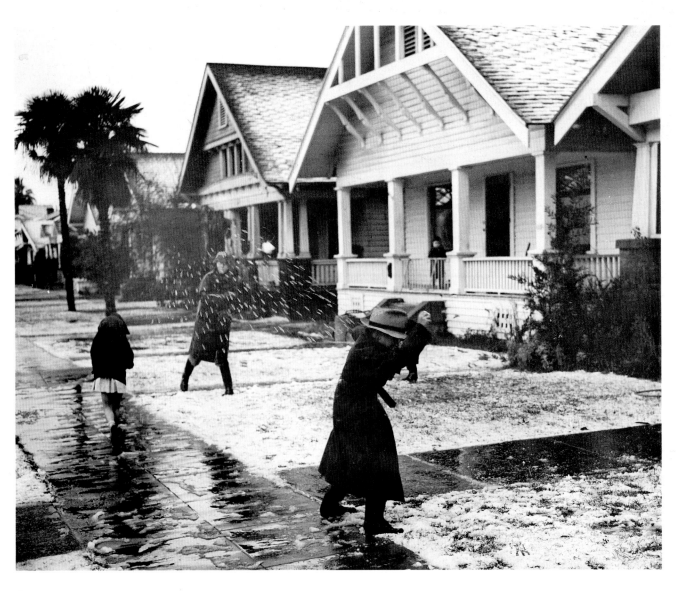

A dusting of snow greeted the New Year at
Vernon Avenue and Figueroa Street,
delighting the children. *January, 1942.*
(Al Humphreys)

Thirty-foot waves threatened to enter the
home of Mrs. Emilia Curtet at 322 Strand in
Redondo Beach as excessively high winds and
ground swells in Northern California had
their effect on the Malibu to Long Beach
coastline. *December, 1945.* (Paul Calvert)

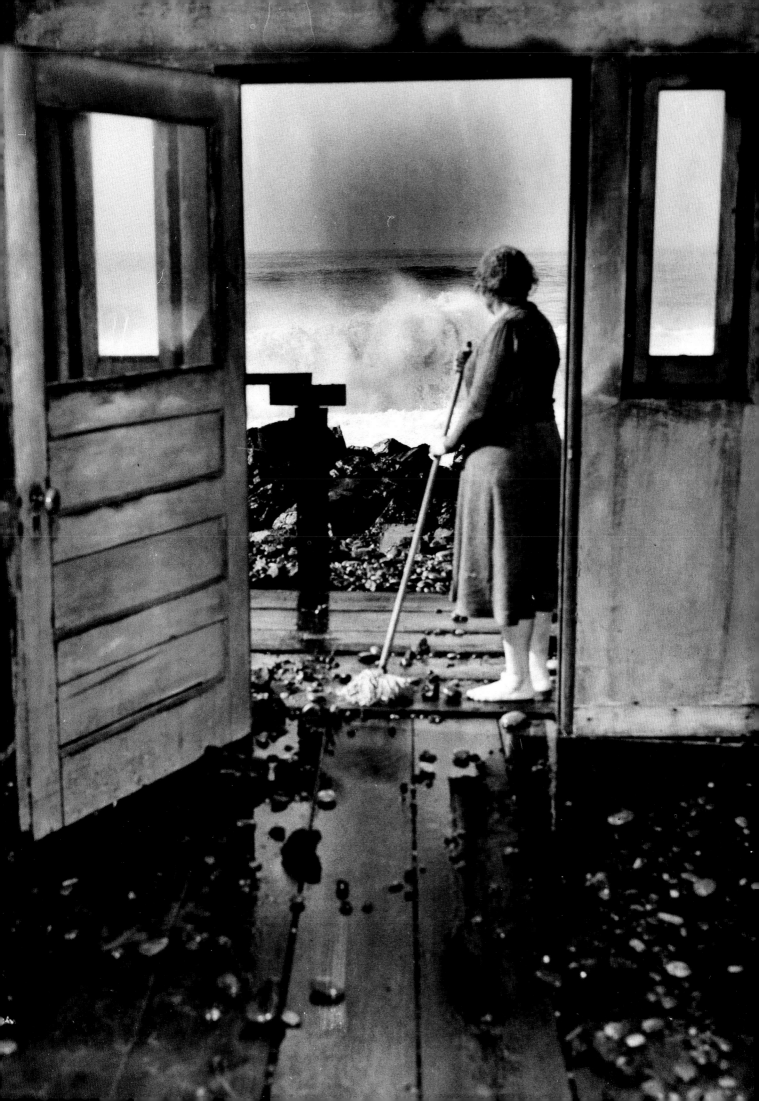

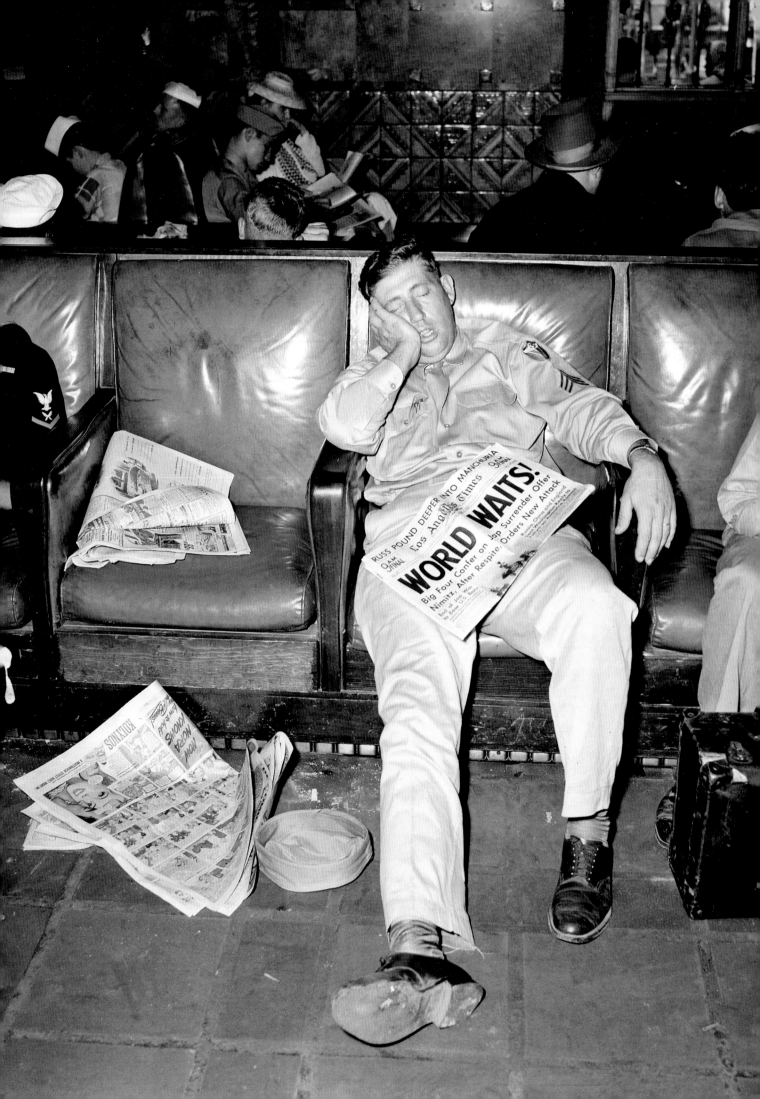

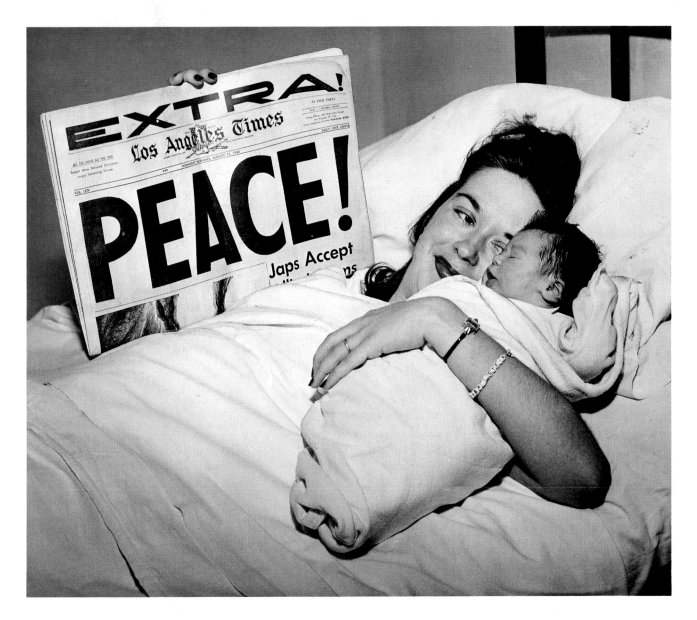

Berna Bronstein, first child born in Los
Angeles on the day the Japanese accepted the
terms of surrender to the U.S., was given the
middle name Vee in honor of the day.
August, 1945. (Los Angeles Times)

Less than a week after Hiroshima the world waited for news
of the formal surrender of Japan, and Sgt. B. A. Kainer
waited in Union Station for a train to take him to Texas to
see his wife and infant son. *August, 1945*.
(Los Angeles Times)

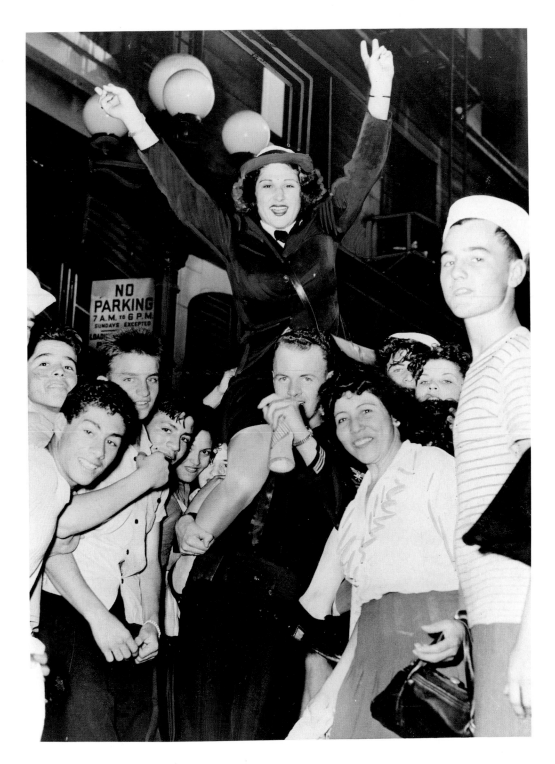

Buddy Phalps hoists Joann Papagni, a Spar,
aloft in tumultuous downtown victory
partying. *August, 1945*. (Harmon D. Toy)

Twenty-five years a "newsboy," Alfred Fehr
jubilantly hawks the best news in years
outside the *Times* building. *August, 1945*.
(Los Angeles Times)

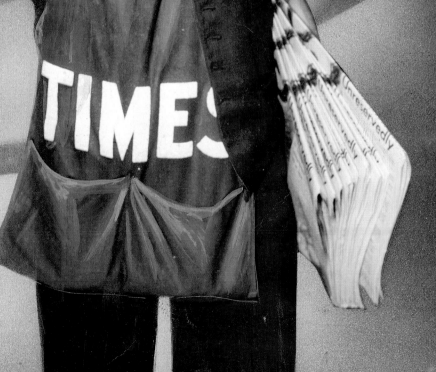

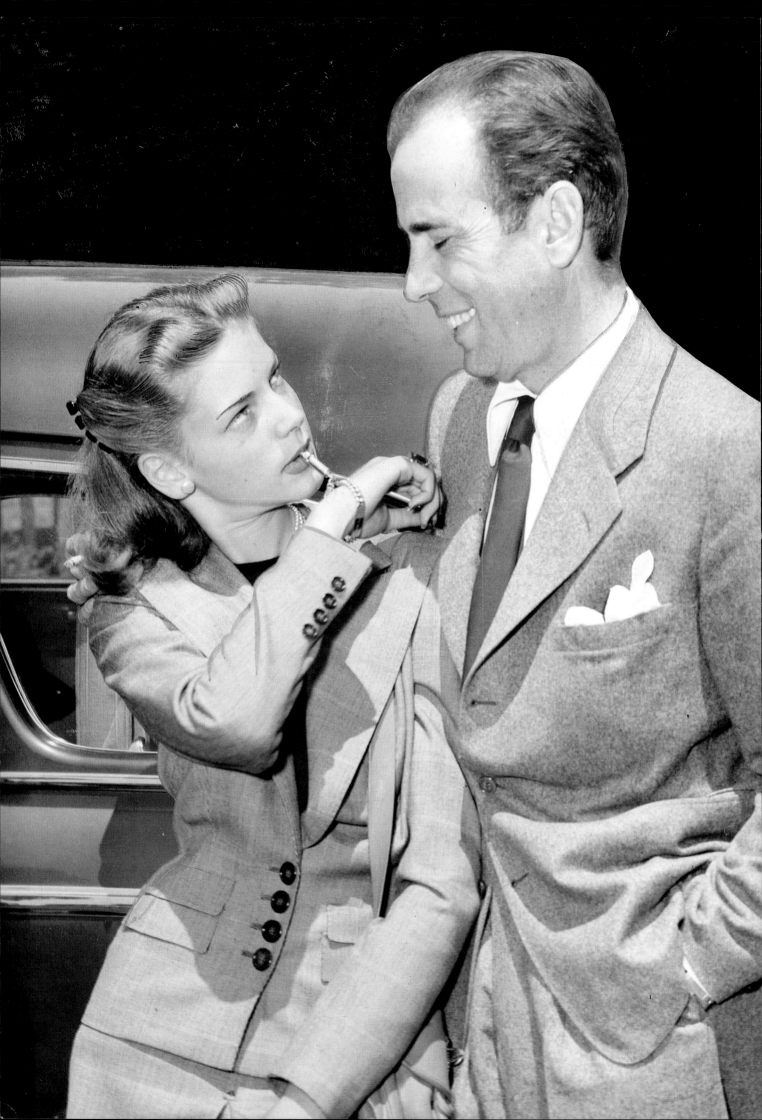

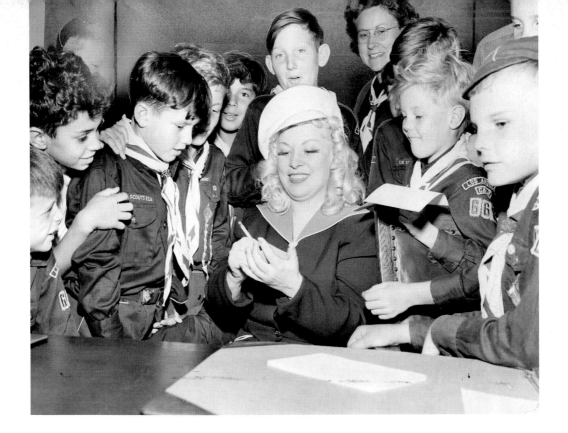

Stars in court included Mae West, defending a plagiarism charge, and Charlie Chaplin, awaiting the verdict on a paternity suit. Courting stars were Humphrey Bogart and Lauren Bacall, seen on return from their marriage in Ohio.

Mae West's case was dismissed after a hung jury could not decide whether she had used material in her 1944 Broadway hit *Catherine Was Great* that was allegedly prepared by two other writers. *August, 1948.* (R. L. Oliver)

Chaplin got a hung jury and despite negative medical tests was later declared the father. As a result of his bad press and partly because of his softness on communism, he was denied reentry to the States after he left for a vacation in 1952. *March, 1944.* (John Malmin)

Bacall, who taught Bogey how to whistle in their first film together, demonstrates again on a gold bracelet charm. *May, 1945.* (L. Maxine Reams)

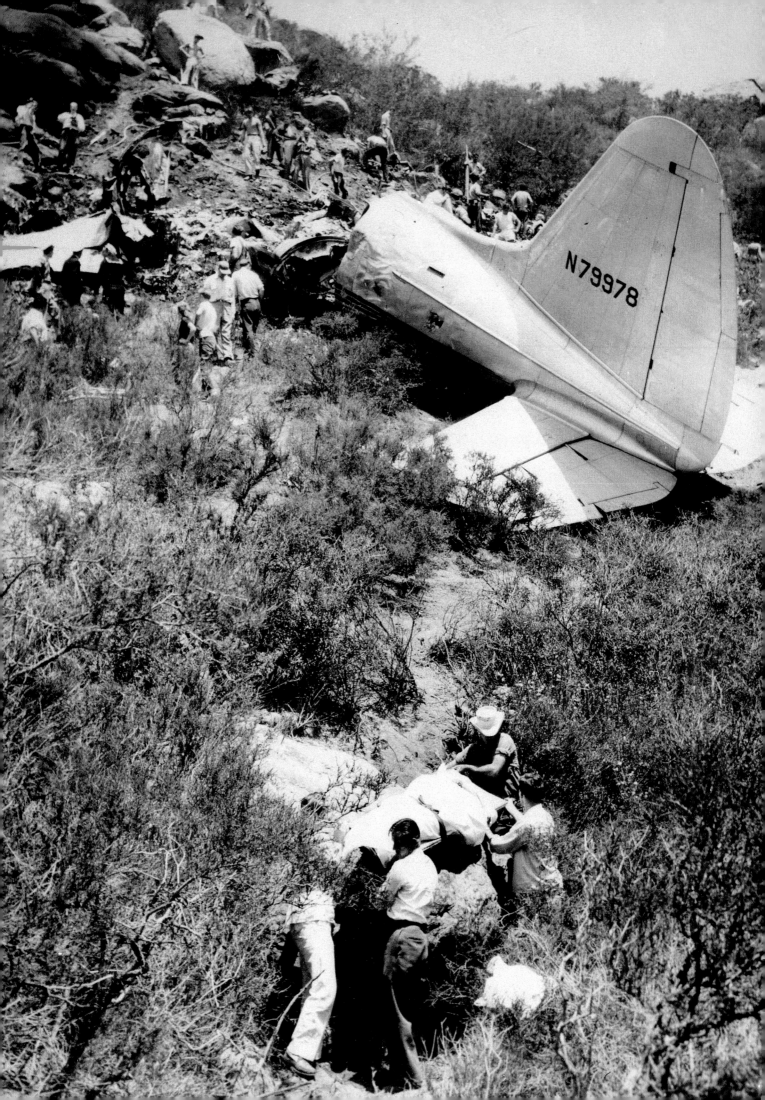

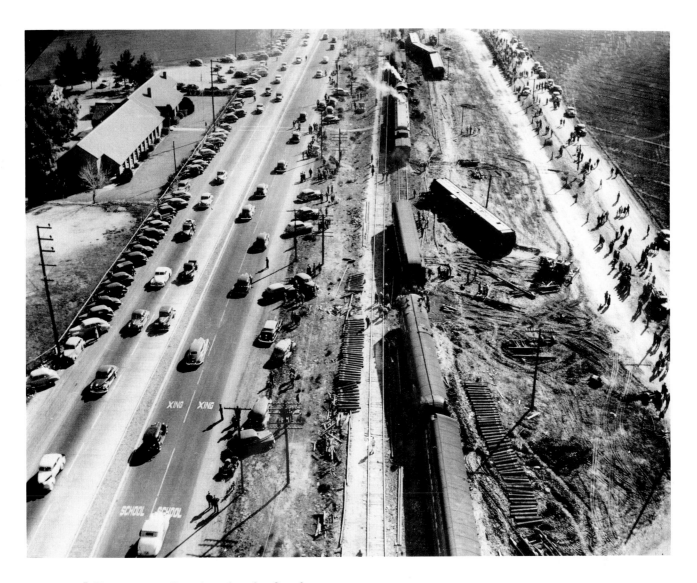

En route to Los Angeles the Southern
Pacific's night flyer Owl derailed at
Bakersfield at 2:40 A.M., killing seven and
injuring nearly 100. *January, 1947.*
(Los Angeles Times)

Thirty-five died as a Standard Airlines C-46 crashed into
the Santa Susana mountains, but 14 persons were
miraculously rescued. *July, 1949.* (Los Angeles Times)

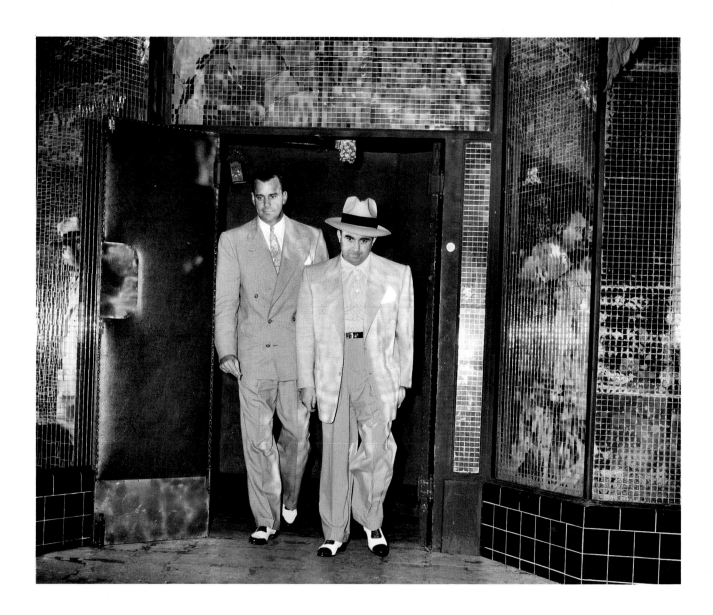

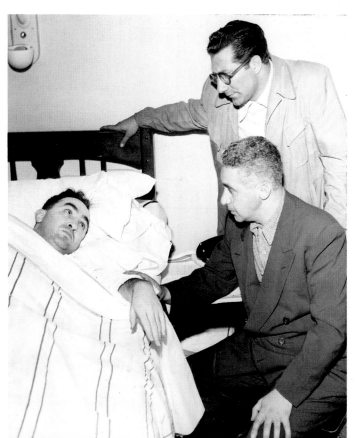

Mickey Cohen led a precarious life while awaiting trial for conspiracy in a wide crackdown on organized crime. Shortly after he was photographed outside the Continental Cafe on Santa Monica Boulevard (with special agent Harry Cooper assigned to guard him), Cohen was hit in the shoulder with a shotgun slug and sent to Queen of Angels Hospital, where he was later visited by two henchmen. *July 21, 22, 1949.* (Larry Sharkey)

Two years later Cohen was again booked, tried, and convicted of three counts of income tax evasion and falsifying a net worth statement. He was sentenced to five years in prison and ordered to pay a $10,000 fine. *June, 1951.* (Los Angeles Times)

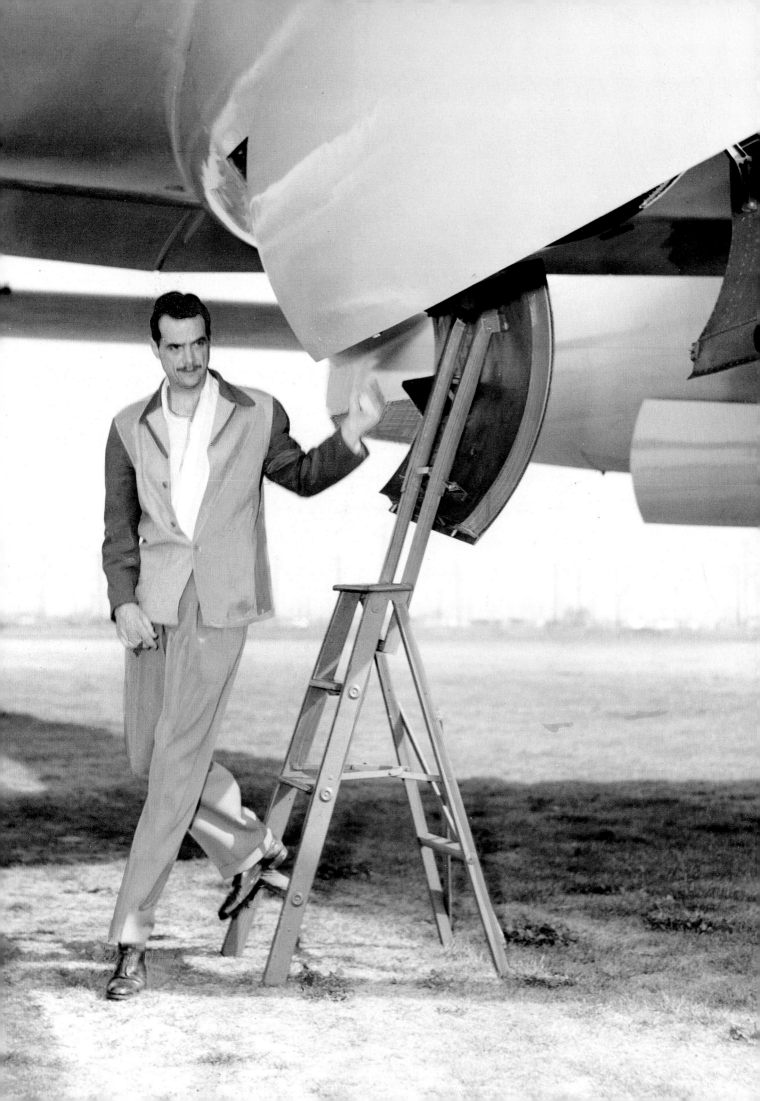

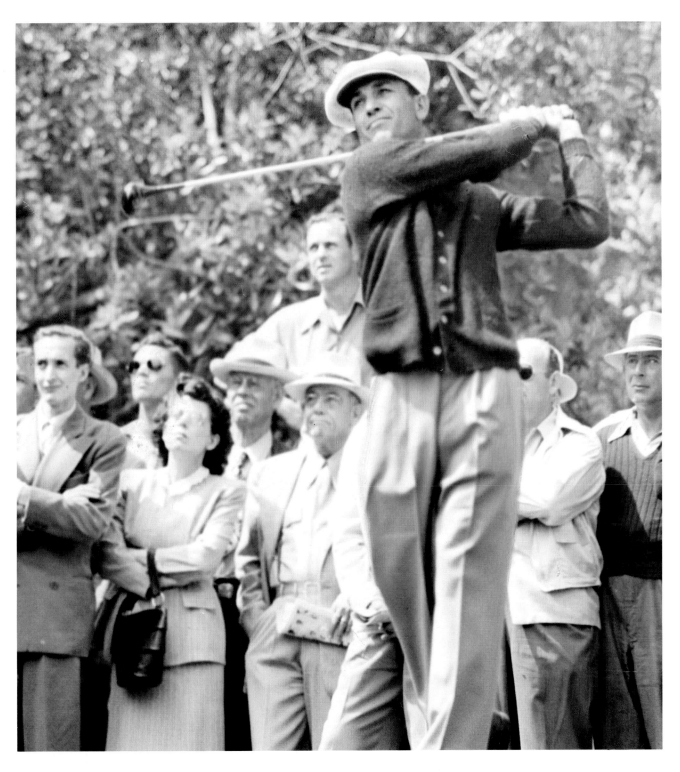

Ben Hogan won his first U.S. Open title at the Riviera Country Club with a 72-hole total of 276. *June, 1948.* (John Malmin)

Down to earth after a second and successful test flight, Howard Hughes steps from a plane he designed and built; he had crashed on his first solo test. *April, 1947.* (Phil Bath)

Wearing his admiral's braid, the Shah of Iran
inspects U.S. marines aboard the carrier
Valley Forge, anchored at North Island.
Thirty-one years later the Shah would die in
exile at a military hospital in Cairo.
December, 1949. (Paul Calvert)

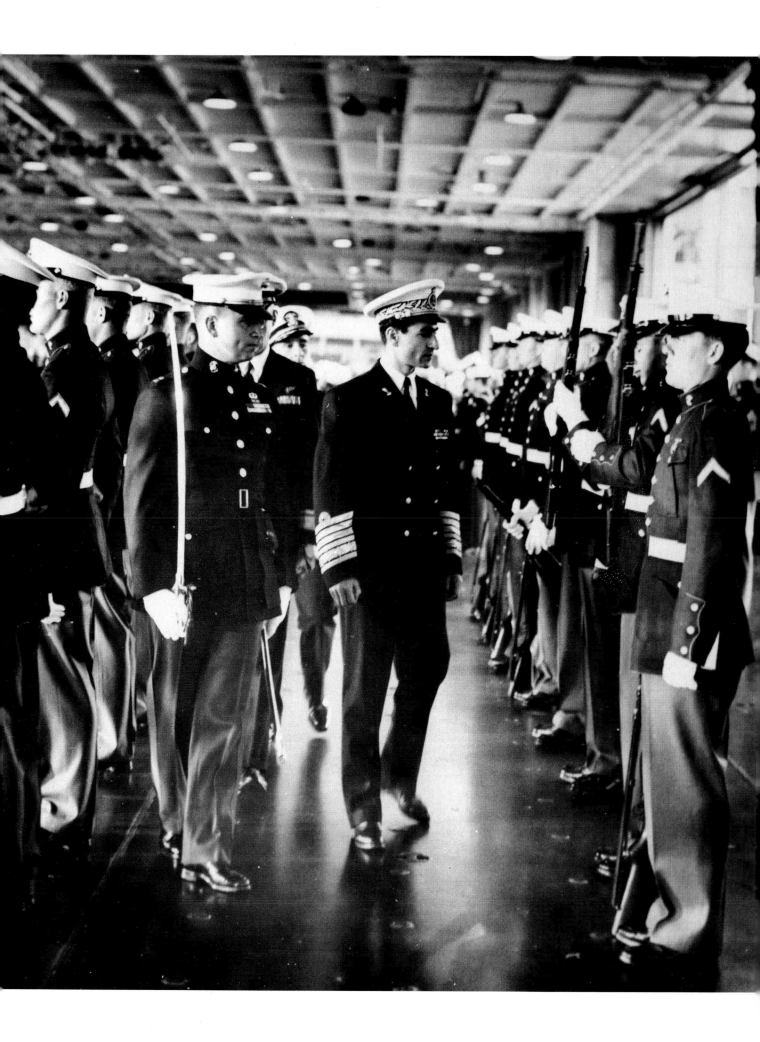

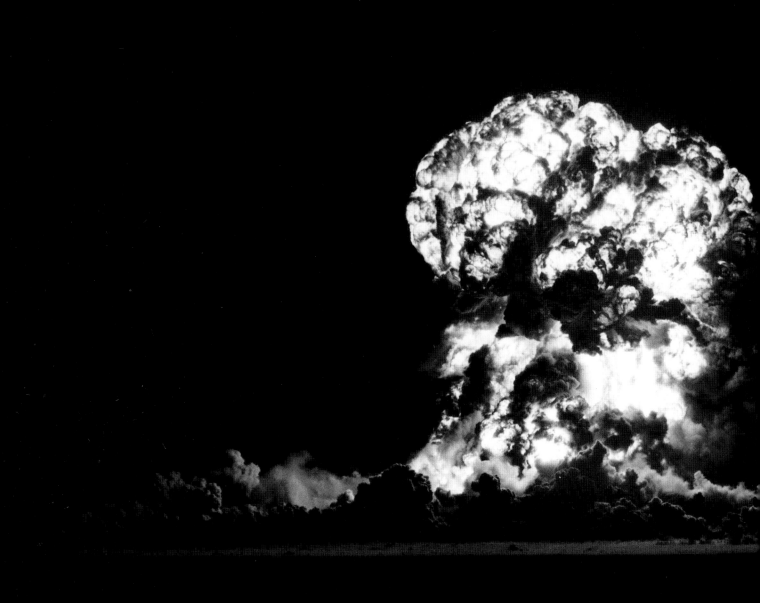

1950s

Ten years after Hiroshima the atomic age was well under way as *Times* photographer Larry Sharkey went out to the desert to photograph a test. Using a 40-inch lens from eight miles distance he captured the fireball soaring four miles high. *May, 1955.*

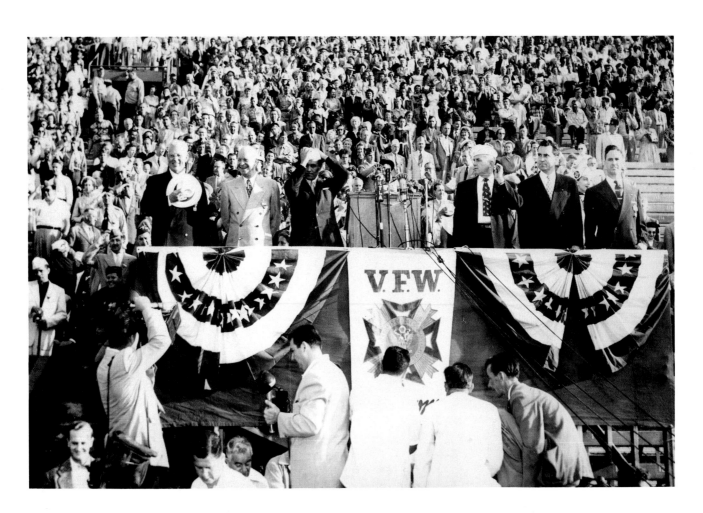

Campaigning General Dwight D. Eisenhower
shared a platform at the Los Angeles
Coliseum with Governor Earl Warren *(left)*,
VP candidate Senator Nixon, and several
V.F.W. officers. *August, 1952.*
(Los Angeles Times)

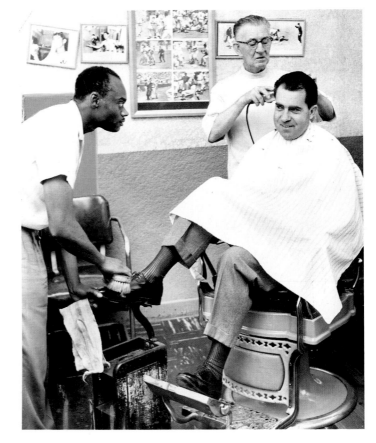

Vice President Nixon was just another
customer at the barbershop at 149 West 11th
Street until a friend identified him.
Bootblack Samuel Walls's comment was,
"Well, I'll be darned!" *August, 1955.*
(Frank Q. Brown)

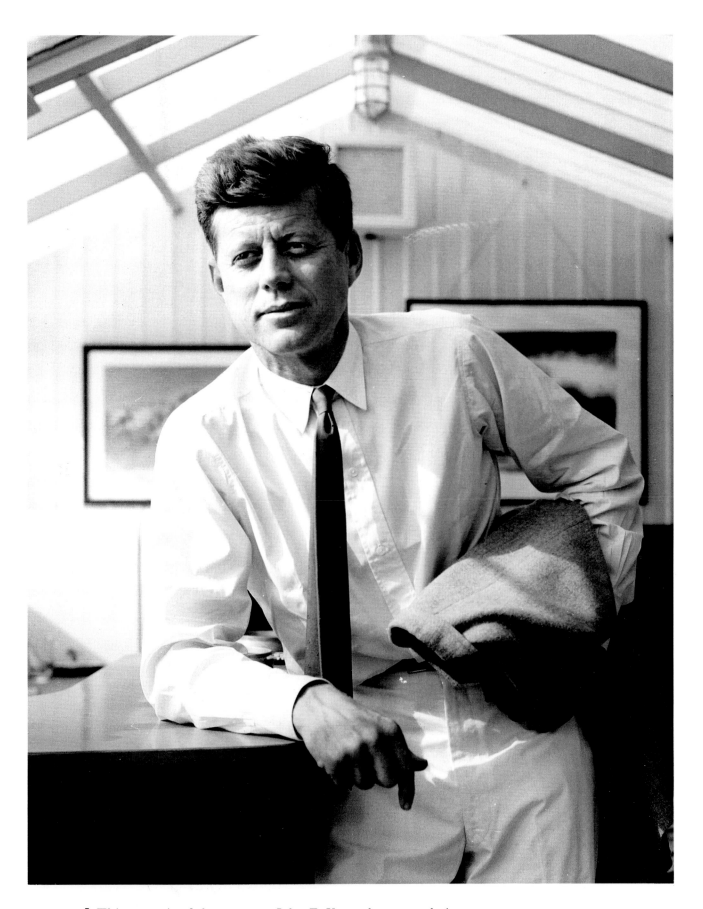

This portrait of then senator John F. Kennedy was made in 1958 at the Santa Monica home of his brother-in-law Peter Lawford. It was later selected by Jacqueline Kennedy to be used on a commemorative stamp issued by the Post Office Department on May 29, 1964, some six months after Kennedy was assassinated. (William S. Murphy)

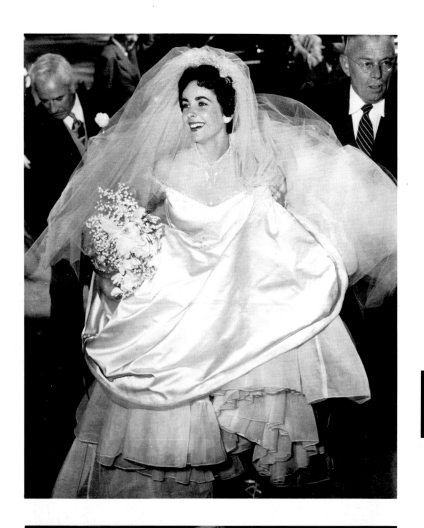

Hollywood's princess, Elizabeth Taylor, was married to the hotel scion Conrad Nicholas Hilton on May 6, 1950, in a flurry of Tinseltown excitement. (Paul Calvert)

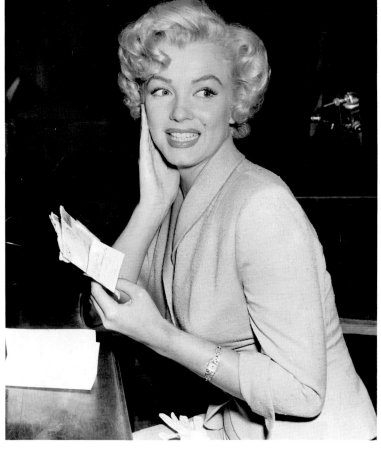

Marilyn Monroe appeared in municipal court as a prosecution witness in the trial of two men accused of using forged, handwritten letters signed with her name to sell nude "art studies" of the actress and two others. The pair got short jail sentences and two years on probation. *June, 1952*. (Nelson Tiffany)

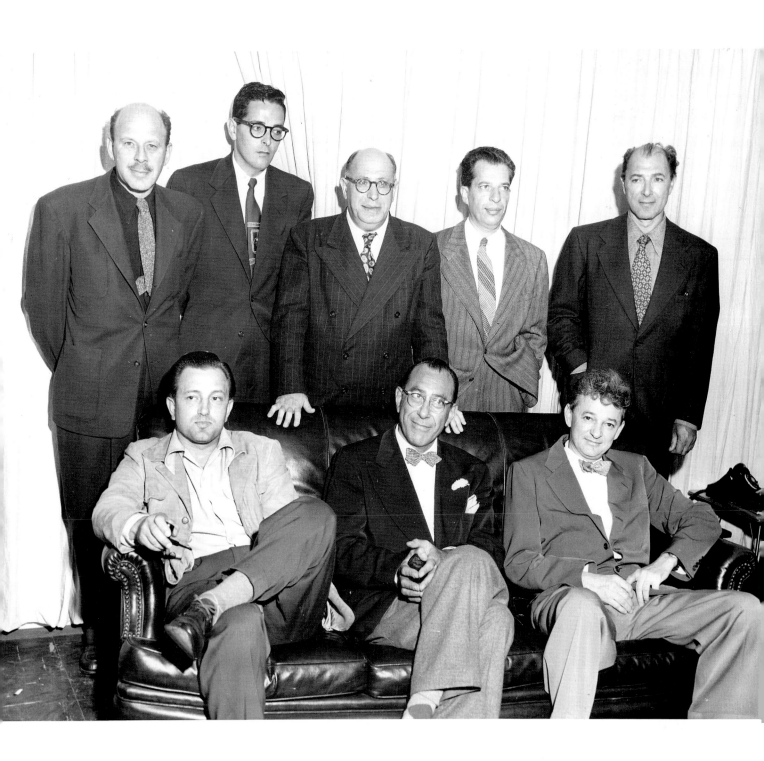

Eight of the so-called Hollywood Ten pose for their portraits two and a half years after their arraignment for contempt of Congress for having refused to testify before a congressional committee about their possible previous membership in the Communist party. Standing, left to right, they are: writers Alvah Bessie, Ring Lardner, Jr., Samuel Ornitz, Albert Maltz, and Lester Cole; seated, left to right, are directors Edward Dmytryk and Herbert Biberman and producer Robert Adrian Scott. Missing were writers Dalton Trumbo and John Howard Lawson. *May, 1950*. (Jack Carrick)

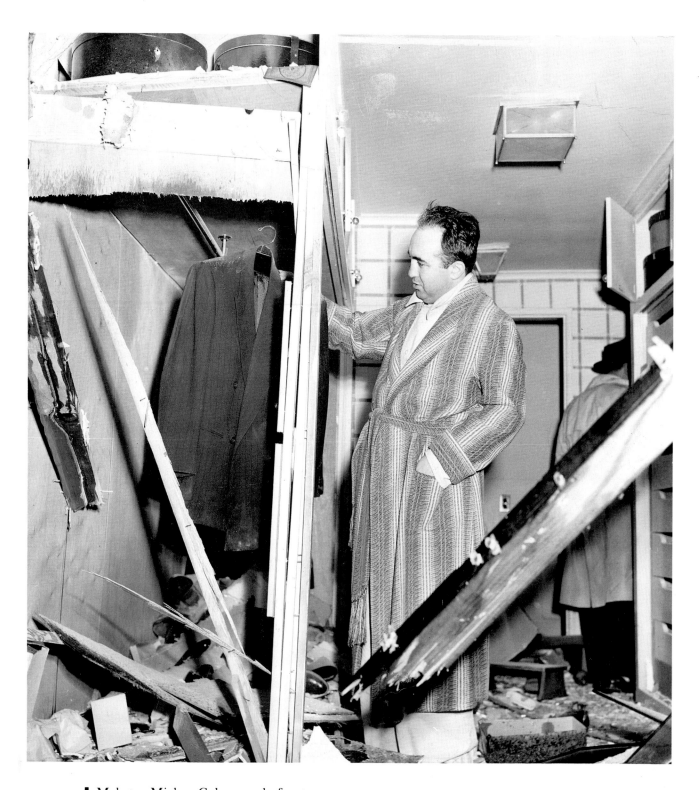

Mobster Mickey Cohen made front page
news again when his Brentwood home was
damaged by a bomb that may have been set
to kill him. *February, 1950.* (S. A. Hixson)

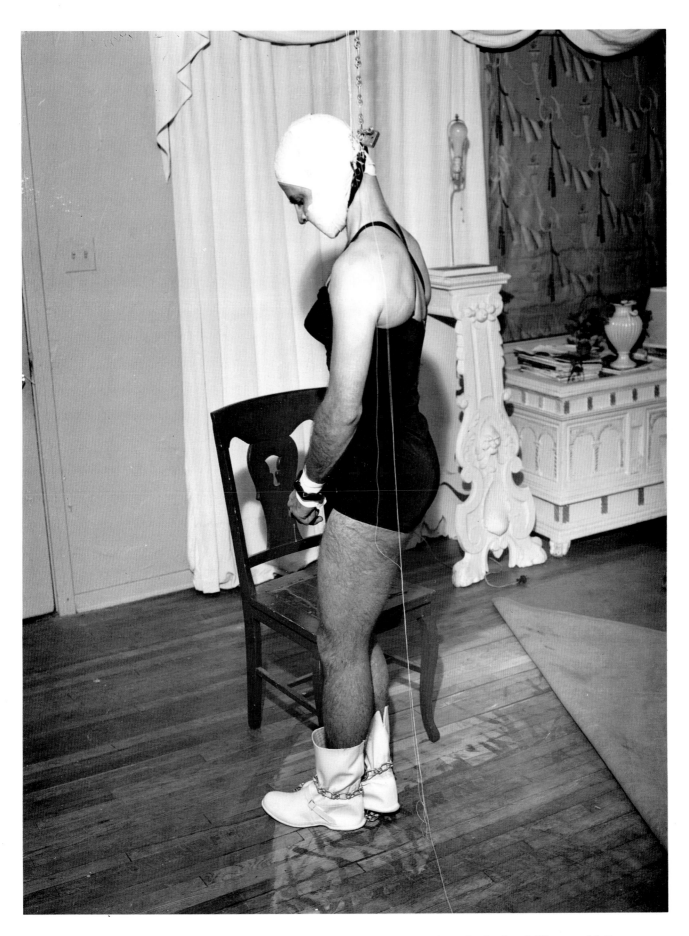

A bizarre murder came to light when the body of 27-year-old
James Felthofer was discovered in a Hollywood residence.
December, 1953. (R. O. Ritchie)

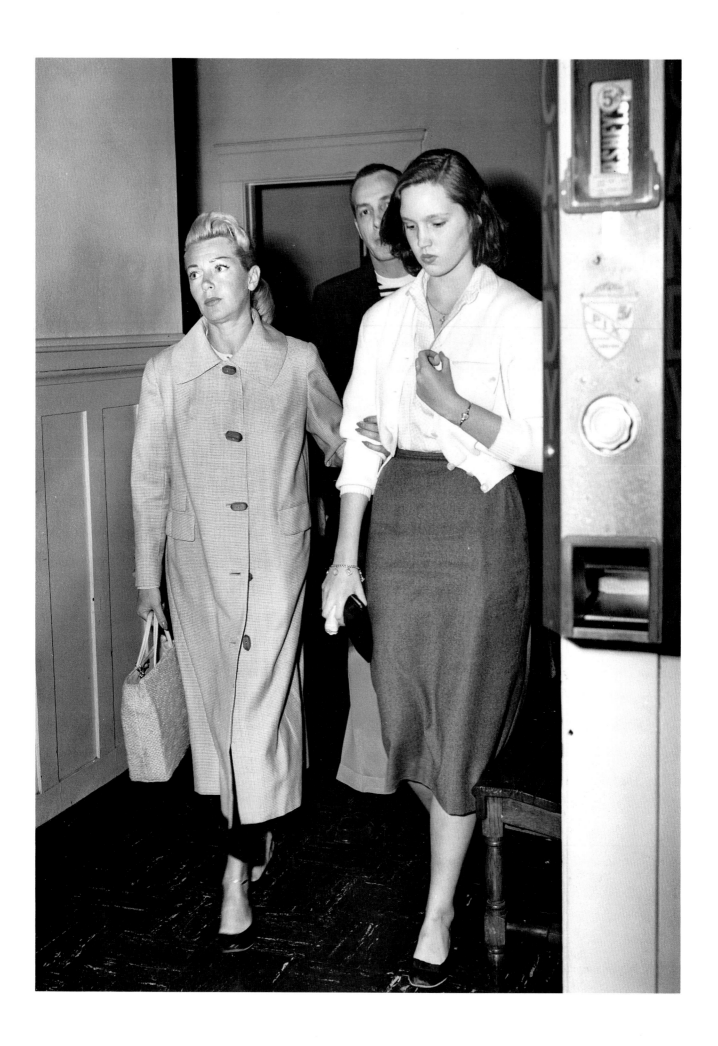

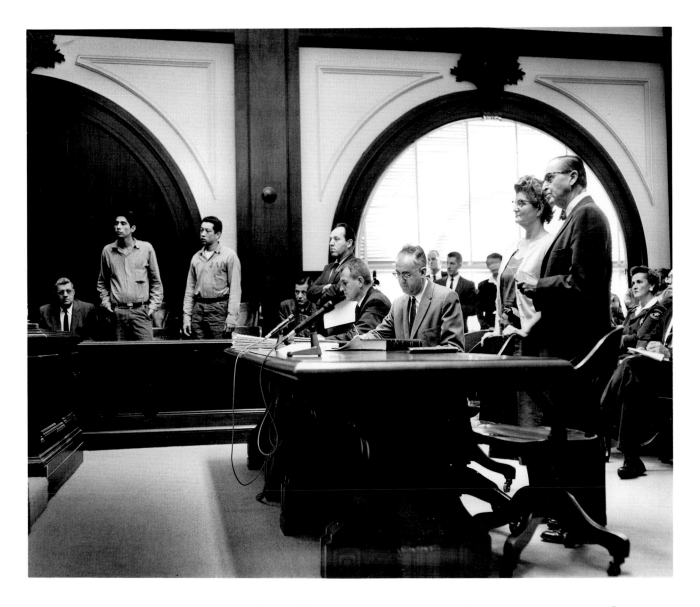

Mrs. Elizabeth Duncan *(right)* and her two codefendants *(standing left)* were tried for the murder of Mrs. Duncan's daughter-in-law in Ventura court, convicted, and executed. *December, 1958.* (John Malmin)

Lana Turner fetches her thirteen-year-old daughter Cheryl Crane from a downtown police station after the girl was found wandering on Skid Row. A year later Cheryl interceded in a heated row between her mother and Johnny Stompanato, stabbing the mobster in the stomach with a kitchen knife. A coroner's jury ruled the death a justifiable homicide. *April, 1957.* (Los Angeles Times)

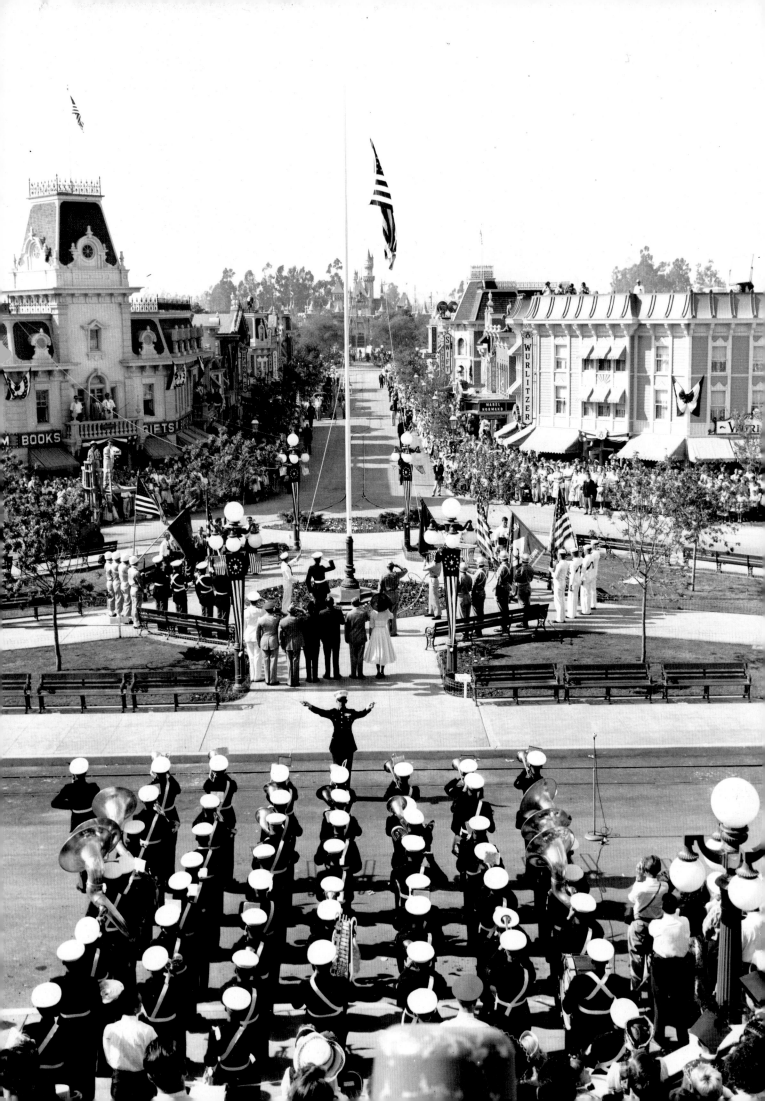

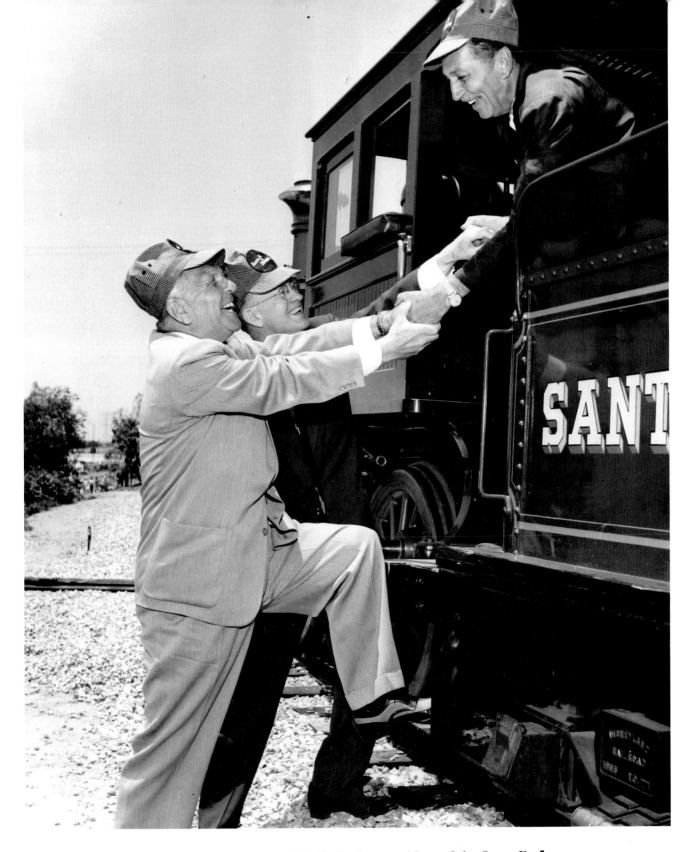

Governor Knight and F. G. Gurley, president of the Santa Fe Railway, congratulate Walt Disney on the opening of his fantasy theme park Disneyland. The formal dedication of the $17.5 million creation took place on Main Street in a flag-raising ceremony. *July, 1955.* (Los Angeles Times)

OVERLEAF
The 1955 Pulitzer Prize for Press Photography went to Jack Gaunt for this moving picture of the despair of a couple who have learned of the drowning of their child in a spring surf off Hermosa Beach.

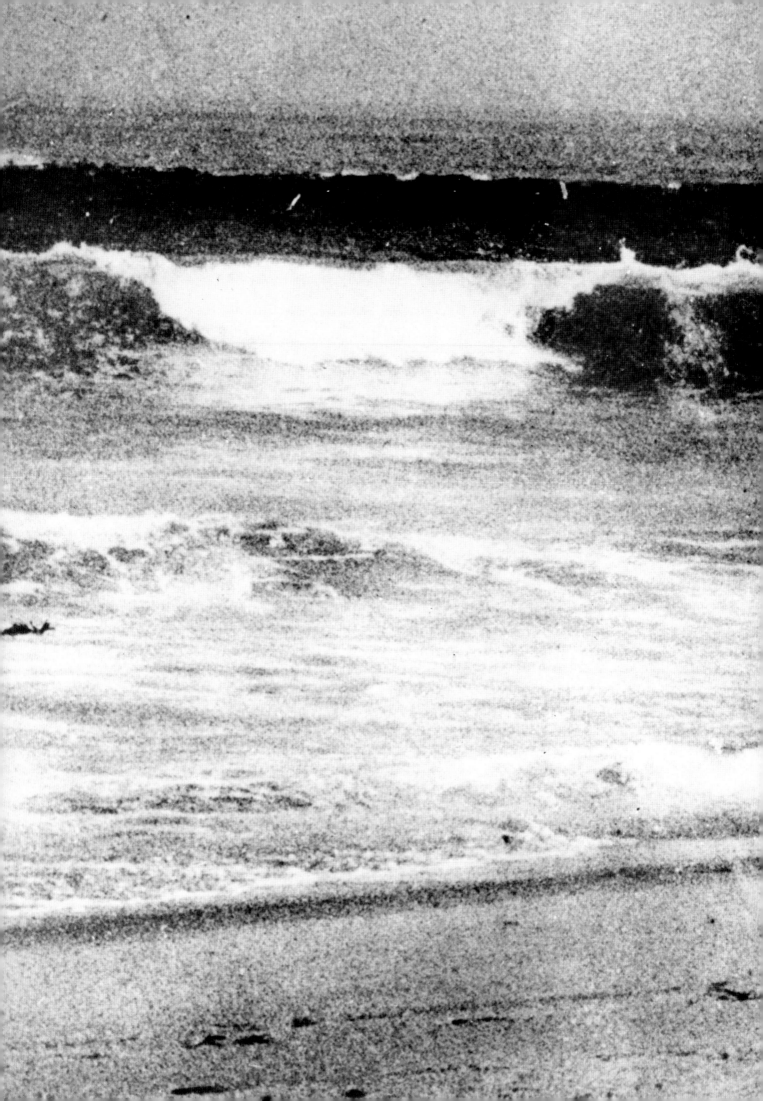

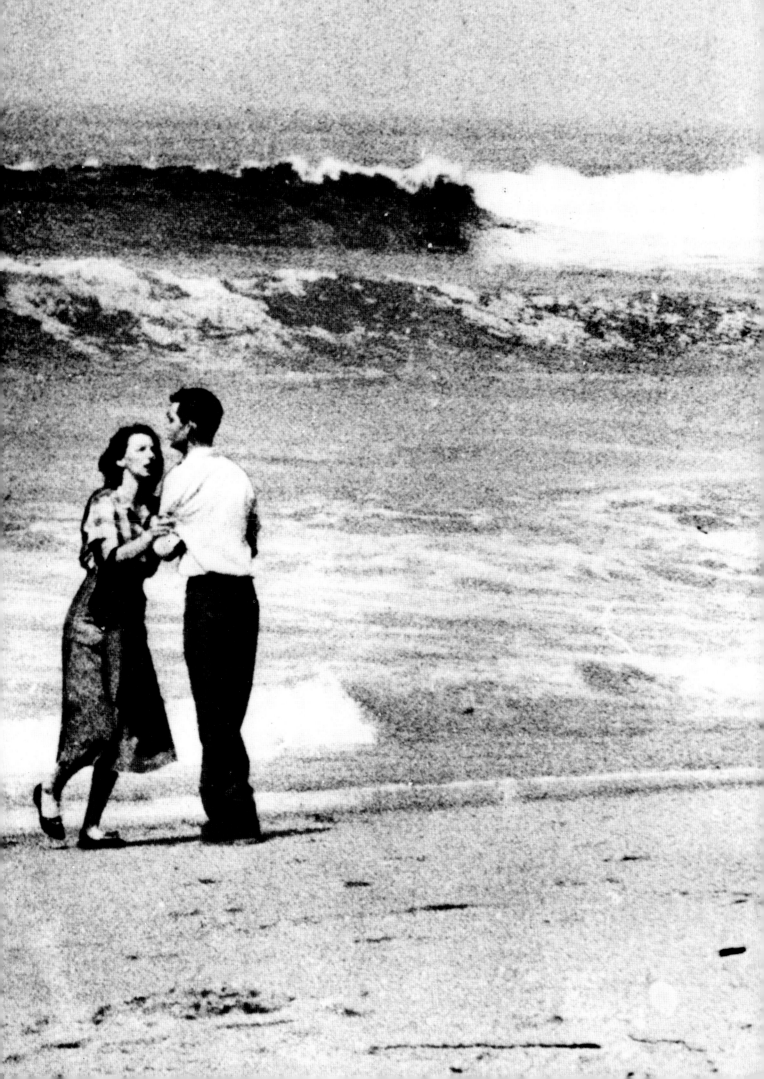

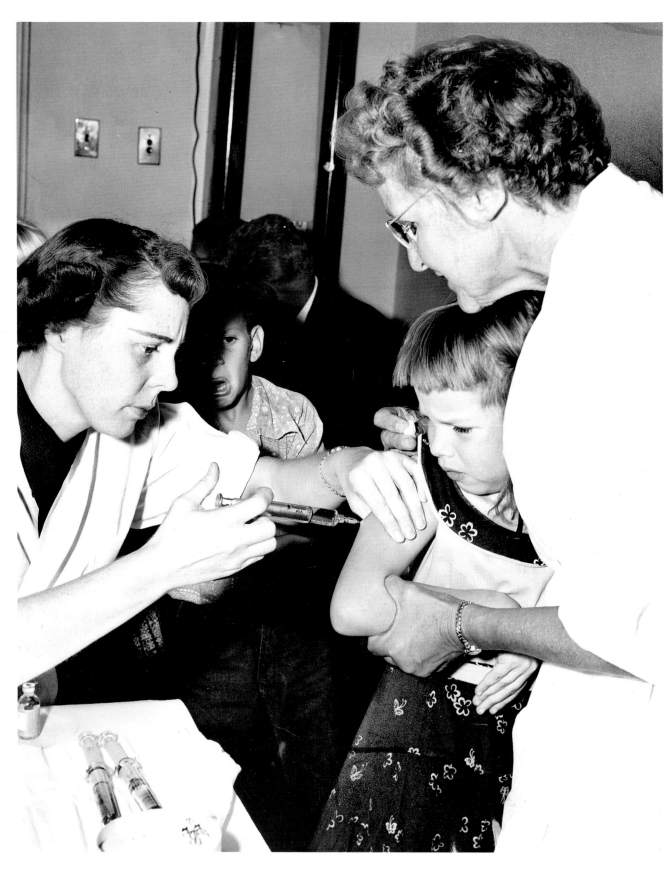

Word that it was good for her didn't allay the distress of
Linda Wahl, 7, receiving her final polio immunization at the
Commonwealth Avenue School from Dr. Dorothy Vollmier.
October, 1955. (Ray Graham)

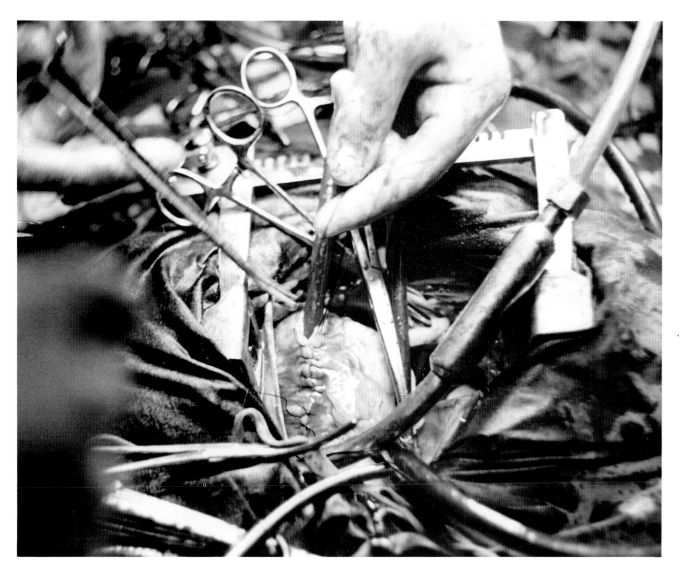

The new technique of open-heart surgery
and the use of a heart-lung machine to carry
the patient through the process would
account for saving countless lives.
January, 1959. (Ray Graham)

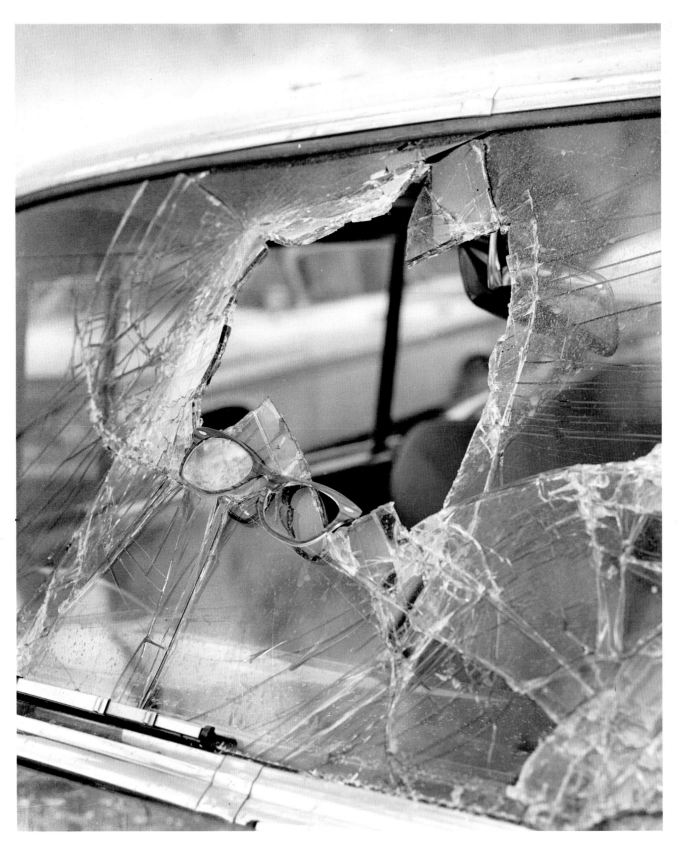

More than glass was shattered in a head-on
collision on a Los Angeles freeway. *1959*.
(John Malmin)

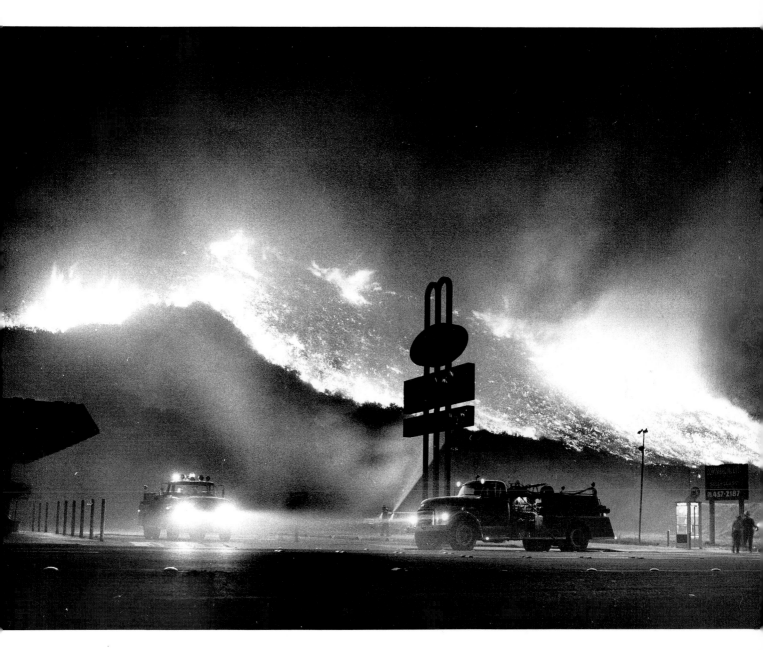

Fire scorches the hillside
above the road in the 2000
block of Pacific Coast
Highway in Malibu.
December, 1956. (Jack Gaunt)

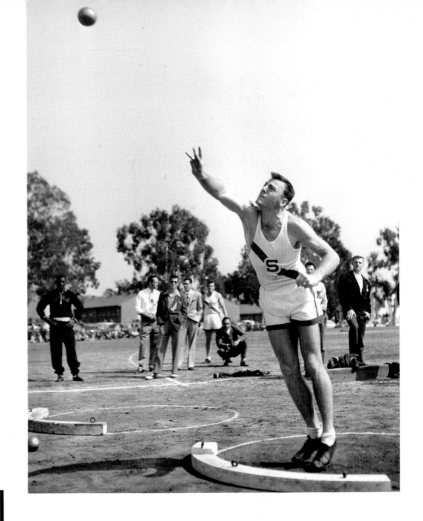

Bob Mathias was not too proud to compete for Stanford as a sophomore even though he was already a two-time Olympic decathlon winner (1948, 1952). *April, 1953.* (Gary Smith)

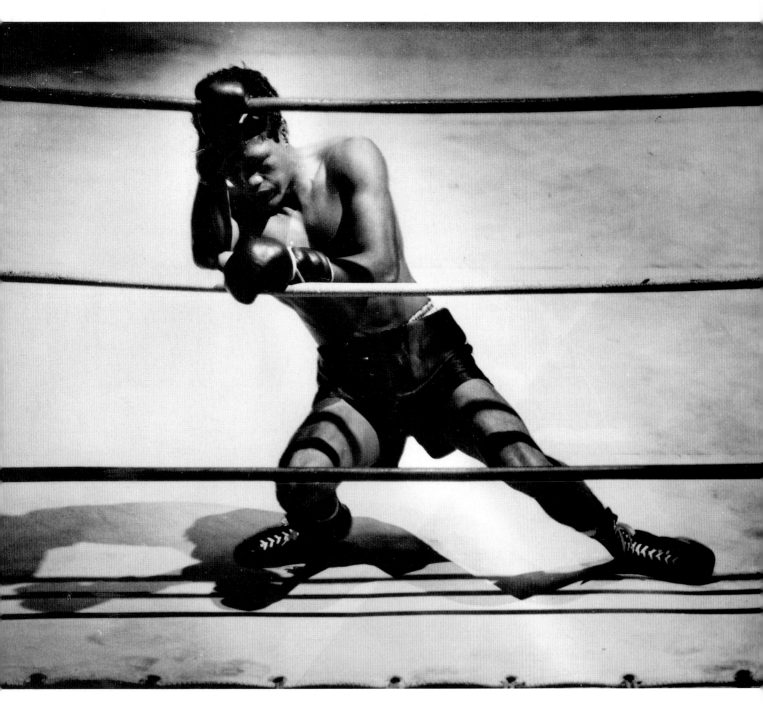

A prize-winning picture of a vanquished fighter: Bernard
Ducosen hangs on the ropes after taking a second-round
beating by John L. Davis. *November, 1950*. (Larry Sharkey)

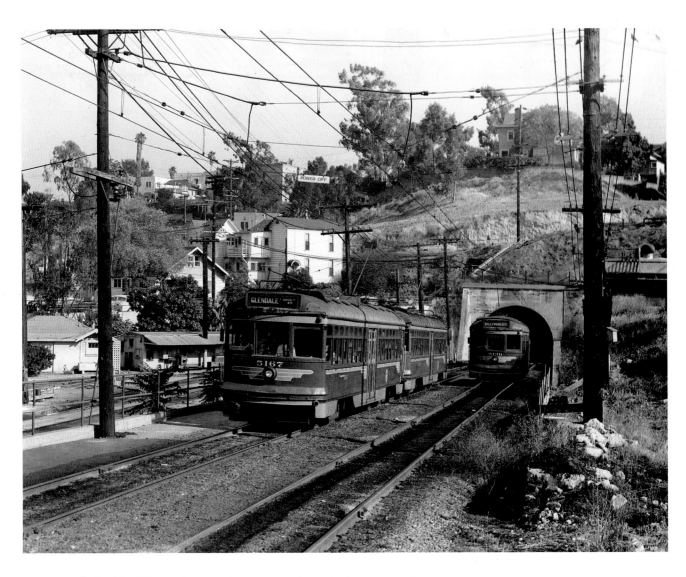

Pacific Electric's Red Cars made the mile-long tunnel journey from downtown to Second Street and Glendale Boulevard for thirty years before closing on June 17, 1955. (Donald Duke)

Seen from Clay Street, the Angels Flight commuter railcar speeds between buildings. *October, 1958.* (John Malmin)

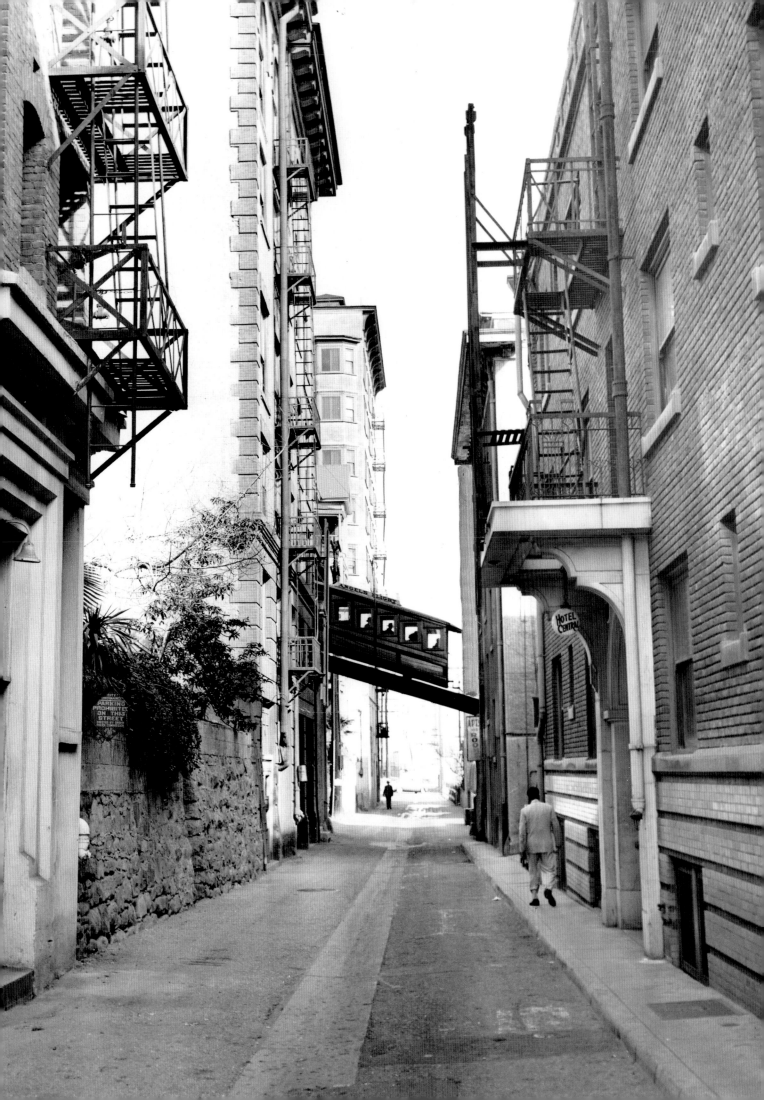

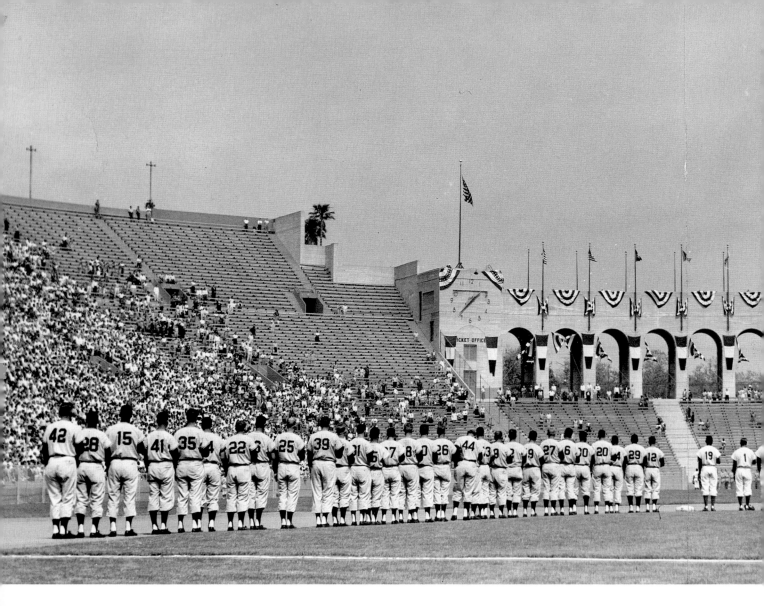

On opening day against the Giants, 78,672 new fans filled the Coliseum, the Dodgers' home for four years. *April, 1958*. (Ken Dare). Brooklyn's loss was L.A.'s gain as the former Bums took Broadway by storm. *April, 1958*. (John Malmin).

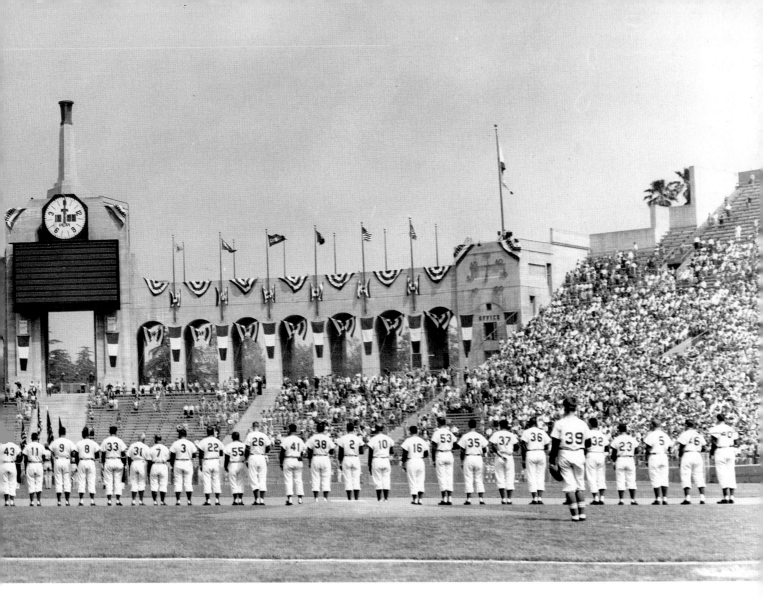

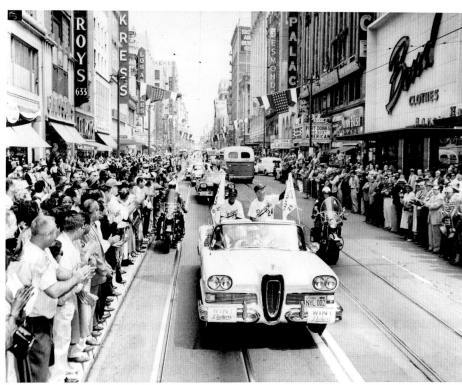

OVERLEAF
Downtown Los Angeles at the end of the
1950s decade was ready for new leaps upward.
1959. (Larry Sharkey)

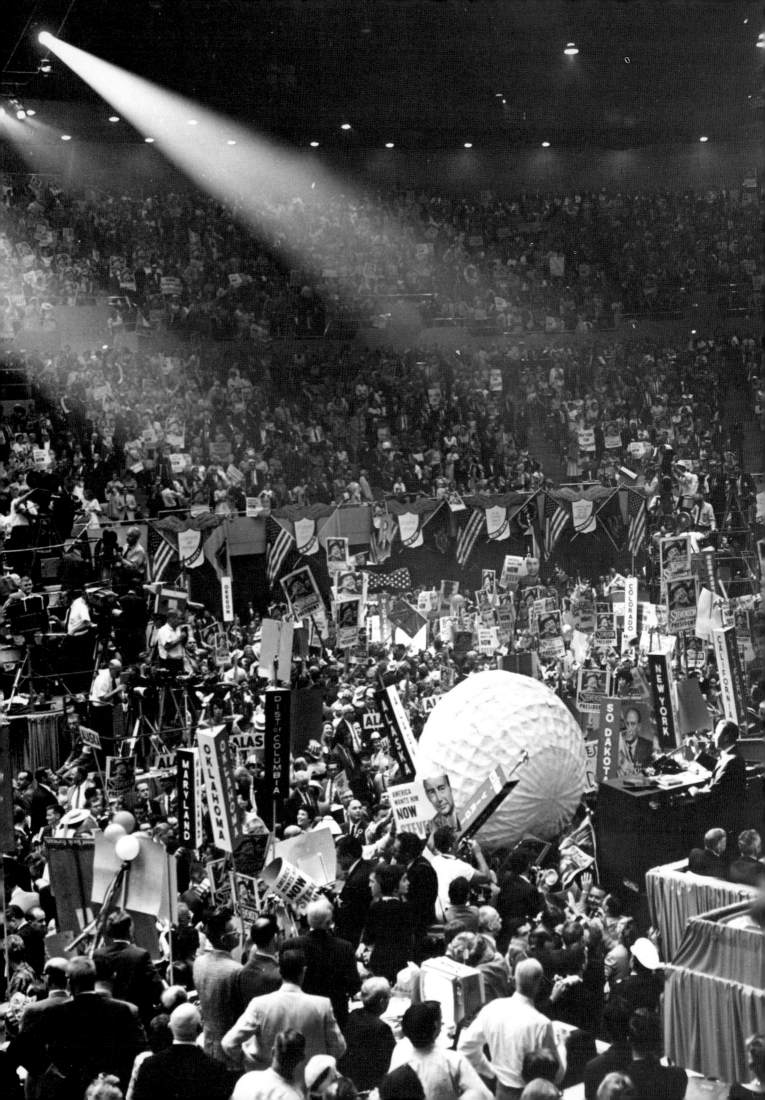

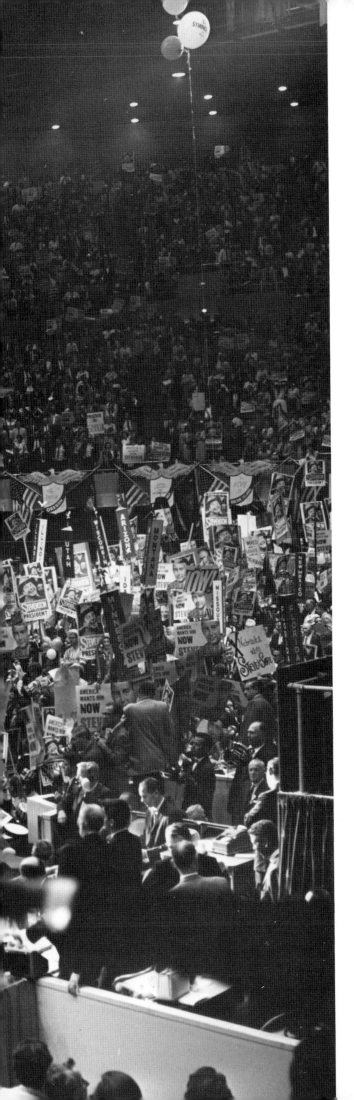

1960s

An enthusiastic demonstration for Adlai
Stevenson was not enough to offset the
ground swell for John F. Kennedy as the
Democratic National Convention drew to a
close. *July, 1960.* (Frank Q. Brown)

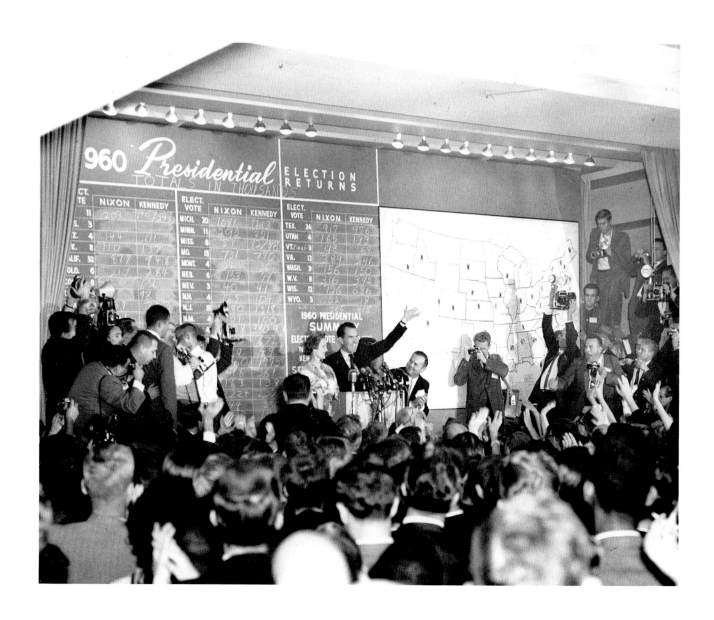

Still looking optimistic, Richard Nixon waves to the faithful as election returns pour in. By midnight he was not ready to concede but admitted that the trend showed "Sen. Kennedy will be the next President of the United States." *November, 1960.* (Bob Martin)

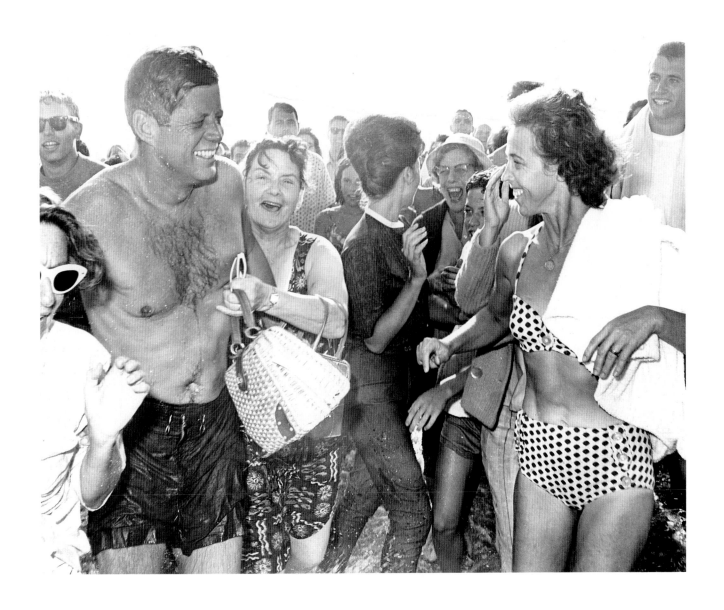

A man of the people, President Kennedy
comes ashore at Santa Monica.
August, 1962. (Bill Beebe)

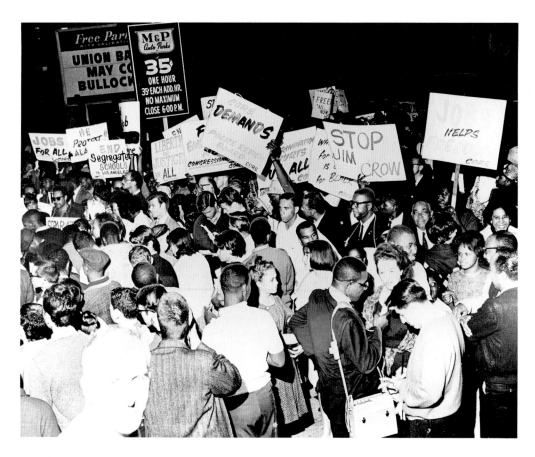

The beginnings of a crowd estimated at 5,000 forms at
Olympic Boulevard and Broadway for a civil rights march to
City Hall. *August, 1963.* (Judd Gunderson)

Nobel Laureate Linus Pauling *(right, center)* leads a peace
parade east on Wilshire Boulevard to Lafayette Park, where
he spoke out against the Vietnam war.
August, 1967. (Don Cormier)

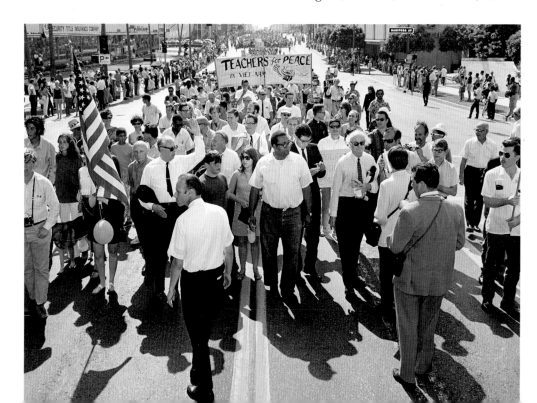

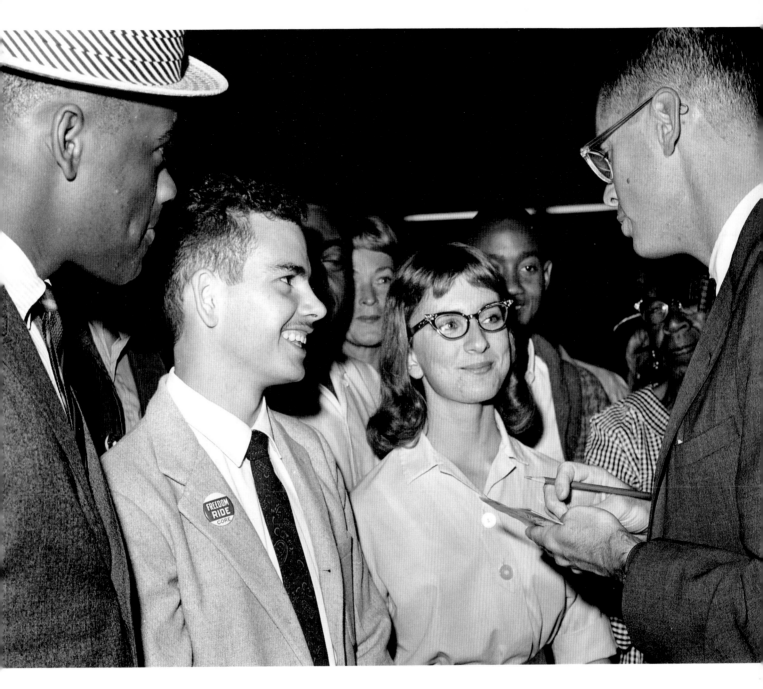

Headed by bus for Jackson, Mississippi, and almost certain arrest, three Los Angeles Freedom Riders, Robert Owens, Mike Wolfson, and Marilyn Eisenberg, speak to a *Times* reporter about their civil rights protest.
July, 1961. (John Malmin)

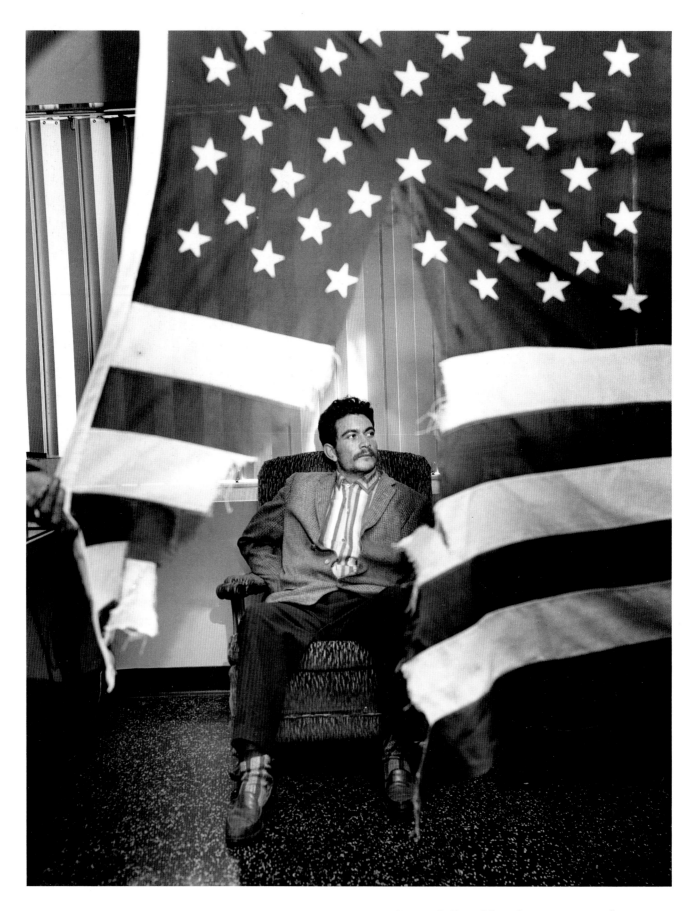

Defacing the American flag and disturbing the peace were the charges against Jesus Ferias Iglesias, whose crime was that he ripped the flag off a staff and trampled it in front of some 200 schoolchildren. *November, 1961.* (Steve Fontanini)

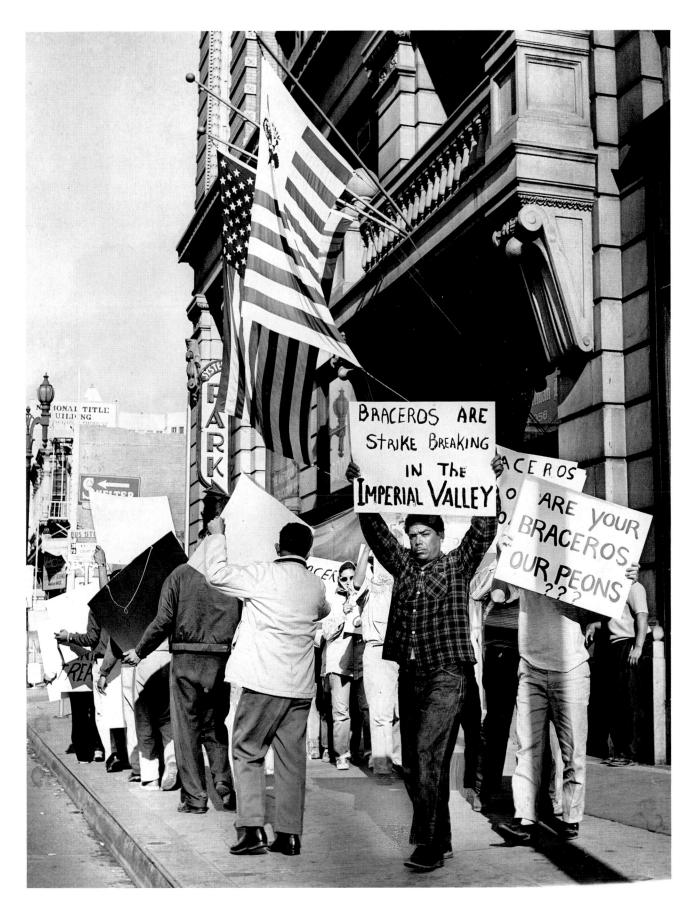

Pickets outside the Mexican consulate on South Spring
Street protest the employment of immigrant labor in
the Imperial Valley lettuce harvest.
February, 1961. (Ben Olender)

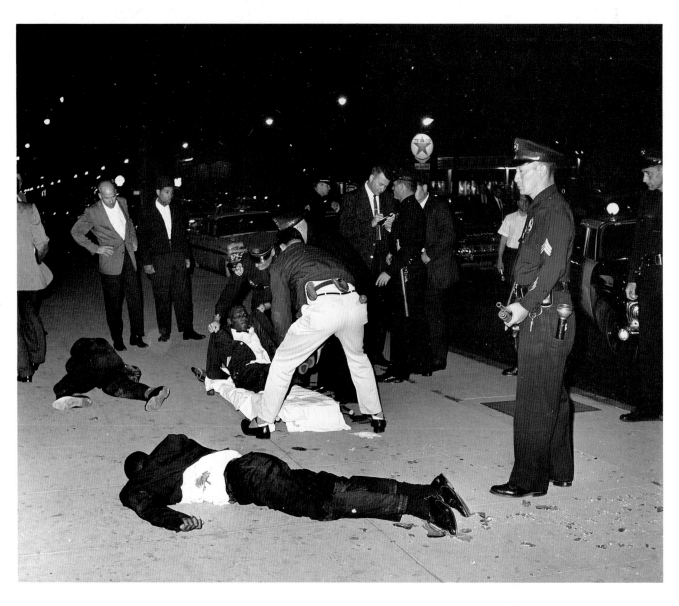

Three suspected Black Muslims lie dead or
wounded on the sidewalk outside
Mohammad's Mosque at 5606 South
Broadway after a gunfight with police.
April, 1962. (Cliff Otto)

A pale blue blanket of the Westwood Village
Mortuary covers the body of Marilyn Monroe
as deputy coroners wheel the star from her
home. *August, 1962.* (Steve Fontanini)

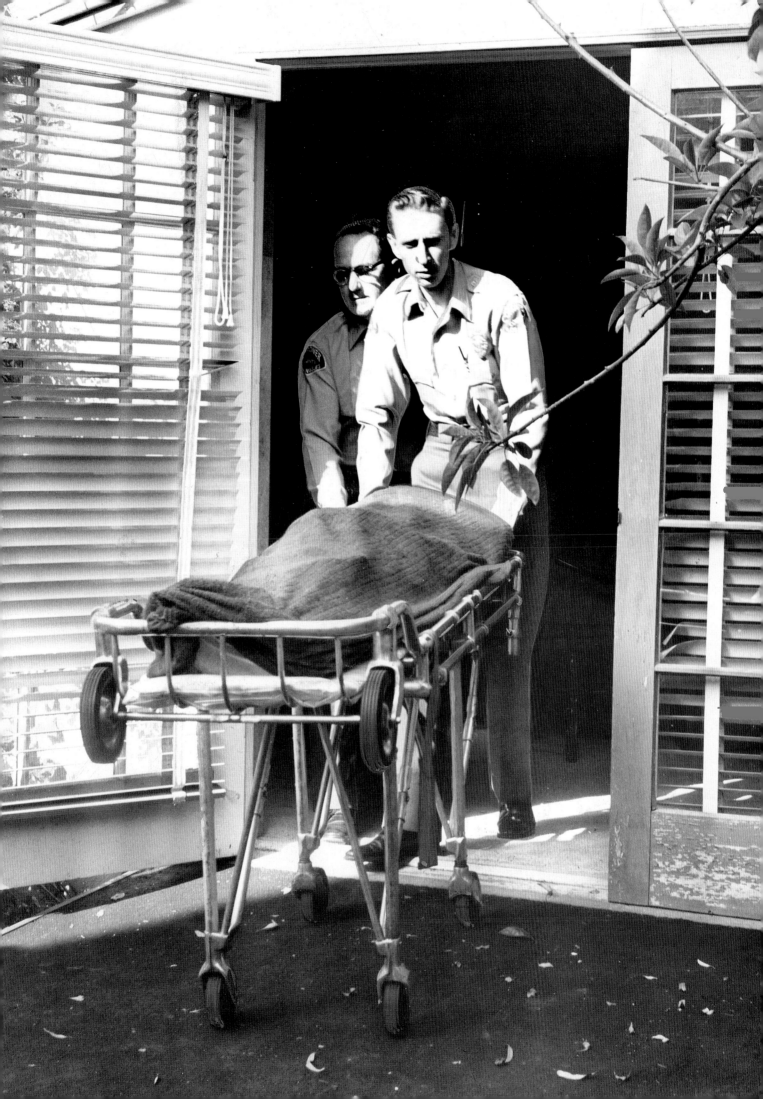

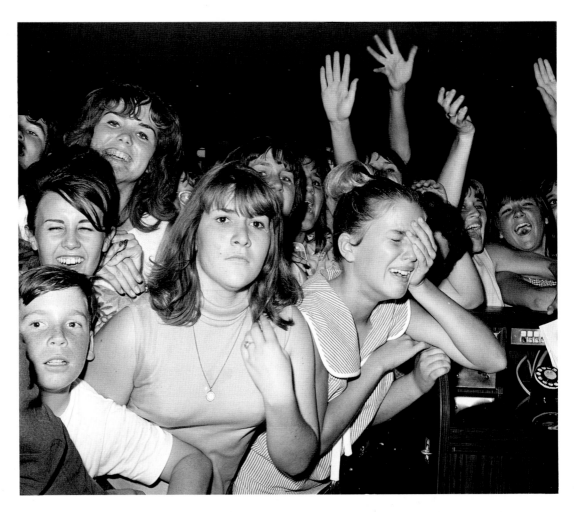

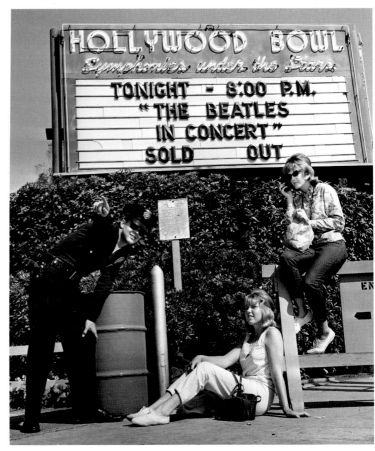

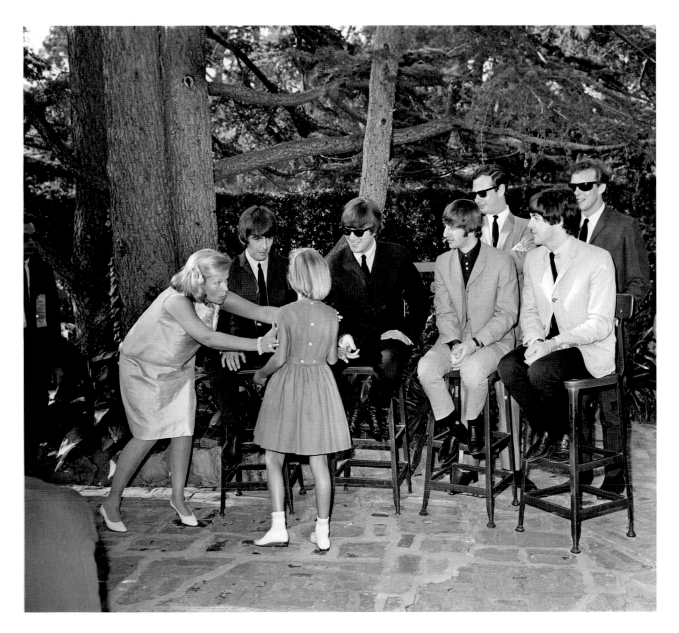

Beatlemania struck Los Angeles hard in August, 1964, when the four Liverpudlians came to town, greeted at the airport (*opposite, above*) by hordes of hysterical teenagers. (Ben Olender). The group sold 18,700 tickets at the Hollywood Bowl, where (*opposite, below*) two hopeful fans camped out, even after the "sold out" sign went up. (John Malmin). Before they left L.A., the Beatles obligingly sat still at a charity children's party where a girl had to be prompted to approach them. (Los Angeles Times)

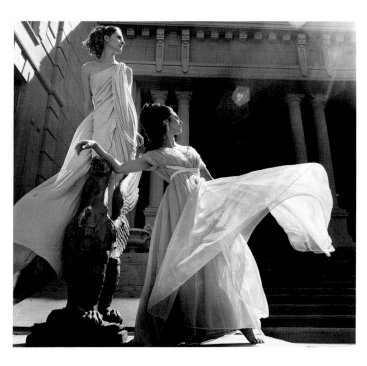

Fashion at the *Times* in the 1960s was covered formally, as in this shot (*above*) of the "classical" influence in the season's gowns, and also in the paper's coverage of society benefits, including the incongruous sight of four extremely fashionable ladies at the circus. (Both, Mary Frampton)

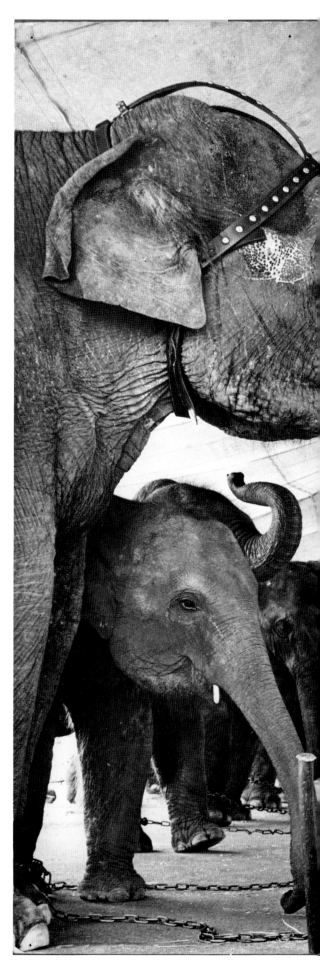

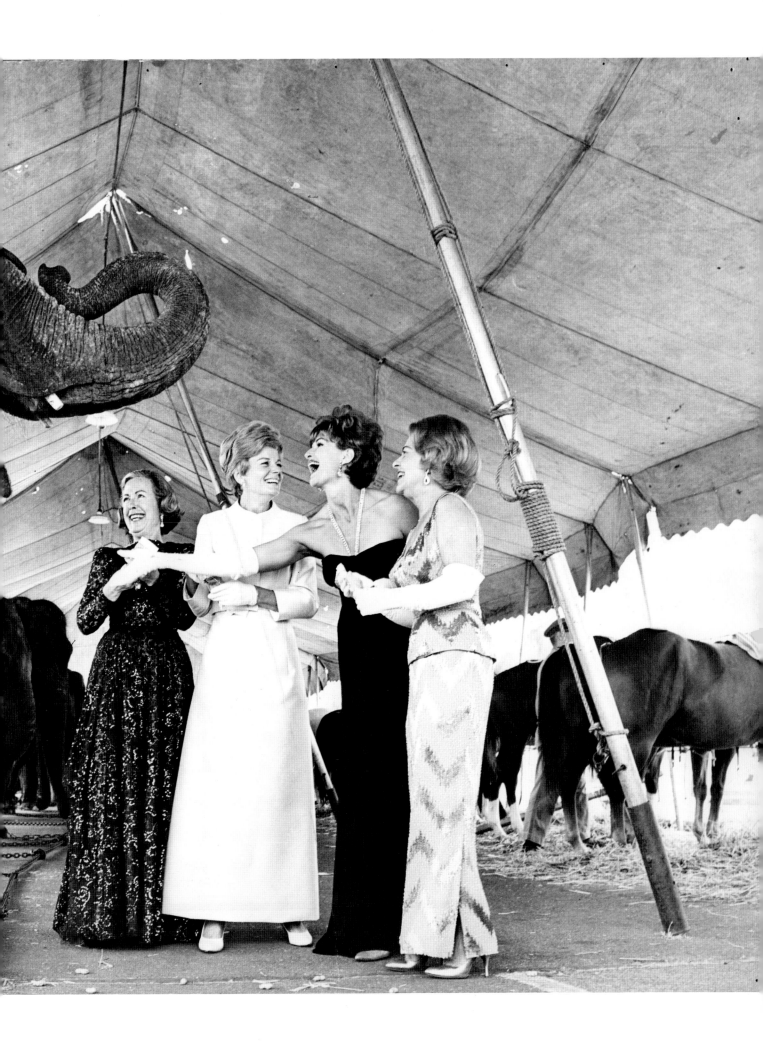

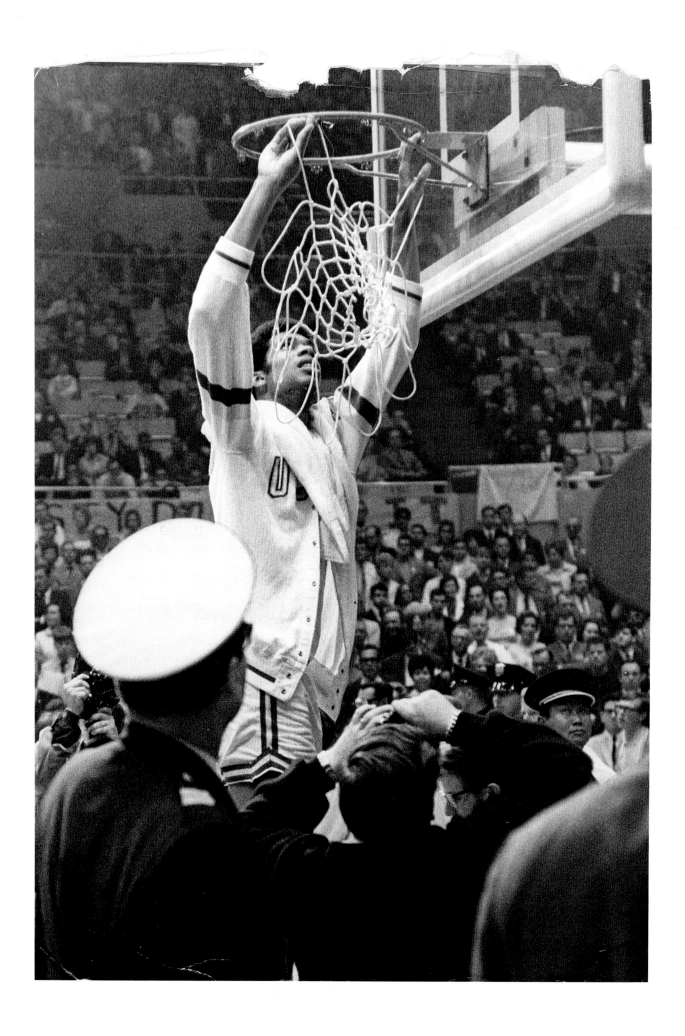

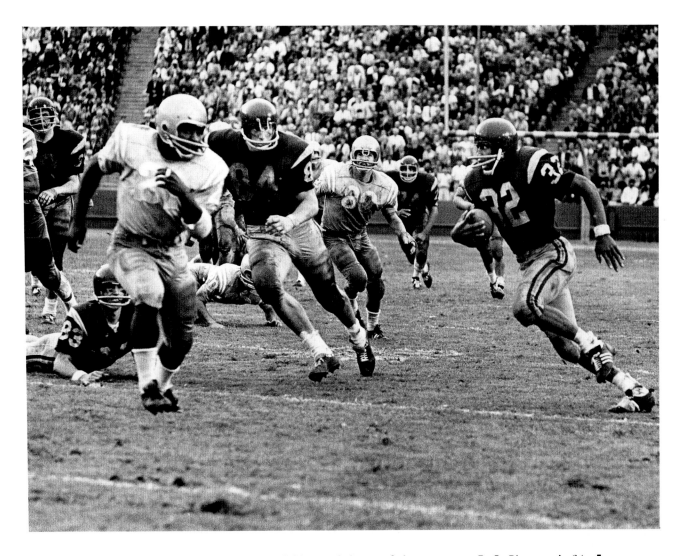

Called USC's touchdown of the century, O. J. Simpson's 64-yard fourth-quarter dash turned the tables on UCLA. *November, 1967.* (Joe Kennedy)

UCLA's Lew Alcindor cuts the triumphal net after the Bruins cut down North Carolina 78–55 to win the NCAA final. *March, 1968.* (Ben Olender)

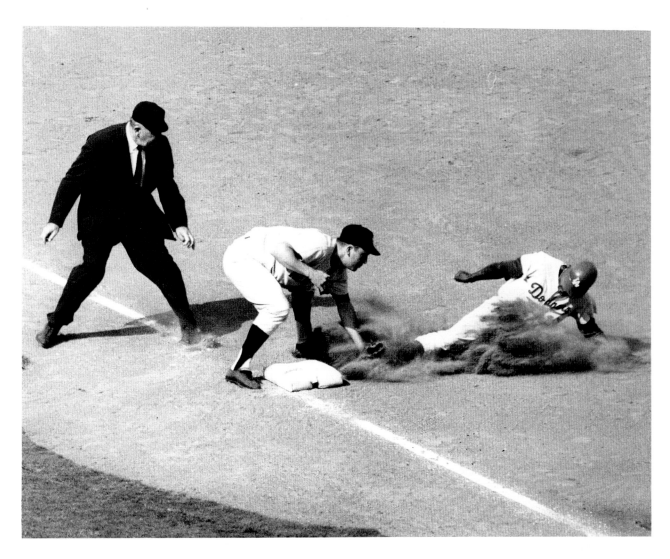

Jim Gilliam was put out by Clete Boyer trying to steal third, but the freewheeling Dodgers rolled over the Yankees in four straight to take the World Series. *October, 1963.* (Larry Sharkey)

True to form, Washington's Jim Piersall thumbs his nose at a fan while walking to the plate. *September, 1962.* (Art Rogers)

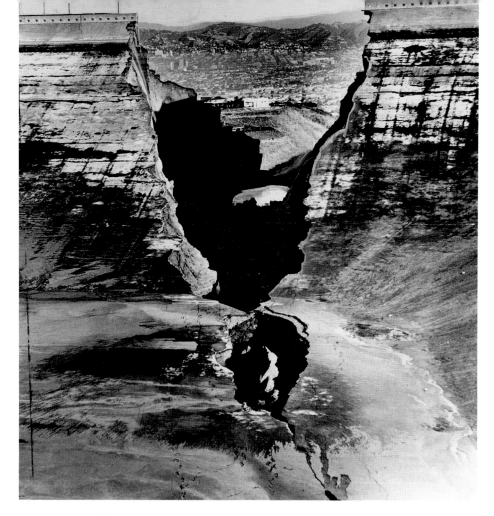

A 75-foot crack in the north wall of Baldwin Hills Reservoir emptied the contents, killing five and destroying 64 homes. *December, 1963.* (John Malmin)

A river where there was none appeared downslope of the Baldwin dam, creating havoc in this choice residential district. *December, 1963.* (Los Angeles Times)

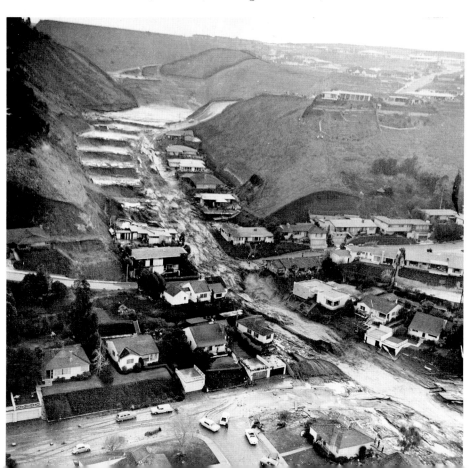

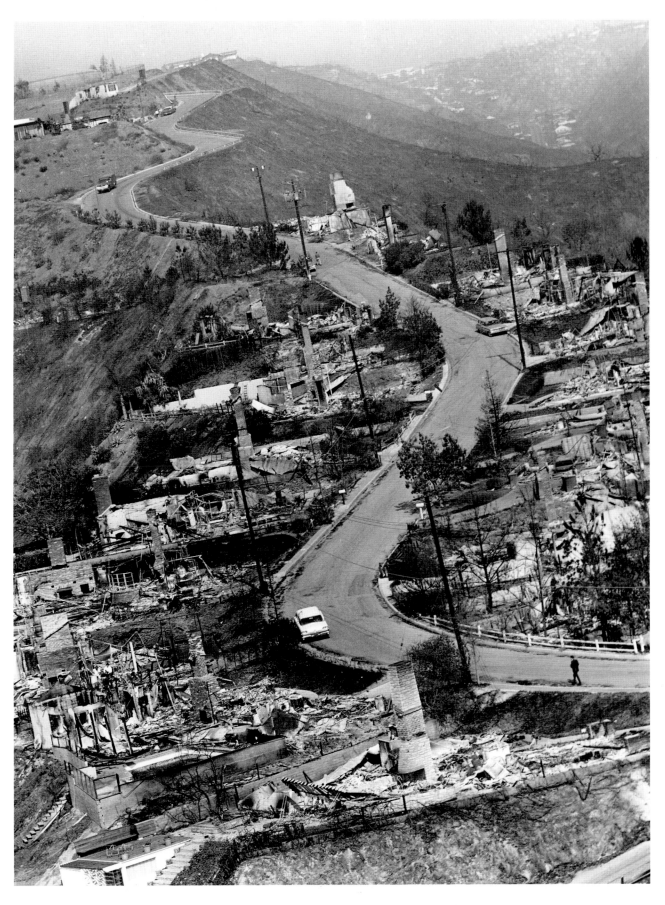

Nearly 500 homes were damaged or destroyed in a Bel Air-
Brentwood fire that devastated Linda Flora Drive.
November, 1961. (Steve Fontanini)

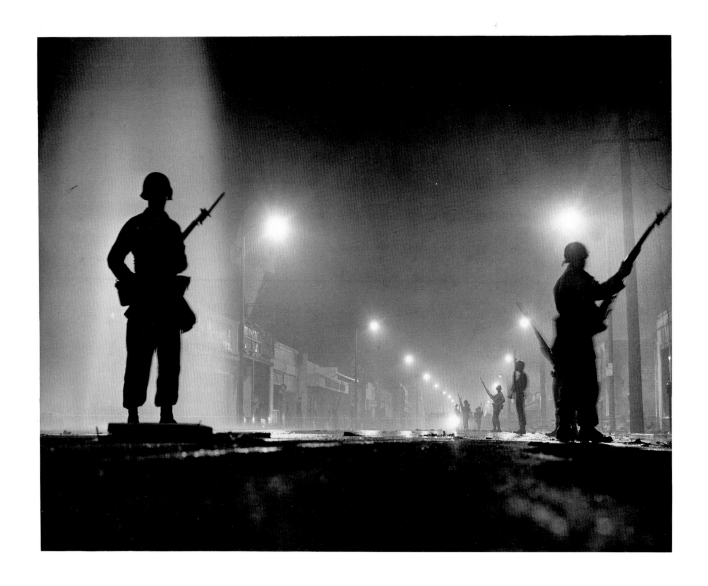

Five hundred National Guardsmen and more than 350 city
and state police officers moved into the Watts and
Willowbrook districts to quell rioting as some 7,000 persons
took to the streets. Nicknamed "Charcoal Alley," 103rd
Street was finally quiet after two nights of war-like
upheavals. *August, 1965*. (John Malmin)

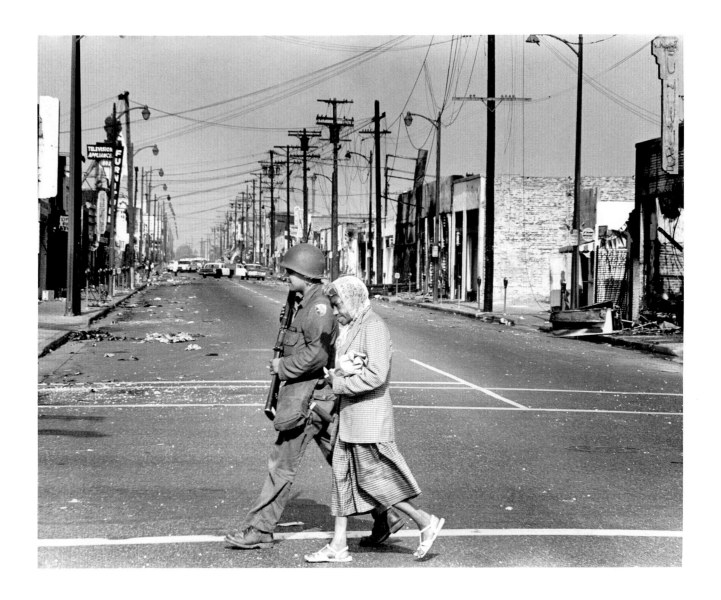

A National Guardsman escorts an elderly resident across the intersection of Wilmington Avenue at 103rd Street on the Sunday morning following the midweek riots.
August, 1965. (Bruce Cox)

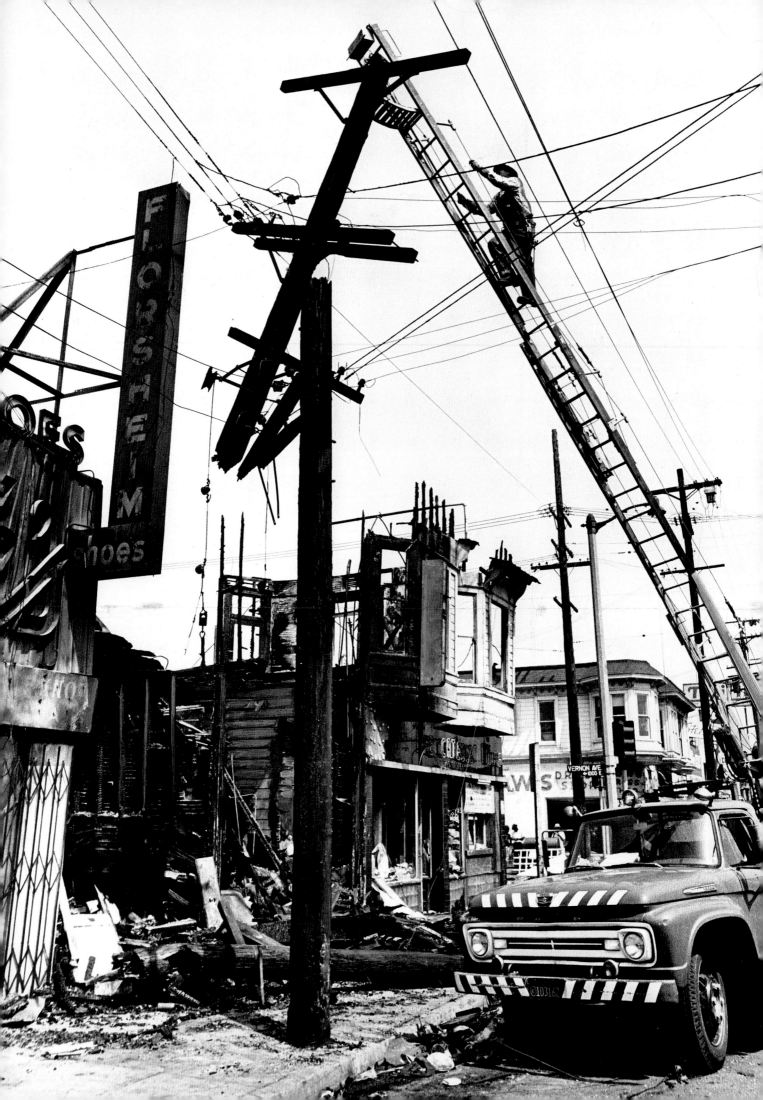

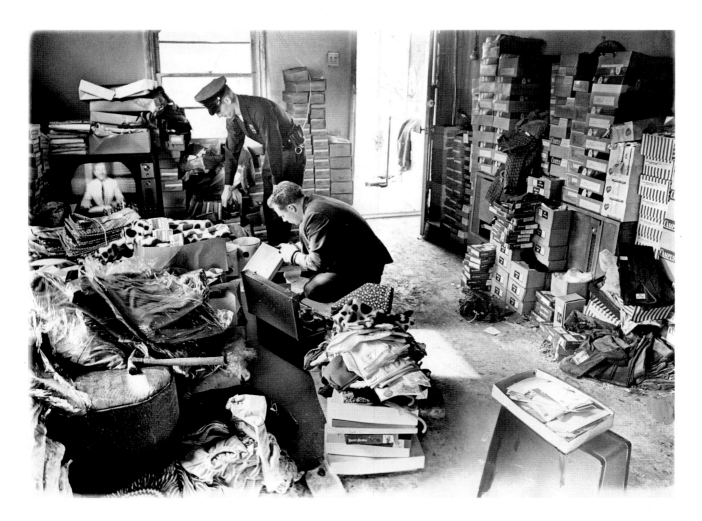

More than a month after the Watts rioting, firemen answering an alarm in a small house at 1627 West 60th Place discovered a veritable storehouse of loot apparently collected earlier. Three trucks were needed to haul away the merchandise. *September, 1965*. (John Malmin)

Water and Power Department workmen begin to repair burned and snapped utility poles on Central Avenue at Vernon five days after the worst troubles. *August, 1965*. (John Malmin)

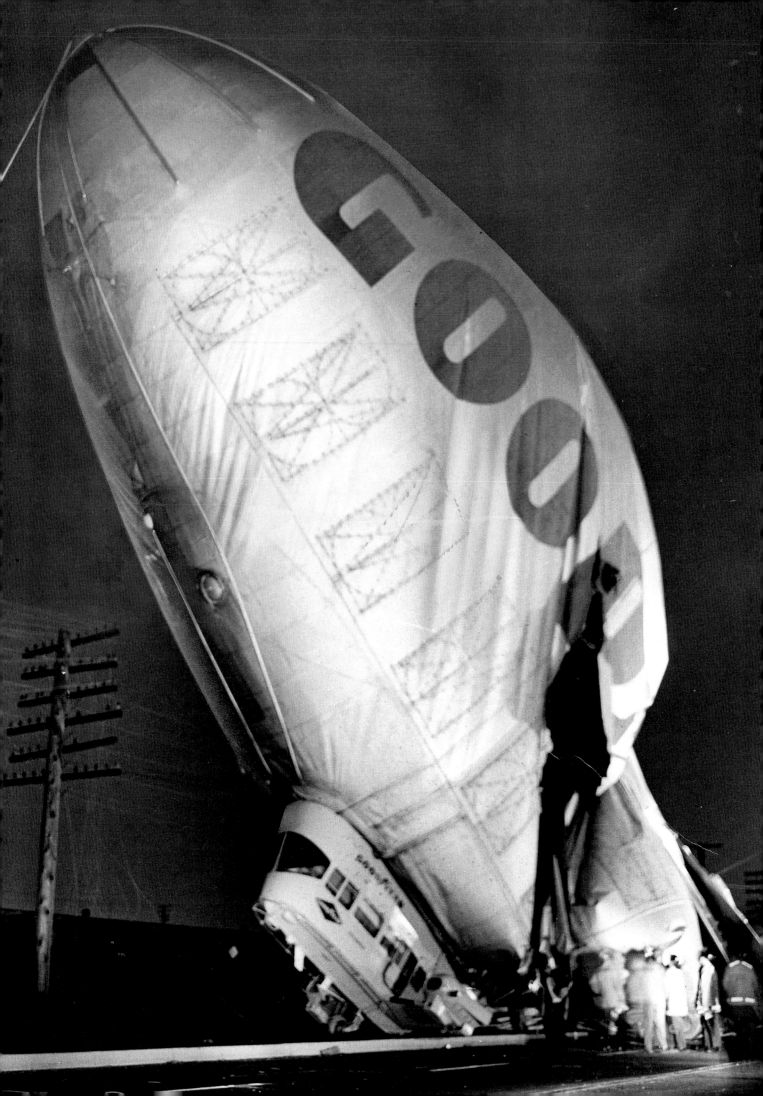

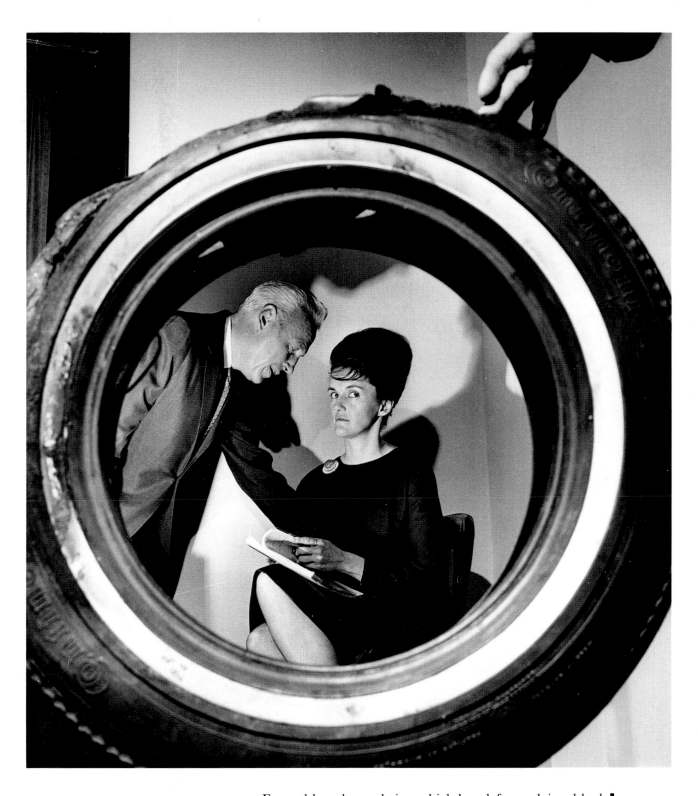

Framed by a burned tire, which her defense claimed had caused the flaming auto death of her husband, Mrs. Lucille Miller consults with her attorney, Edward P. Foley. Convicted of murder in the first degree and sentenced to life imprisonment, she was released after serving seven years. *February, 1965*. (John Malmin)

Down but not out, the Goodyear blimp sags earthward after it crashed into power lines, tearing the gas bag but injuring no one. *November, 1966*. (Jack Gaunt)

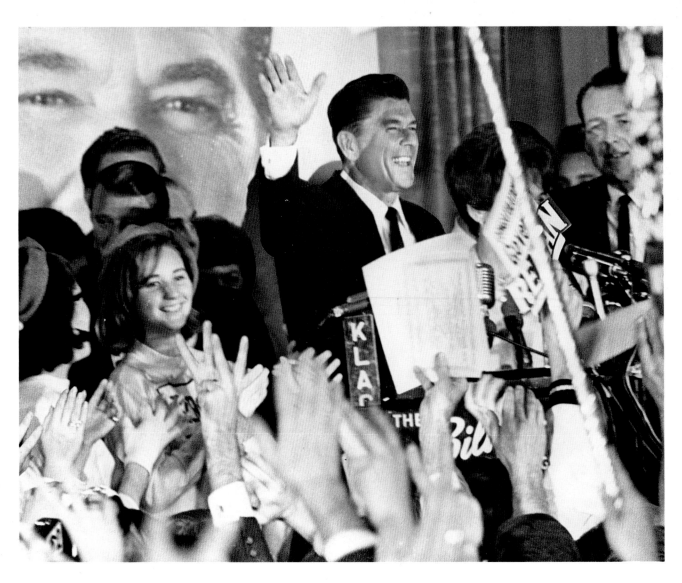

Waving to supporters, Ronald Reagan celebrates his victory
in the gubernatorial election. At right is his running mate,
Robert H. Finch. *November, 1966.* (Larry Sharkey)

A tragic decade for a popular American family ended as
Robert F. Kennedy was shot and killed at the Ambassador
Hotel in Los Angeles moments after he had made a victory
statement, having captured the California Democratic
presidential primary. *June, 1968.* (Boris Yaro)

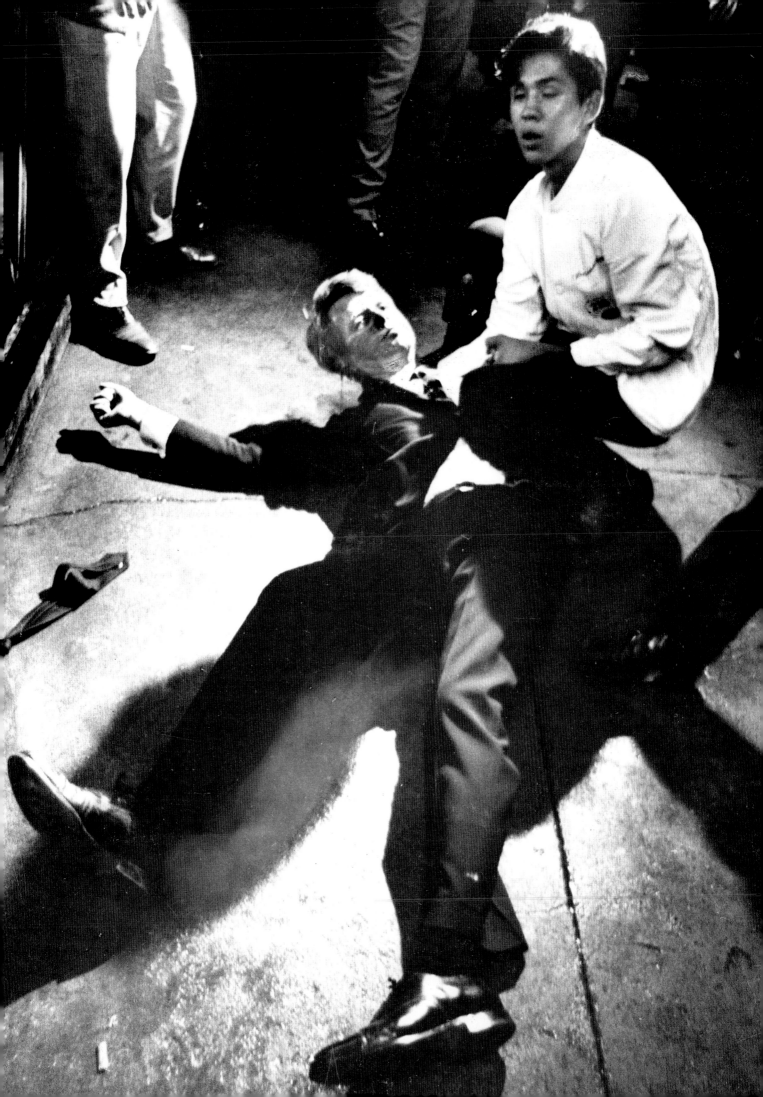

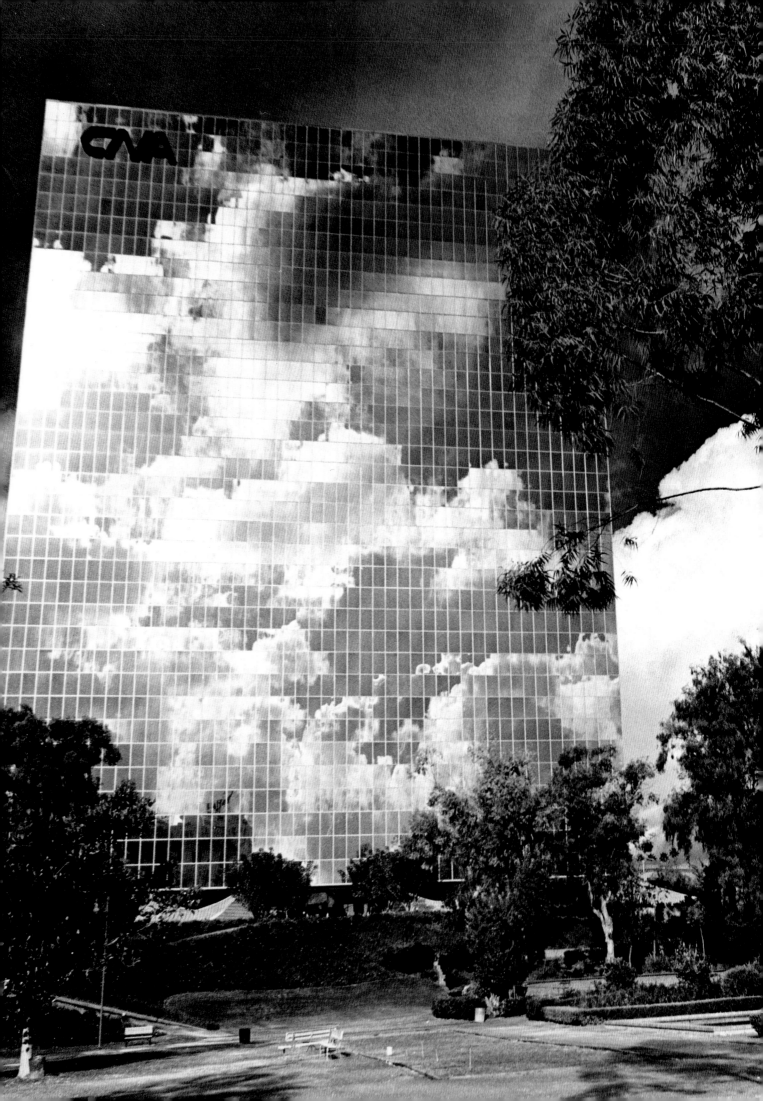

1970s

A brief rain shower left an unusual display of clouds reflected in the mirrored walls of the CNA building at 6th Street and Commonwealth. *November, 1971.* (Bruce Cox)

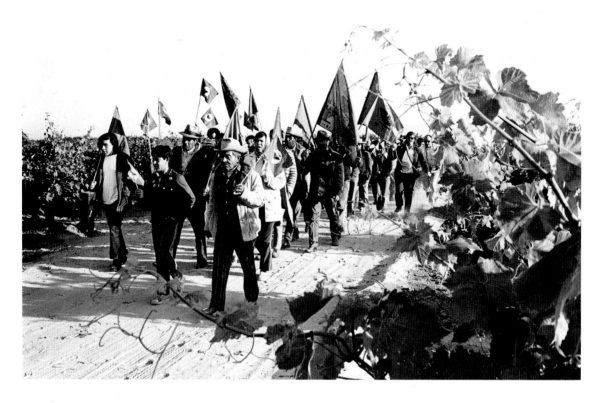

| Members of the United Farm Workers Union march on
strike against grapegrowers. *April, 1973*. (Rick Browne)

Farm Workers leader Cesar Chavez waits to speak at a rally
on the UCLA campus. *February, 1978*. (Ken Hively) |

| Mexican laborers harvest tomatoes on a North San Diego
County property. *1979*. (Len Lahman)

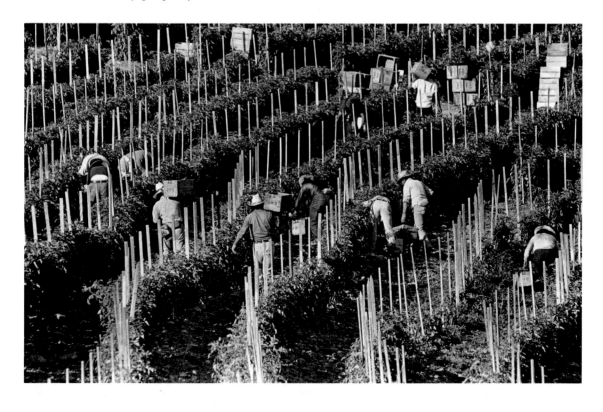

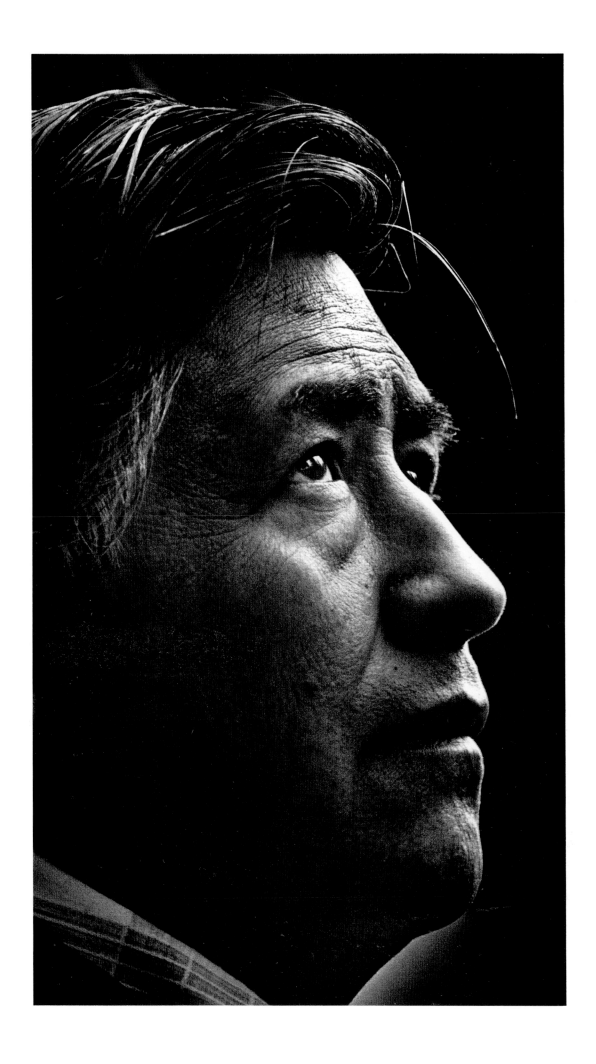

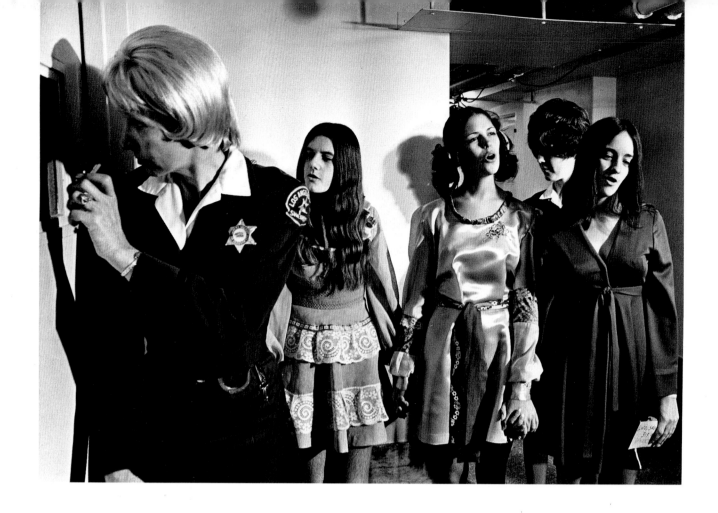

Charles Manson appeared bearded and haggard in the early days of his trial, along with three women accomplices, for the August, 1969, murders of seven people, including the actress Sharon Tate. (John Malmin). Before one of the many pretrial hearings, members of the so-called Manson "family" held hands and sang; they are, *left to right*, Patricia Krenwinkel, Leslie Van Houten, and Susan Atkins. (John Malmin). Two months after a verdict was finally rendered in the trial on January 25, 1971, Manson appeared clean shaven but with a swastika scarred into his forehead. (Larry Sharkey). He and the women were all found guilty of murder in the first degree.

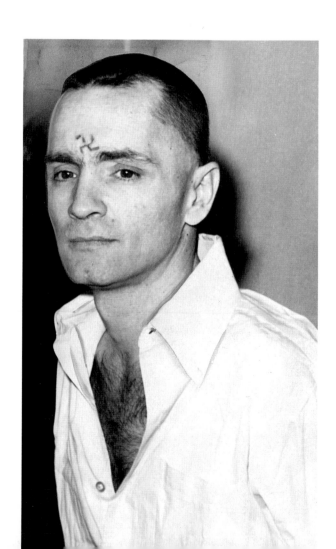

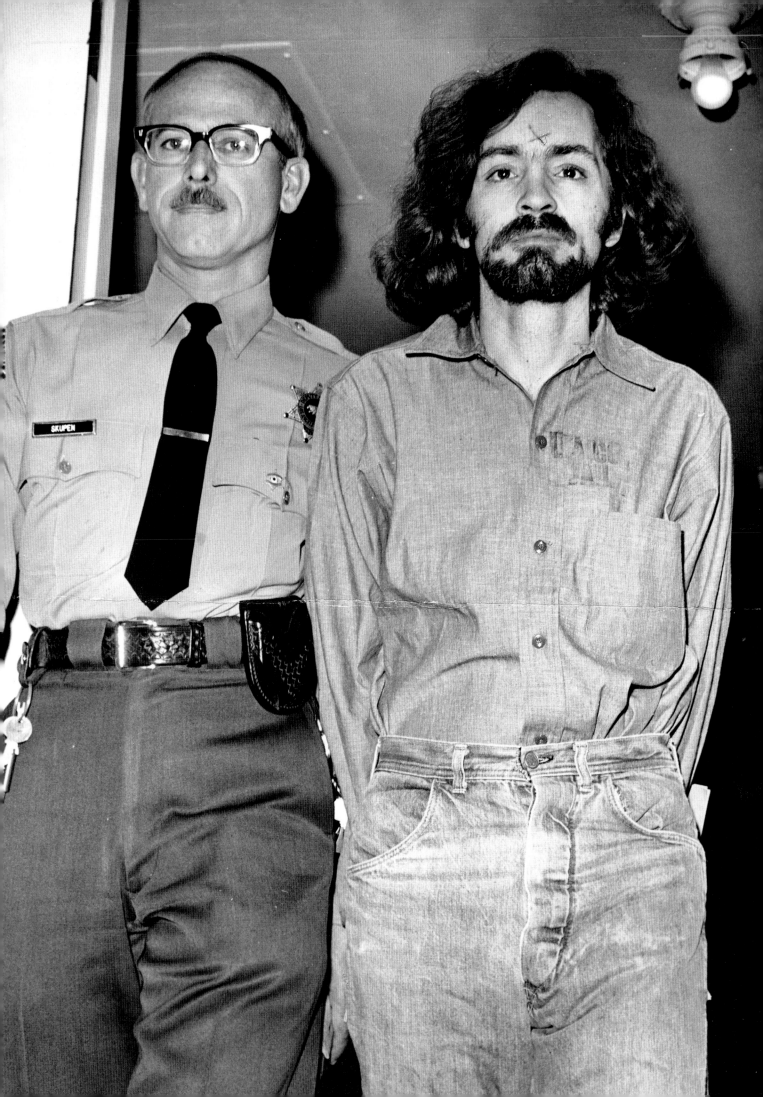

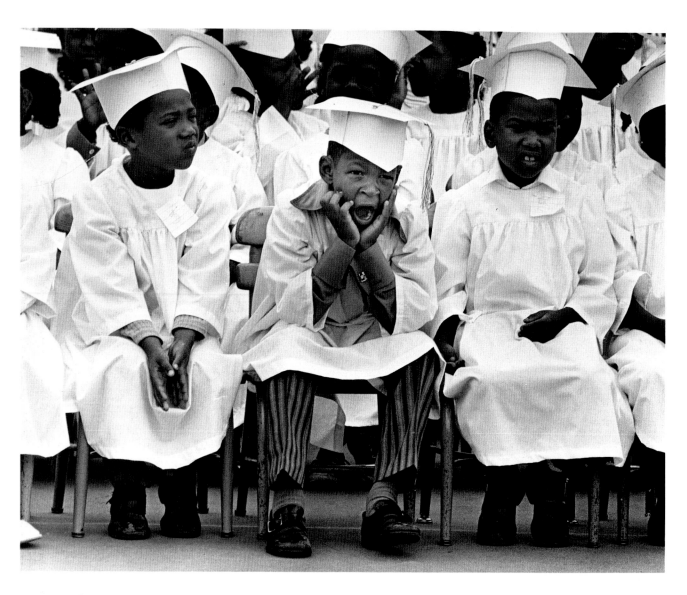

Contemplating the first of many graduation ceremonies,
Shawn Lynch, 6, awaits his kindergarten diploma with 200
students of the 107th Street Elementary School.
June, 1971. (Steve Fontanini)

Concentration is the key as this 75-year-old
player at Leisure World, Laguna Hills,
returns serve. *1974.* (Cliff Otto)

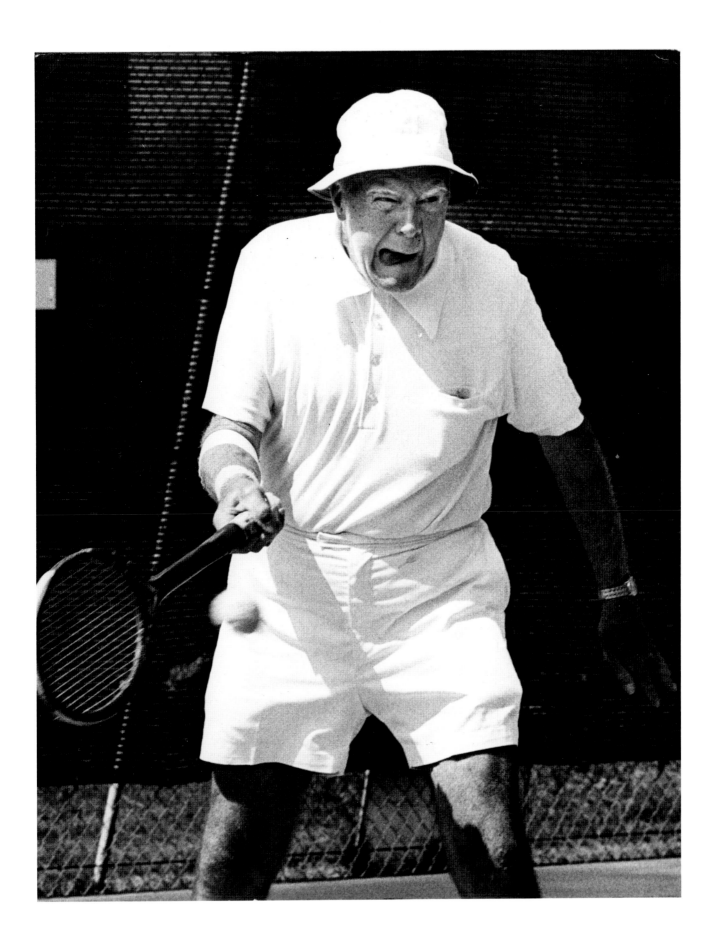

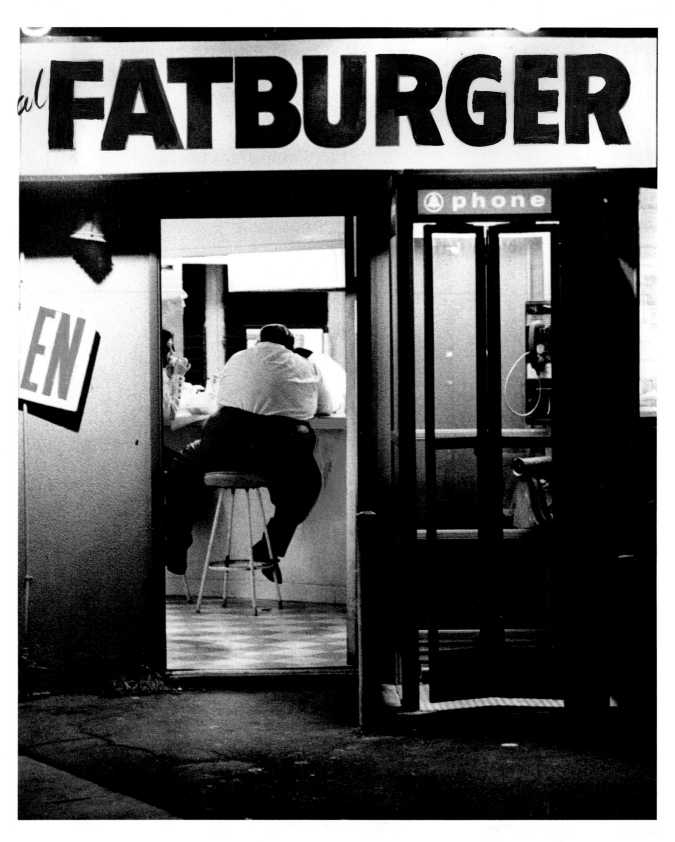

From a late-night hangout in the 1960s to a fast-food
franchise in the 1980s, L.A.'s *Fatburger* has always rallied a
conspicuous clientele. *September, 1972.* (Boris Yaro)

Leo, 650 pounds and five years old, lives at the home of
magician-animal trainers Siegfried and Roy. The size and
age of the dog is not known. *December, 1974.* (John Malmin)

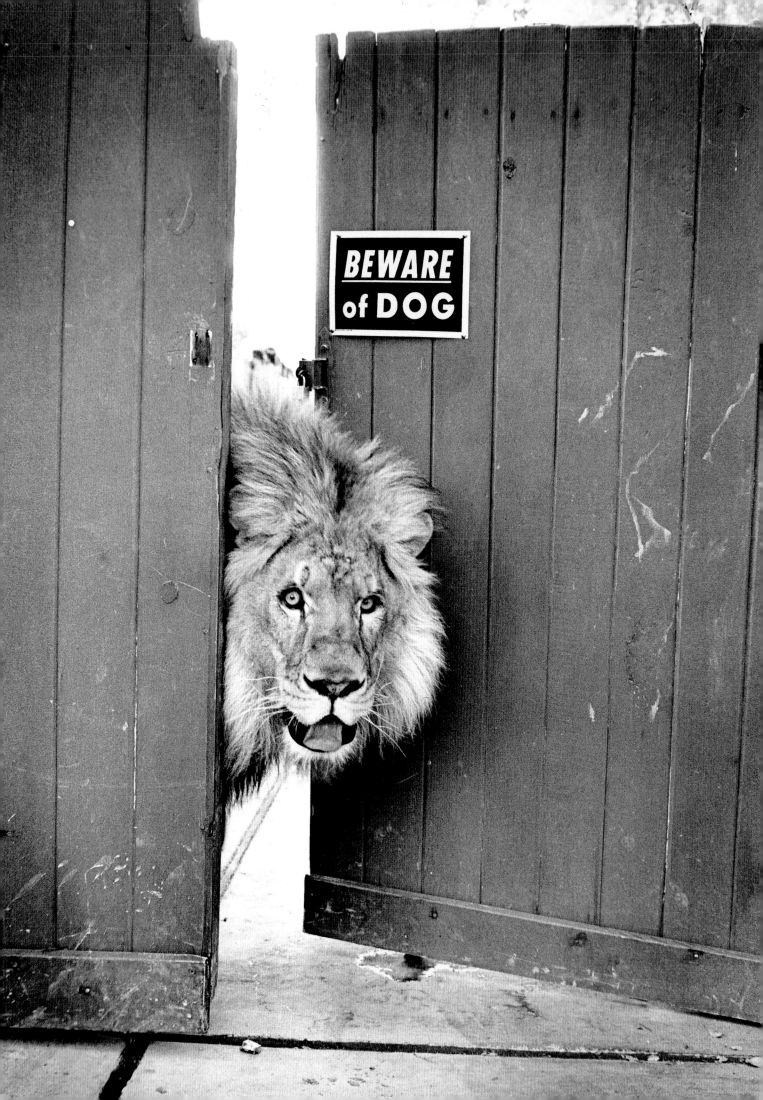

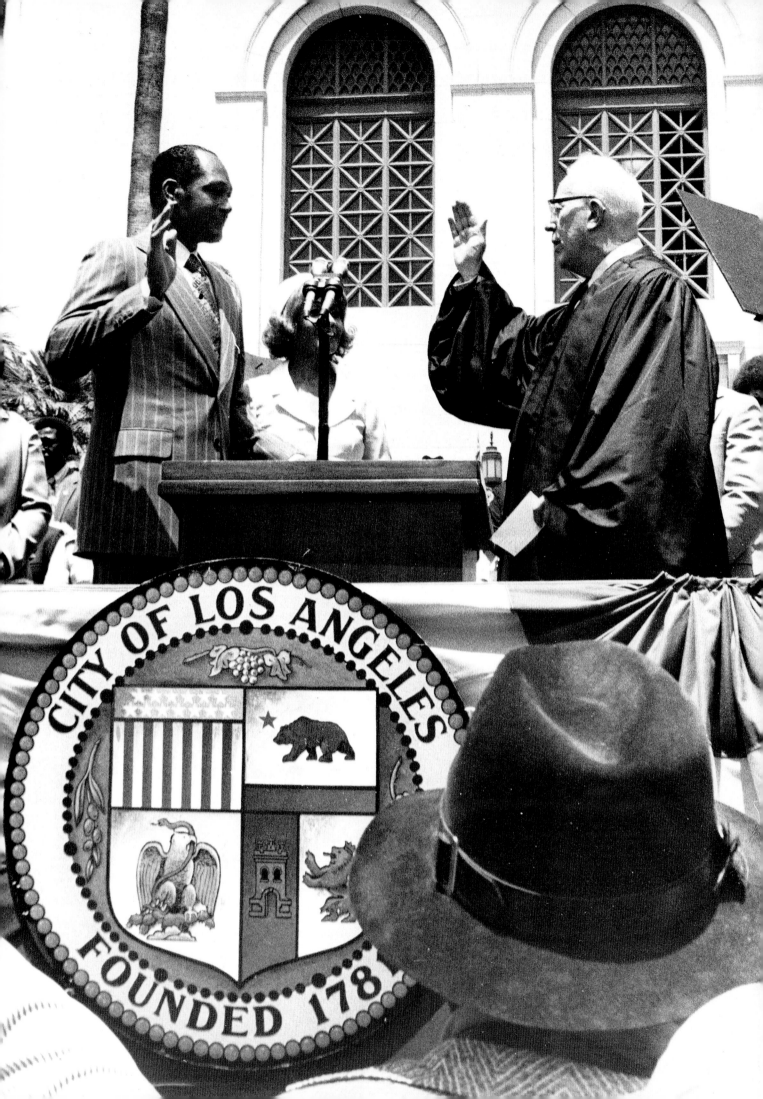

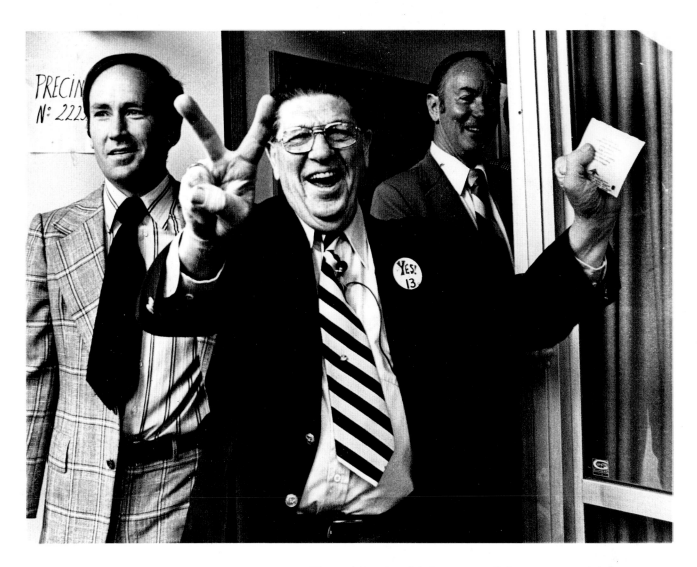

Howard Jarvis, chief sponsor of the controversial
Proposition 13, signals victory as he casts his own vote at the
Fairfax-Melrose precinct. *June, 1978.* (Ben Olender)

Son of a sharecropper, City Councilman Tom Bradley takes
the oath of office as Mayor of Los Angeles from former
Chief Justice Earl Warren, having won in a landslide over
12-year mayor Sam Yorty. Los Angeles became the largest
U.S. city to elect a black mayor. *July, 1973.* (Reed Saxon)

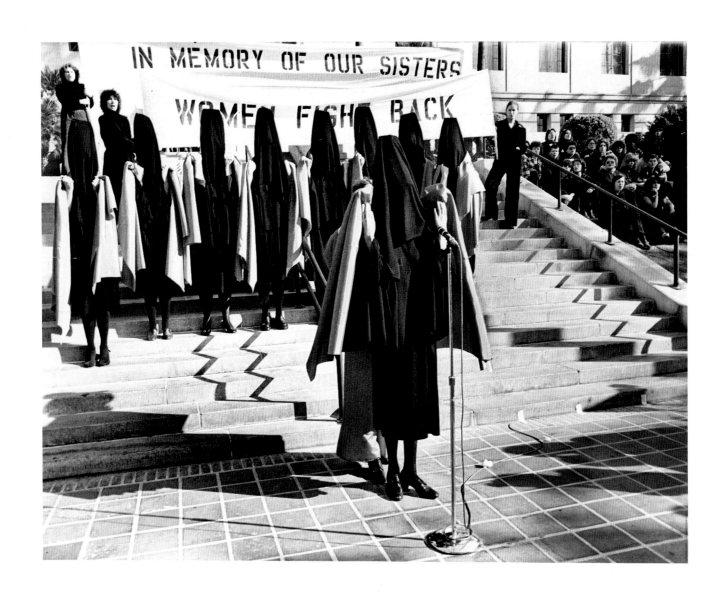

During the terrifying reign of the "Hillside Strangler," a group of veiled women demonstrated against the violence in a militant memorial service on City Hall steps. *December, 1977.* (Ben Olender)

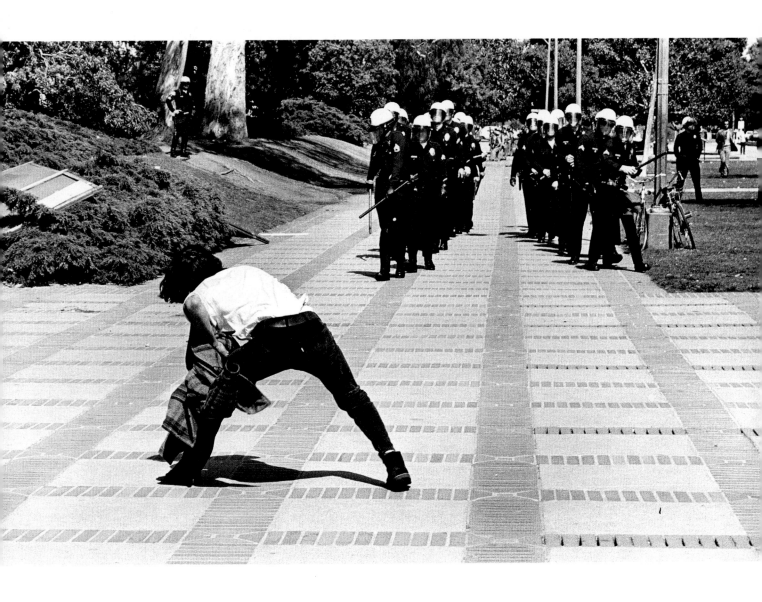

Increased American bombing in Vietnam heightened student
demonstrations. At the Westwood campus of UCLA, a rock-
throwing student threatened a squad of LAPD officers.
May, 1972. (Fitzgerald Whitney)

OVERLEAF
A gallery of Los Angeles New Wave Rock Bands.
August, 1979. (George Rose)

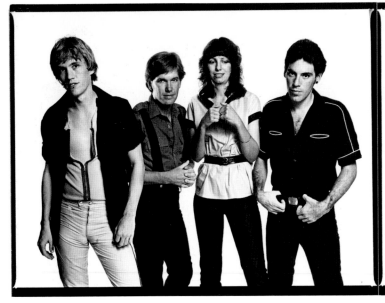 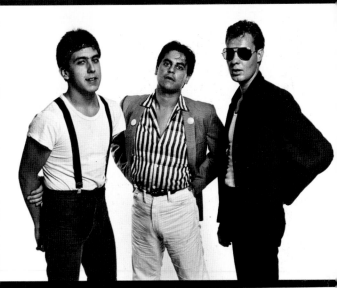

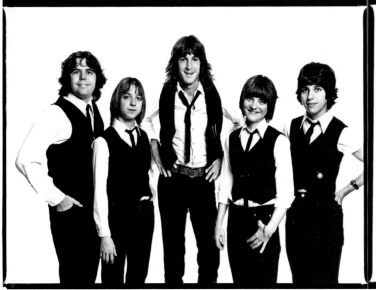 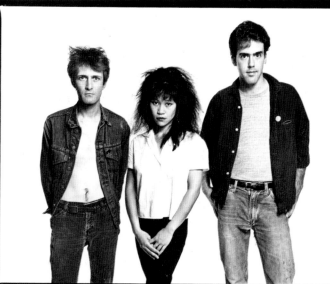

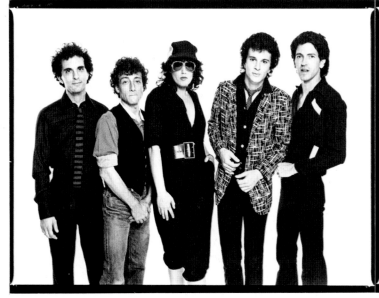 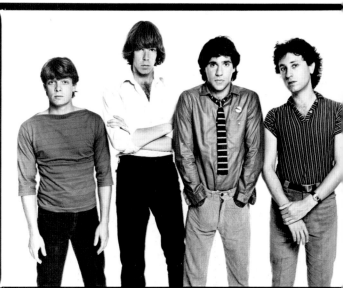

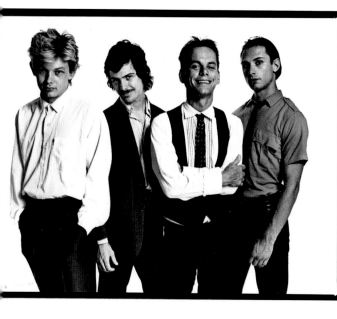
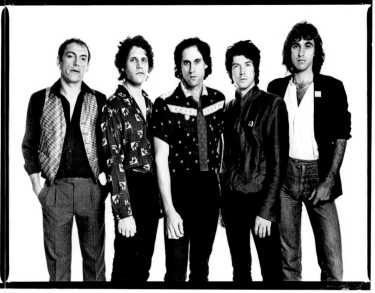
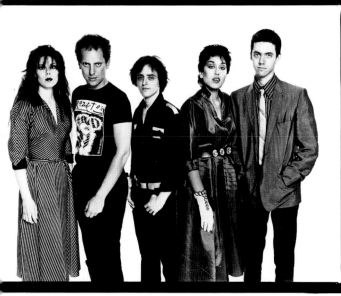
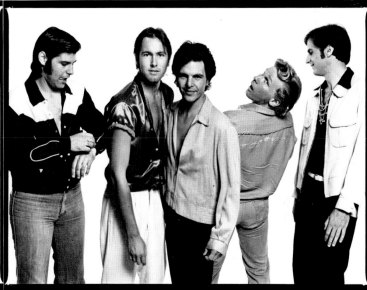
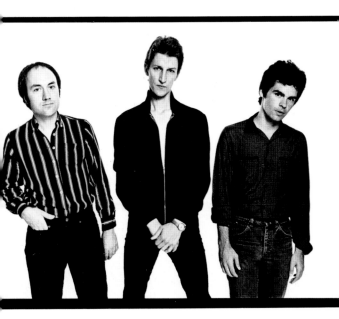
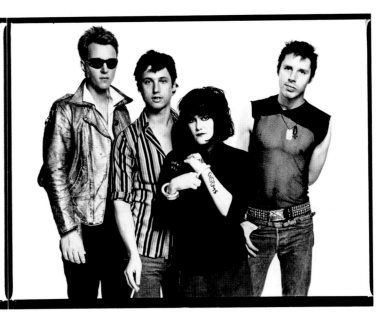

131

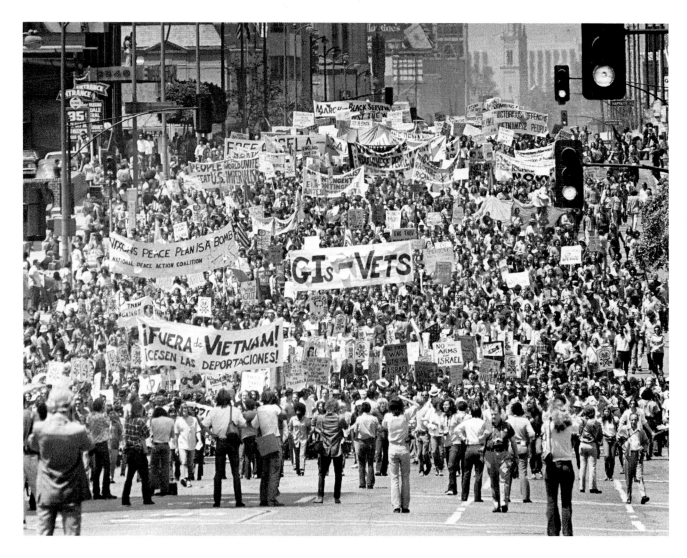

Heading toward MacArthur Park for a rally, some 7,000 antiwar marchers created a two-mile parade on Wilshire Boulevard. *April, 1972.* (Joe Kennedy)

Feigning death, a group of Vietnam war protestors, including some disabled vets, demonstrate outside President Nixon's Los Angeles campaign headquarters. *May, 1972.* (Bruce Cox)

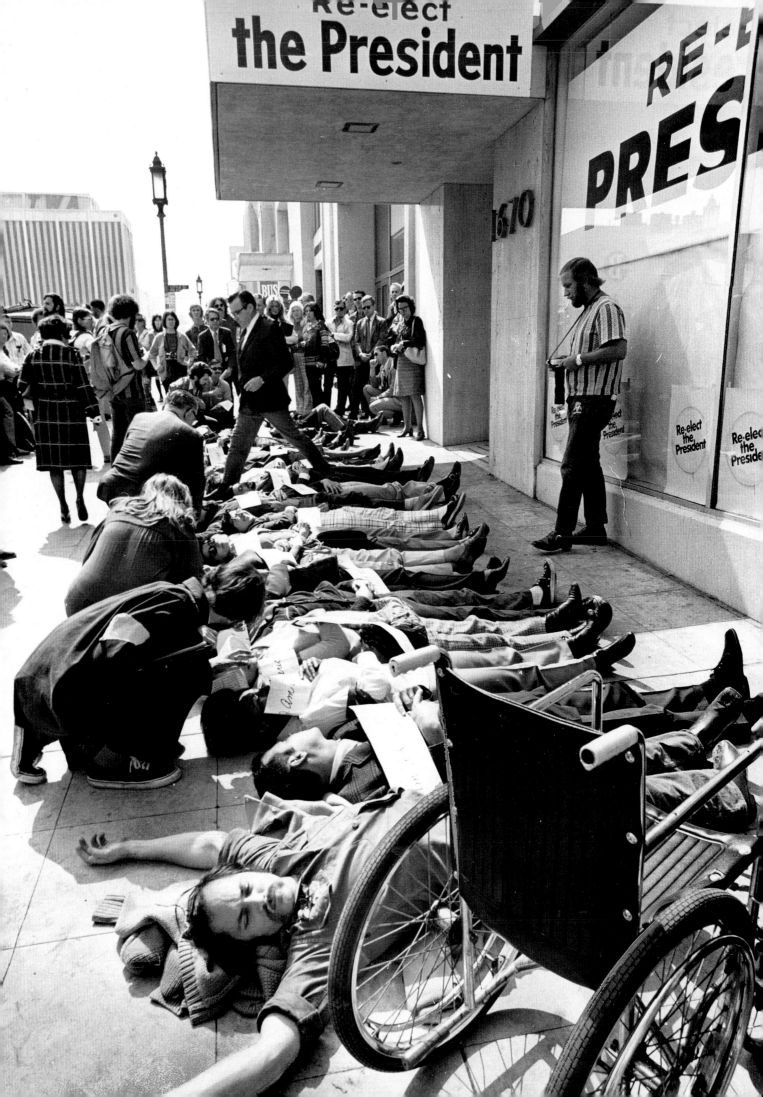

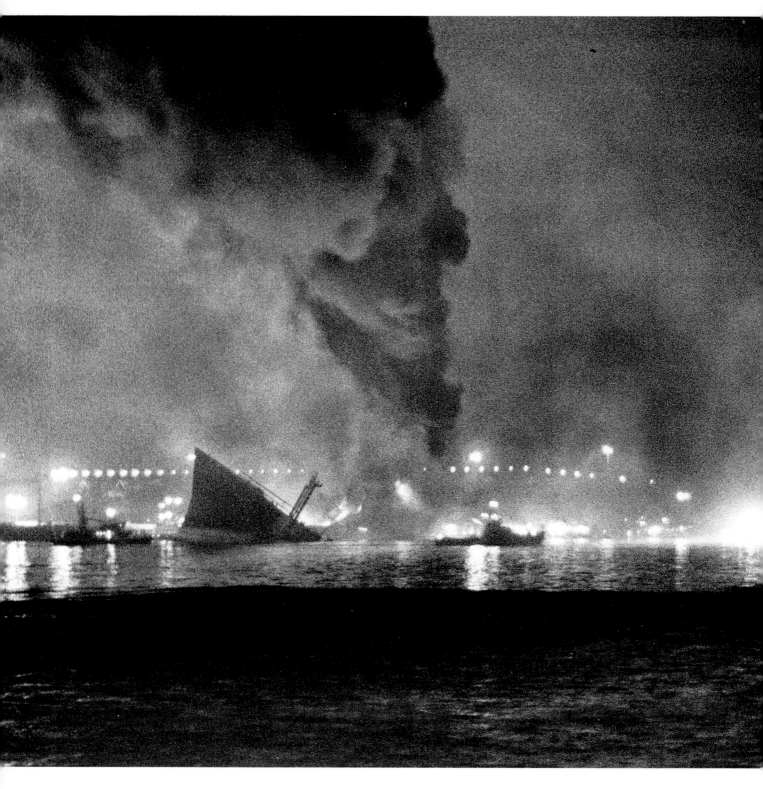

Split in two, the 810-foot Liberian oil tanker *Sansinena* lies burning at San Pedro in Los Angeles Harbor after an explosion aboard rocked the coast, shattering windows in Costa Mesa, 20 miles away. *December, 1976.* (Jack Gaunt)

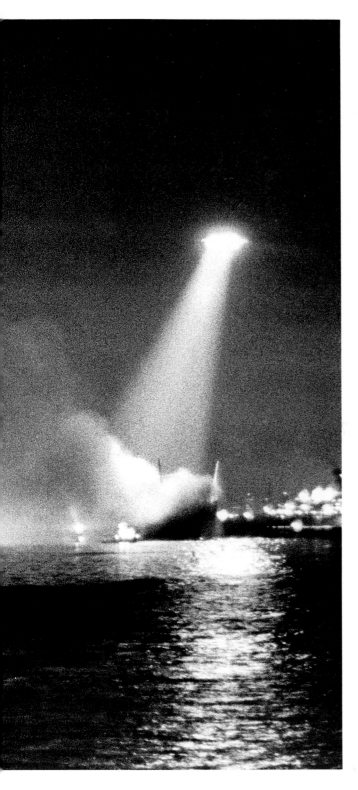

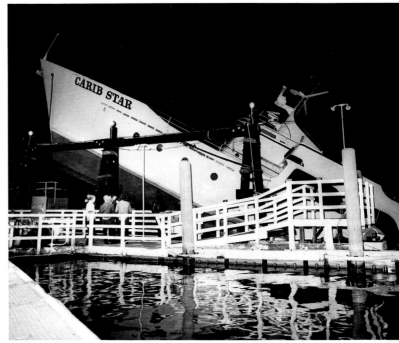

A mysterious blast sank the *Carib Star* in Los Angeles Harbor only four hours after it had returned from a routine run to Santa Catalina Island. The cruise ship may have been sabotaged because of a rumor that a sister ship might be sold to a buyer in Kuwait, the oil-rich Arab state. *April, 1975.* (Jack Gaunt)

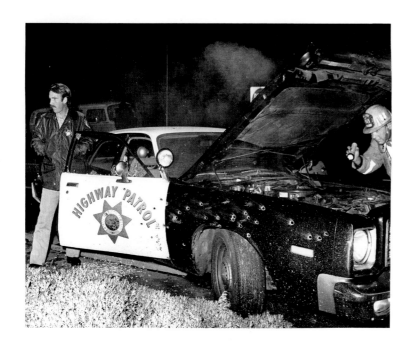

Luck was with the two Highway Patrol officers whose car was riddled with 33 rifle shots; only one man suffered a minor wound. The assailant, a 25-year-old security guard, fired on the officers after they pulled him over for reckless driving. *March, 1977.* (George Fry)

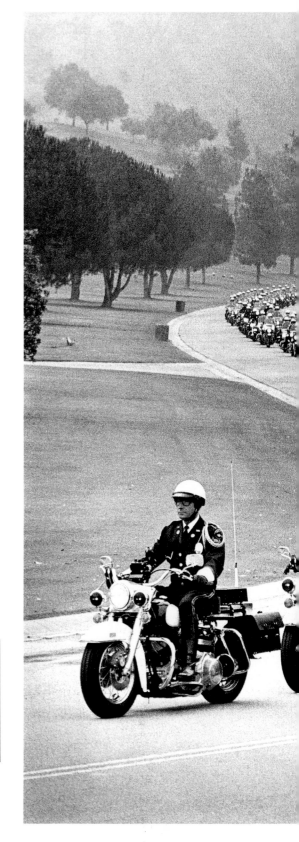

More than 200 motorcycle policemen escort a hearse bearing the body of a fellow officer, John T. Lawler, to his burial at Rose Hills Memorial Park. Lawler, who had received the Medal of Valor in 1969 for rescuing two women from a burning car, was killed in a highway accident. *July, 1973.* (John Malmin)

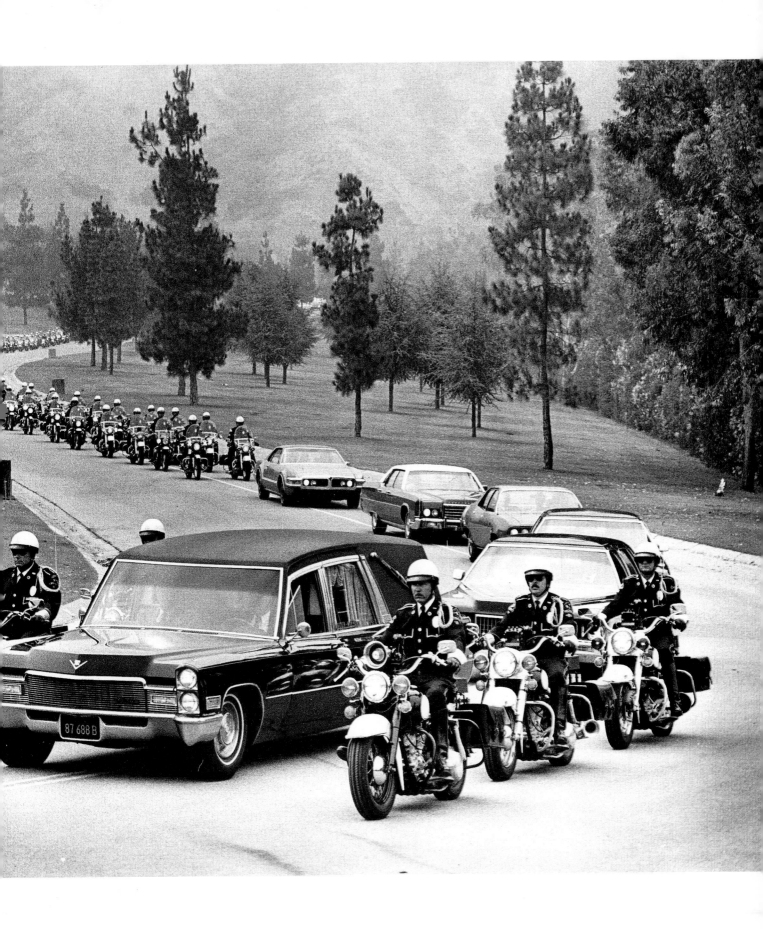

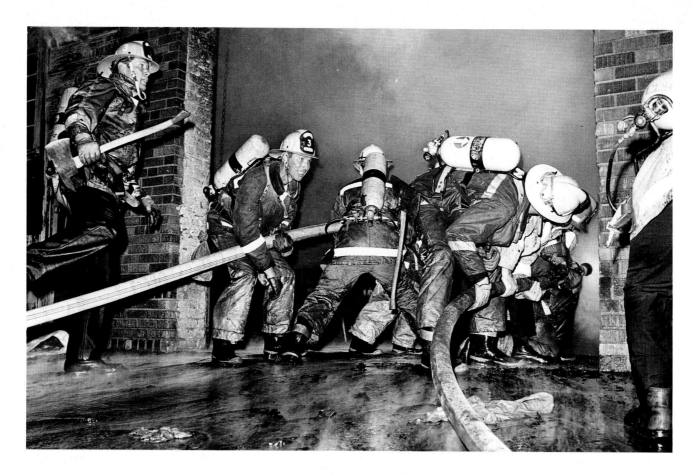

The **LAFD** at work fighting a
blaze at 1215 East 1st Street.
December, 1972. (Jack Gaunt)

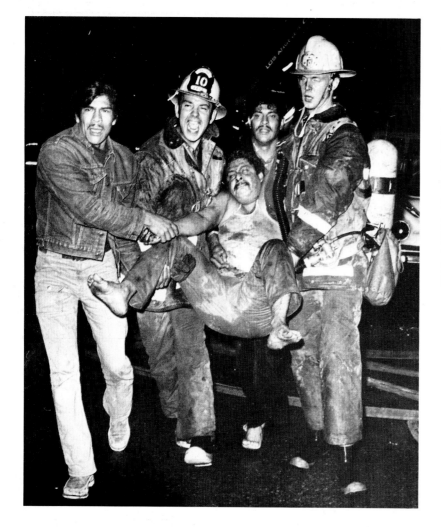

Twenty-five died and more
than fifty were injured in the
arson fire that destroyed the
Stratford Apartments on West
6th Street, the most
devastating fire in terms of
human loss in the history of
Los Angeles. *November, 1973.*
(Jack Gaunt)

Spectacular flames roar
skyward as a refinery burns.
June, 1978. (George Fry)

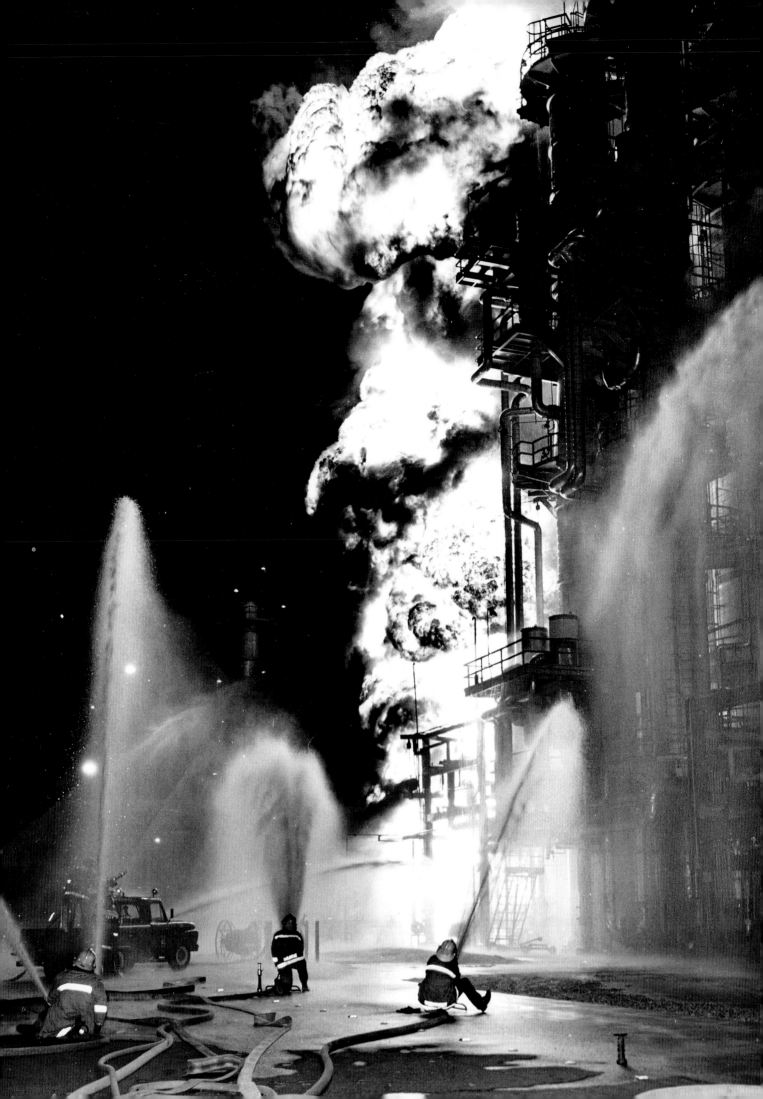

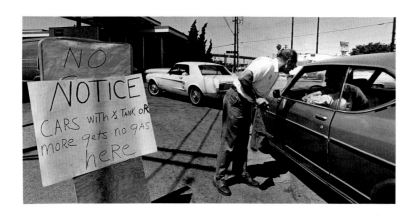

Many gas stations during the oil crisis refused to fill up cars with a half tank or more, hoping to spread their thin reserves among more customers. *May, 1979.* (George Fry)

Too much gas may have been the problem as this cement mixer went out of control and crashed into a million-dollar home on Palos Verdes Peninsula. *October, 1971.* (Jack Gaunt)

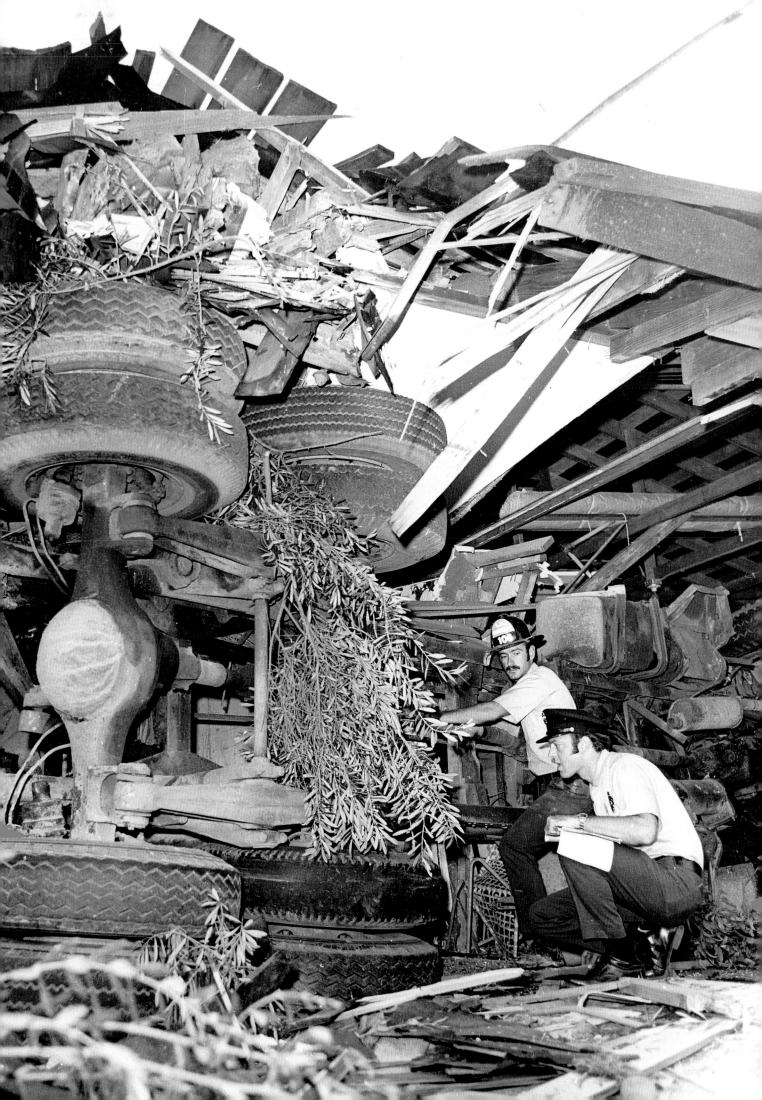

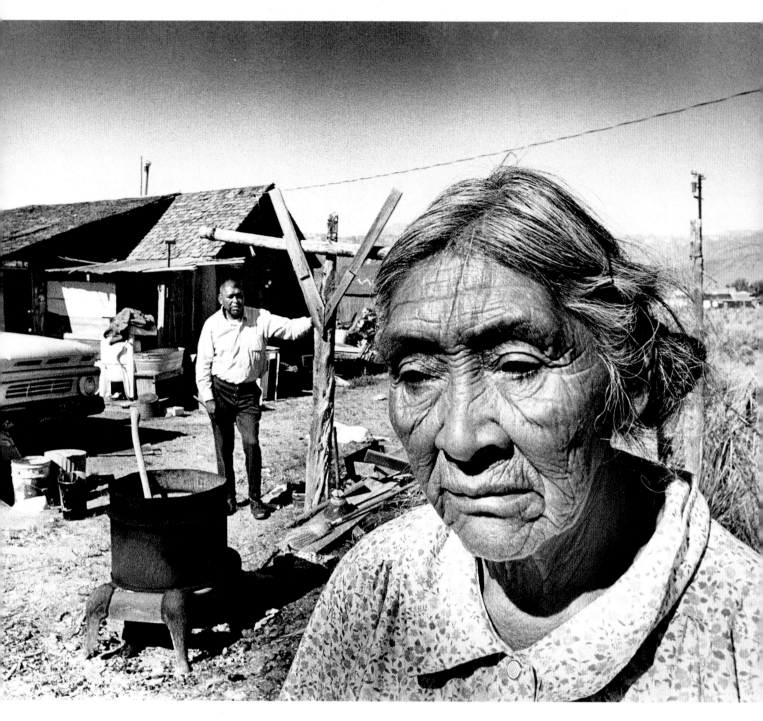

Full-blooded Paiute Mrs. Lucille Gilbert and her cousin Cecil Rambeau were among 60 members of an Indian group about to be evicted from their homesites in Bridgeport. At the time there was hope that U.S. officials would give the colony twenty acres of vacant federal land. *August, 1972.* (John Malmin)

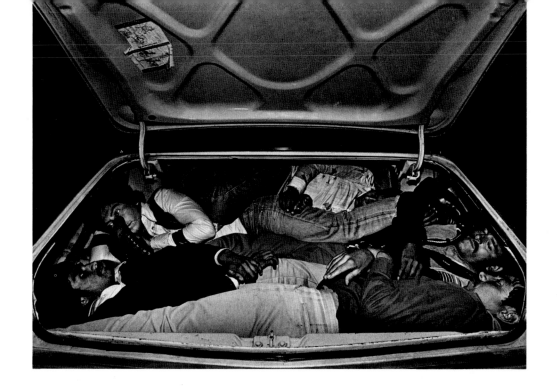

Five illegal aliens fill the trunk of a car
stopped by U.S. Border Patrol agents on
Interstate 5 near San Onofre. In the
preceding 12-month period 23,889
immigrants, most of them Mexican, had been
apprehended on their way north.
December, 1979. (John McDonough)

Heavy rains swept a torrent of mud through the edge of
Palm Desert, destroying numerous houses. *July, 1979.*
(Dave Gatley)

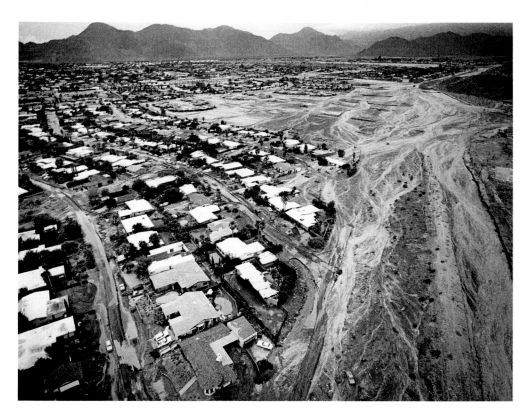

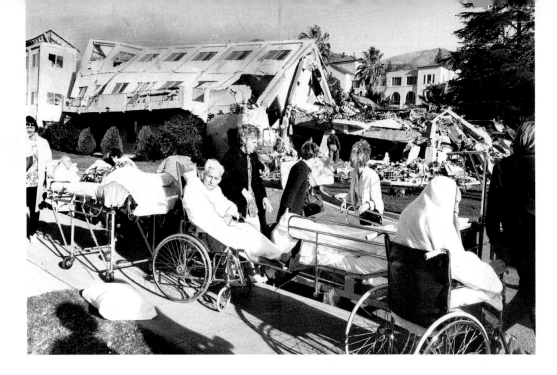

Olive View Hospital suffered heavily in the 1971 quake.
February, 1971. (Boris Yaro)

A quake registering 6.4 on the Richter scale shook the Imperial Valley, causing some $15 million in damage and injuring more than a hundred persons. This El Centro supermarket got off lightly. *October, 1979.* (Dave Gatley)

Forty people died in the earthquake at San Fernando Veteran's Administration Hospital. These survivors wait for transportation to other facilities as workers search the wreckage for victims. *February, 1971.* (Bruce Cox)

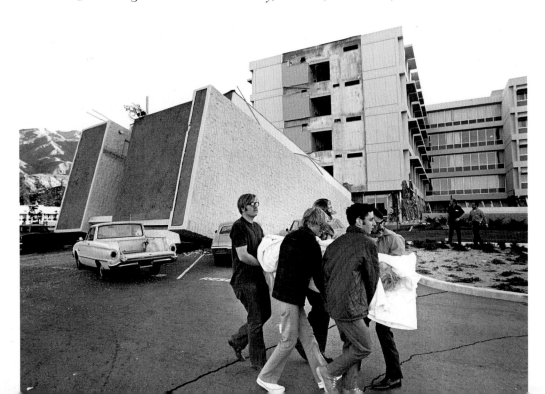

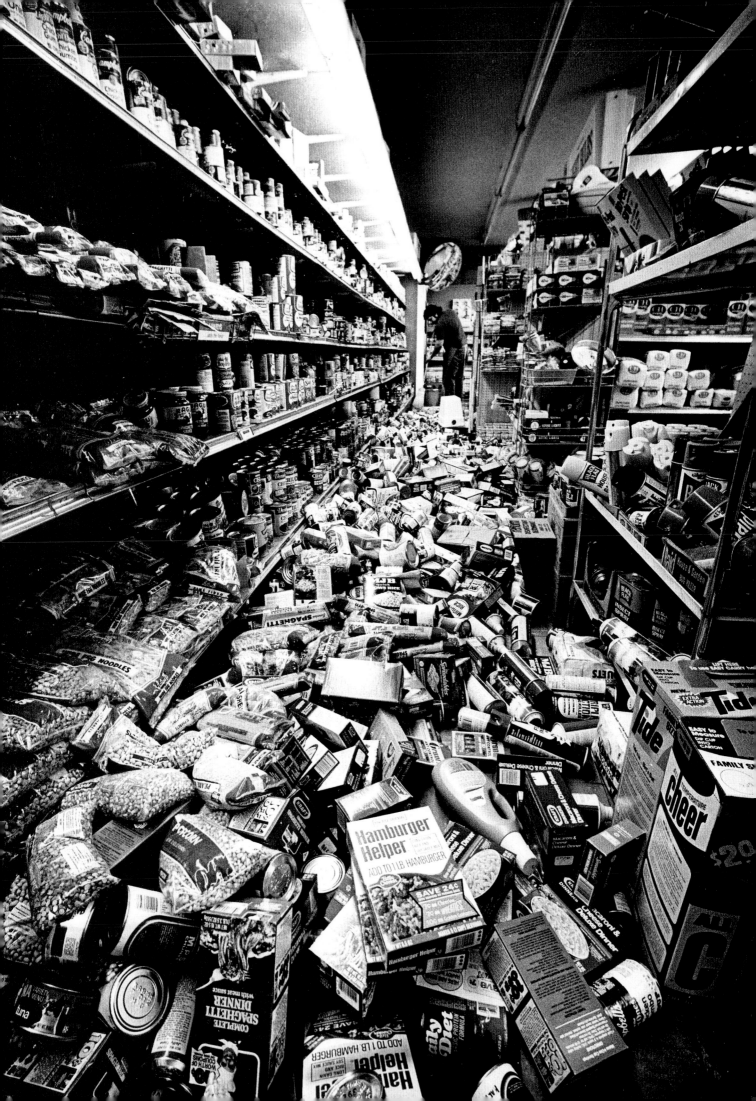

1980s

A single rose stands in mute tribute at the Washington, D.C., memorial to the men and women who died in Vietnam, their names engraved in black granite. *November, 1982.* (Bernie Boston)

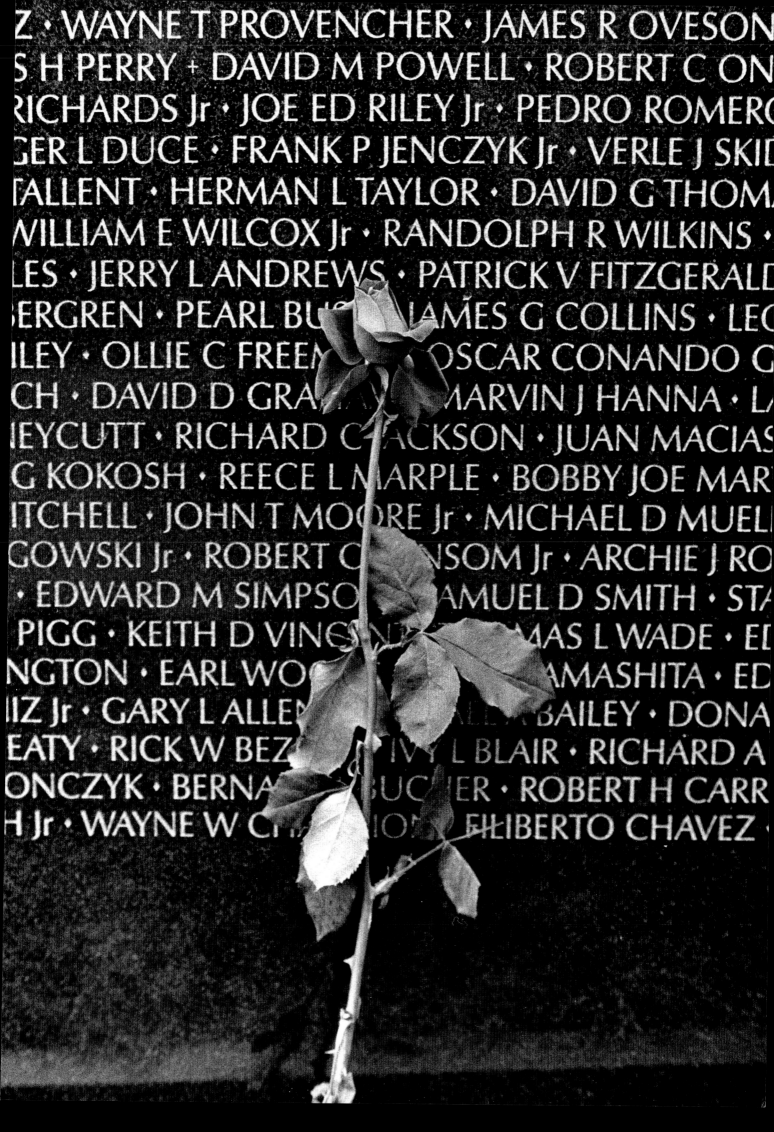

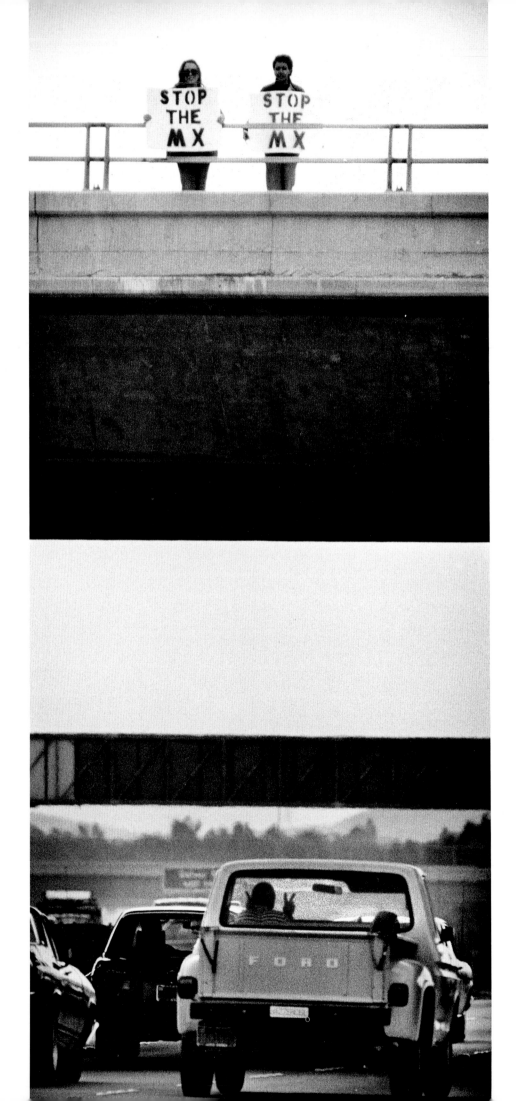

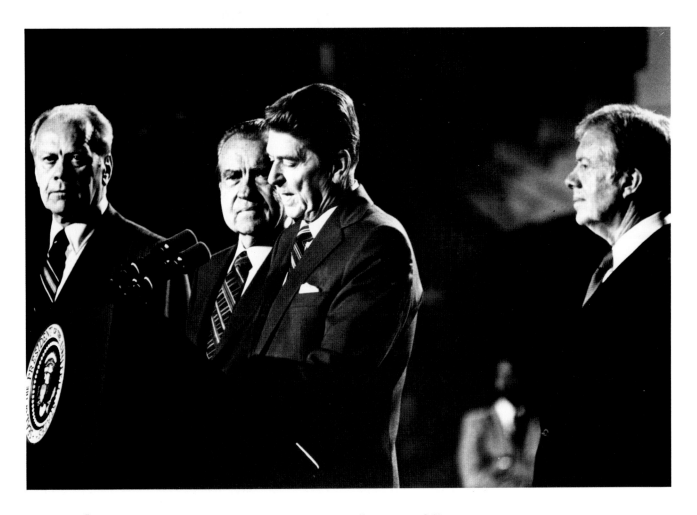

Four Presidents at the White House pay tribute to a fallen friend, Egyptian President Anwar Sadat, who had just been assassinated in Cairo. *October, 1981.* (Bernie Boston)

Protestors from the Alliance for Survival stationed atop an overpass find a sympathetic motorist on the San Diego Freeway in Irvine. *May, 1985.* (Kari Rene Hall)

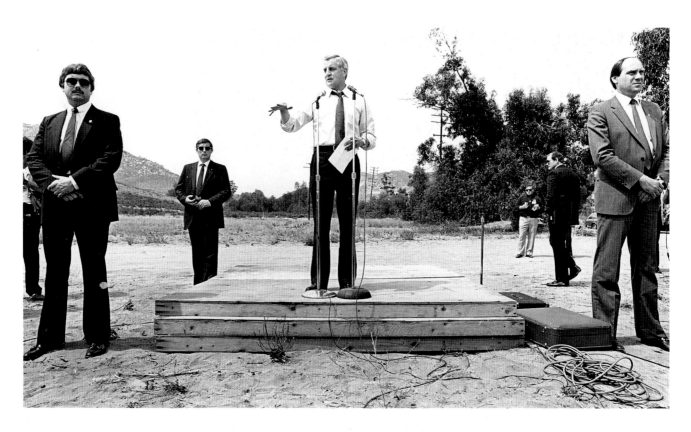

Candidates for President of the United States sometimes
speak in rather makeshift circumstances but never without
an audience of Secret Service men. *May, 1984.*
(Marsha Traeger)

No mystery man, the candidate was simply awaiting the sign
painter to complete this billboard along the San Gabriel
Freeway at Santa Fe Springs. *March, 1982.* (Ken Hively)

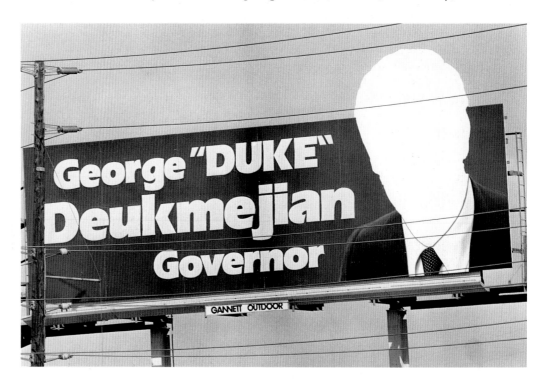

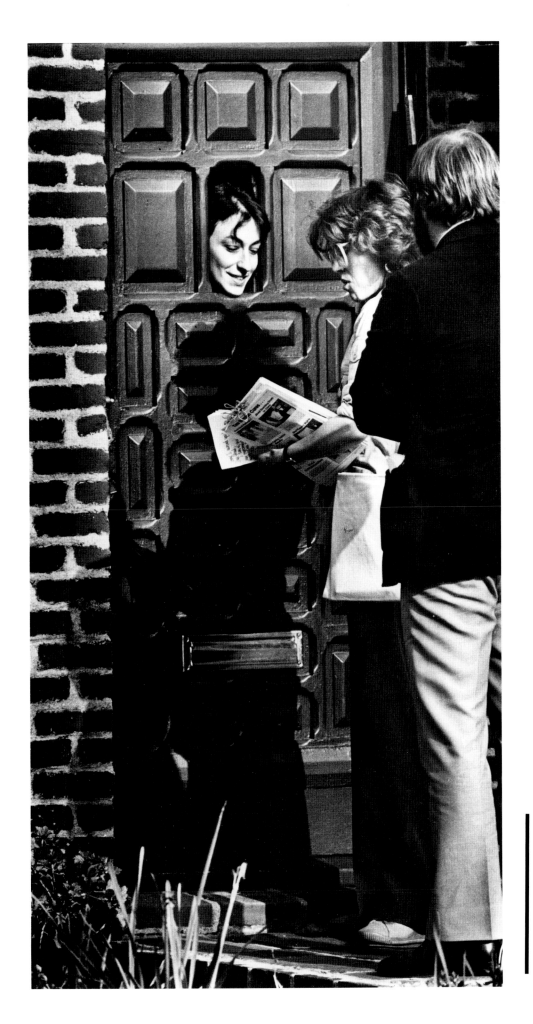

Doing her wifely best, Jane Fonda campaigned for husband Tom Hayden, running for the 44th Assembly District in Los Angeles, but failed to convince a woman to open her door. *May, 1982.* (Robert R. Chamberlin)

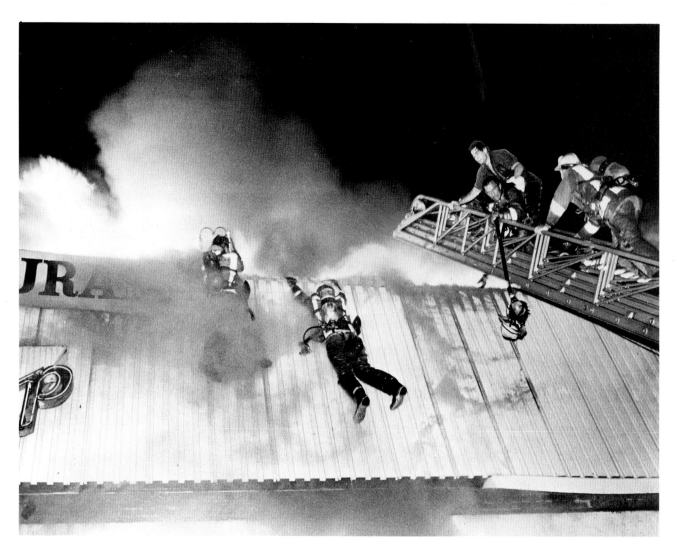

Firefighters struggle desperately to rescue two colleagues
clinging to the roof edge of Cugees Restaurant in North
Hollywood; one of the men fell into the fire and died. The
arsonist who set the fire was sentenced to 25-years-to-life.
December, 1983. (Mike Meadows)

Tough but tender James Bryan rescues Elizabeth Ann Foster
from the burning California Hotel near downtown L.A.
1981. (Jose Galvez)

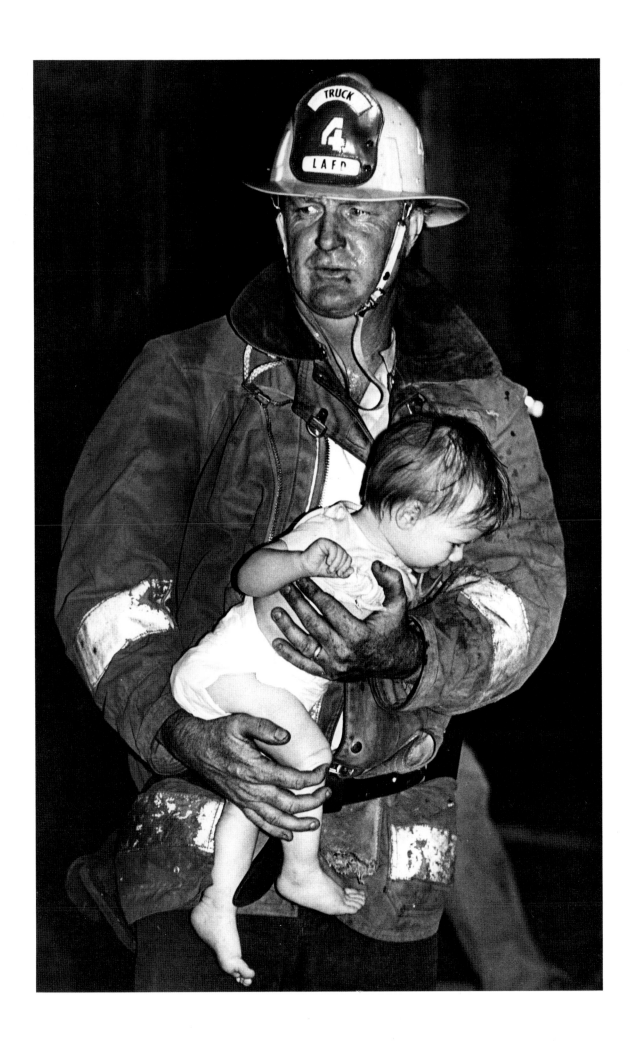

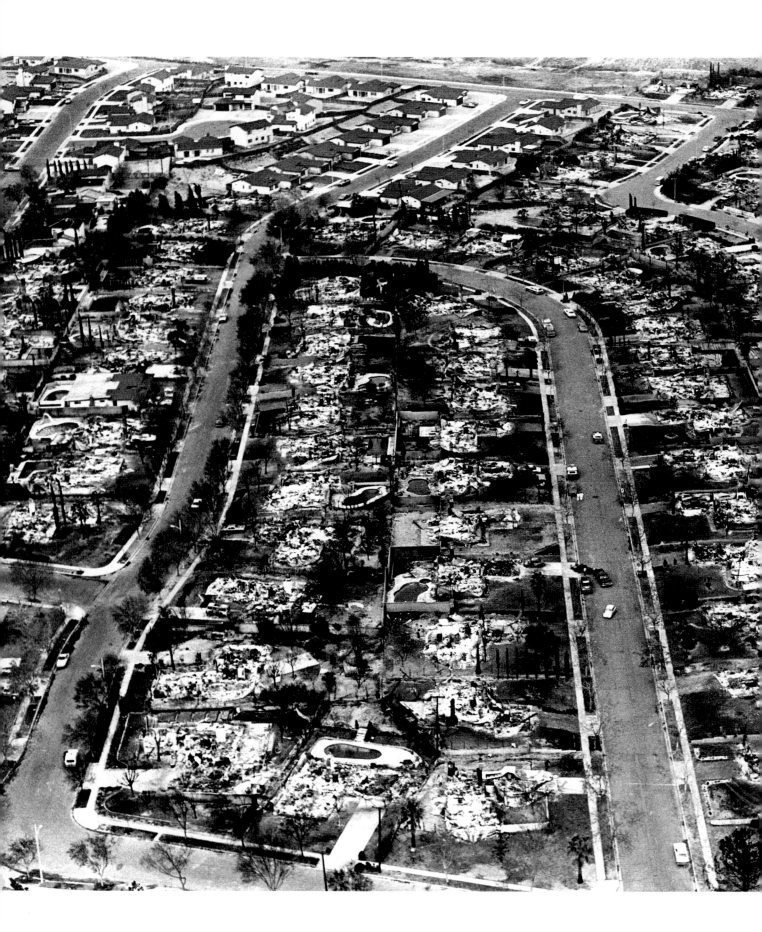

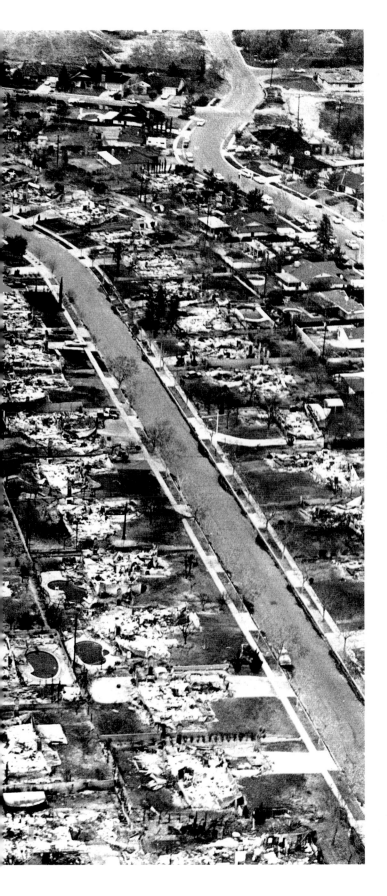

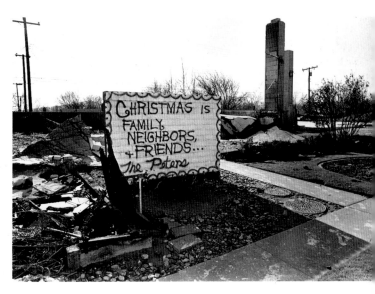

A sign of hope and thankfulness stands out on Northpark Boulevard in San Bernardino. *December, 1980*. (Ken Hively)

More than 70 houses were destroyed in the Waterman Canyon area and another 200 elsewhere in San Bernardino. *November, 1980*. (Joe Kennedy)

A TV cameraman covering a fire in the Normal Heights area leaves his work to lead a woman to safety. *June, 1985*. (Vince Compagnone)

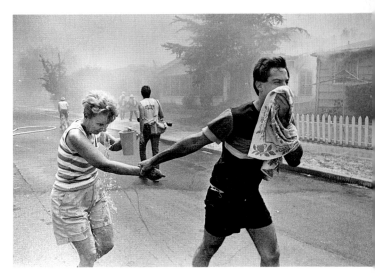

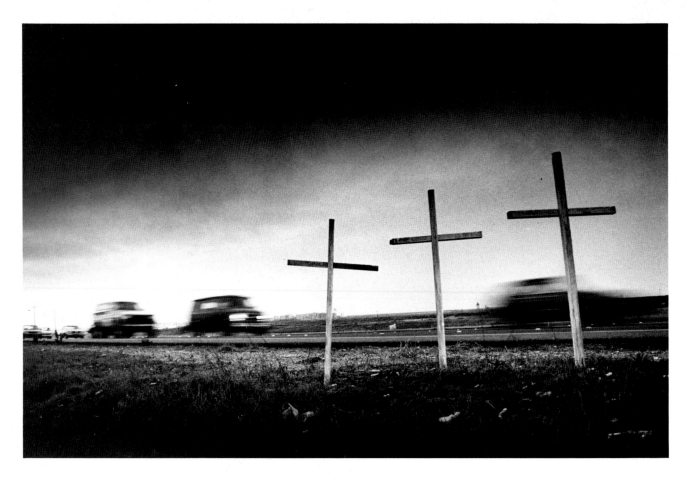

Three handmade crosses mark the site at
Seal Beach where three high school
cheerleaders were killed in a head-on crash
with a drunken driver. *1984.*
(Thomas Kelsey)

A lonely worker stands amid the wreckage of the General
Hospital in Mexico City, where maternity-ward patients,
doctors, nurses, and students were crushed between
collapsed floors. Hundreds died in the earthquake.
September, 1985. (Dave Gatley)

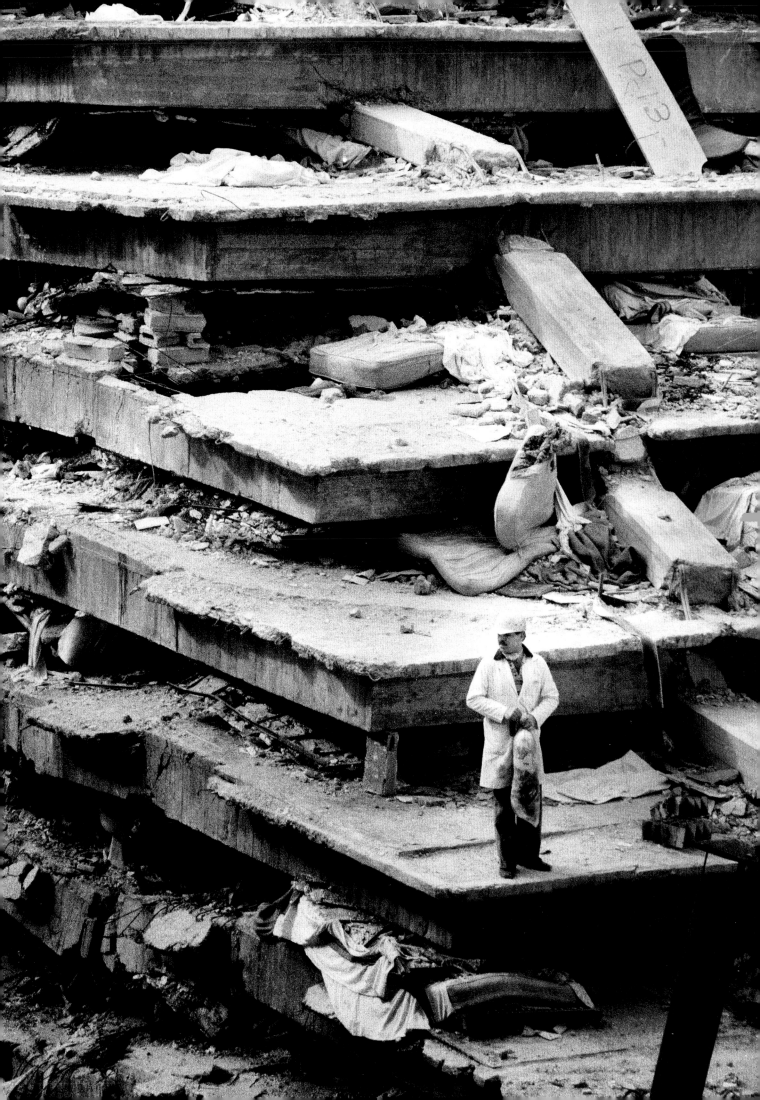

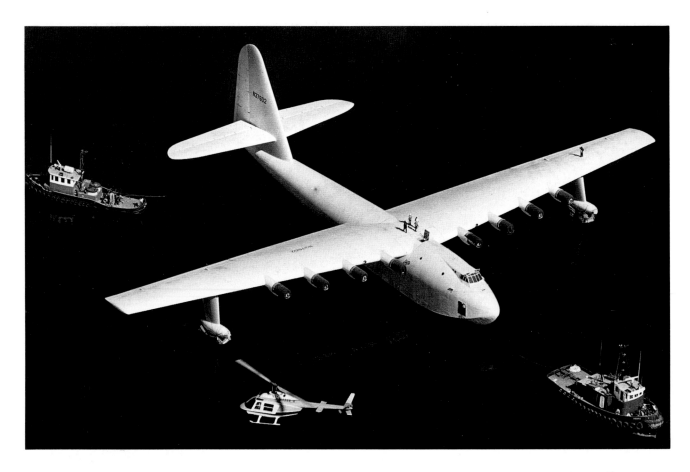

Howard Hughes's notorious wooden flying boat, dubbed Spruce Goose, with a wingspan the length of a football field, comes out of a hangar at Long Beach Harbor, where it had been under wraps since 1954. *October, 1980.* (Ken Hively)

No optical illusion, this rentable limo is 50 feet long, has a 12-foot swimming pool, four cellular phones, fish tanks, and a microwave oven. Ultra Limousine of La Palma spent three and a half years creating it. *February, 1985.* (Ken Hively)

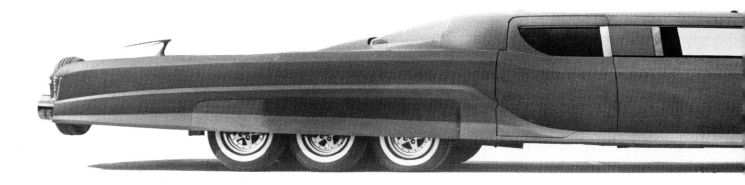

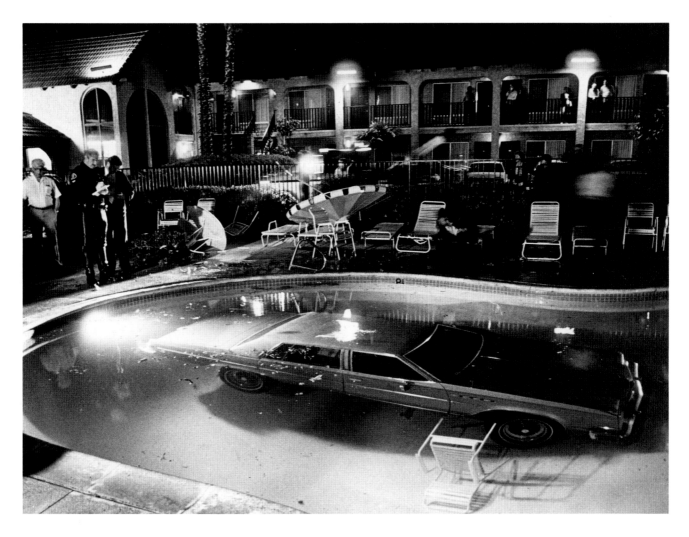

No one realized that parking was quite so scarce until Robert Lee Linch's car wound up in the pool of the Costa Mesa Inn. He was arrested on suspicion of driving while intoxicated. *March, 1984* (Colin Crawford)

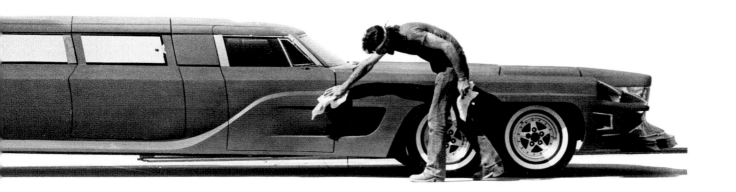

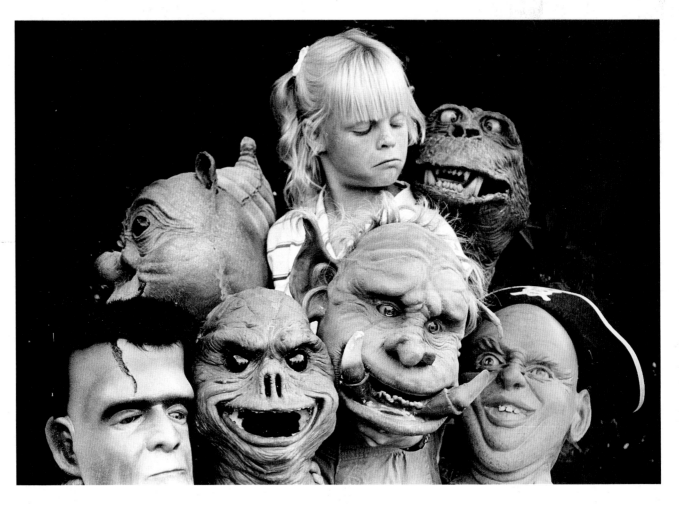

Courtney Hayes is not frightened one bit by foam rubber horror movie masks made by artist Mel Slavick of Orange. *October, 1985.* (Gail Fisher)

Nothing unusual happened on Halloween at the bus stop near South Coast Plaza in Costa Mesa. *October, 1985.* (Kari Rene Hall)

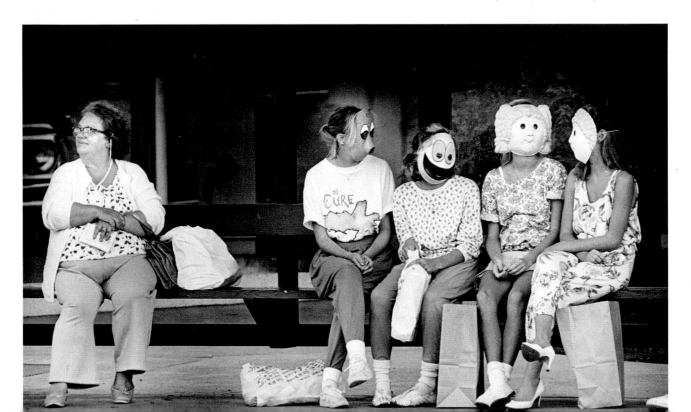

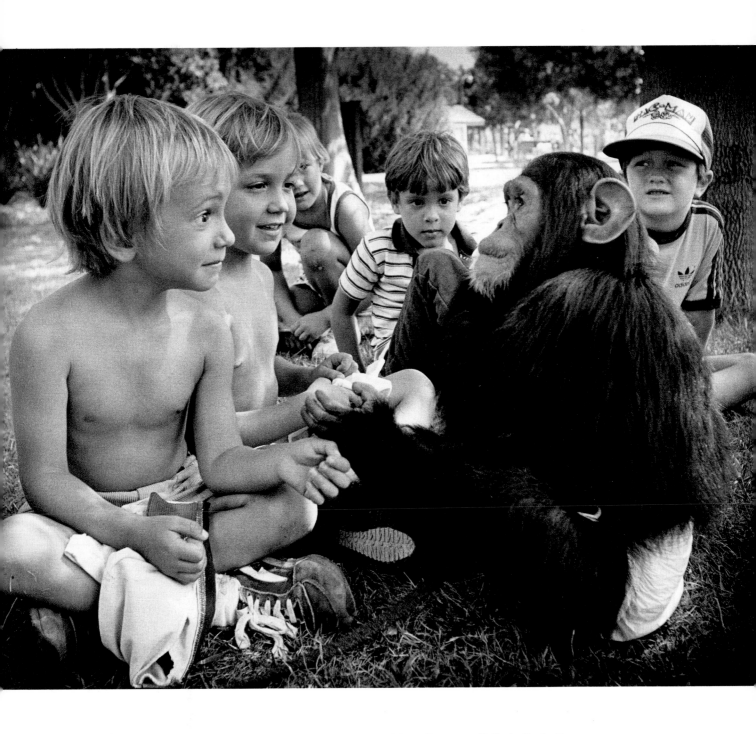

Isaac, a two-year-old chimp from Lion Country Safari, finds
plenty to chat about with the Chipmunk group from Camp
Frasier. *June, 1983.* (Kari Rene Hall)

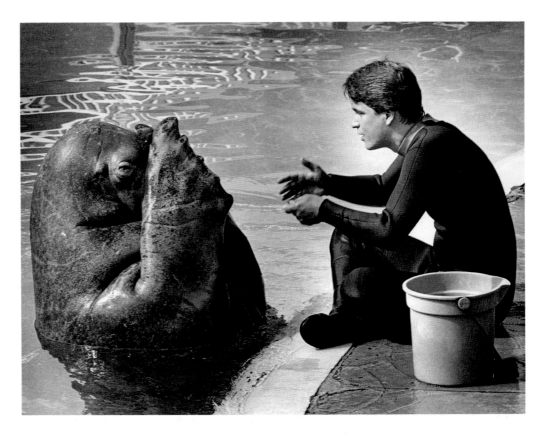

Flo the walrus at Sea World Park in San Diego finds her trainer all wet. *1984.* (Barbara Martin)

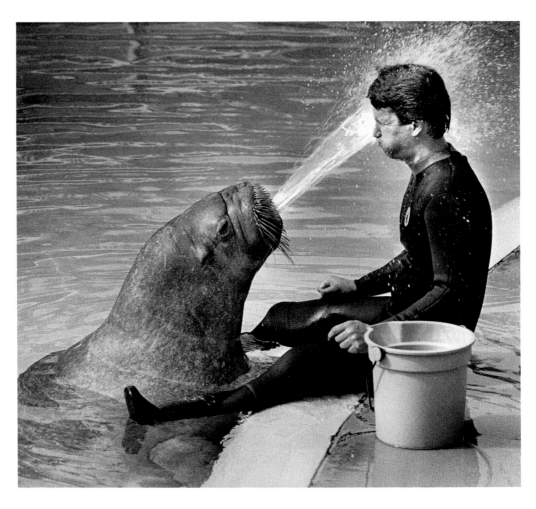

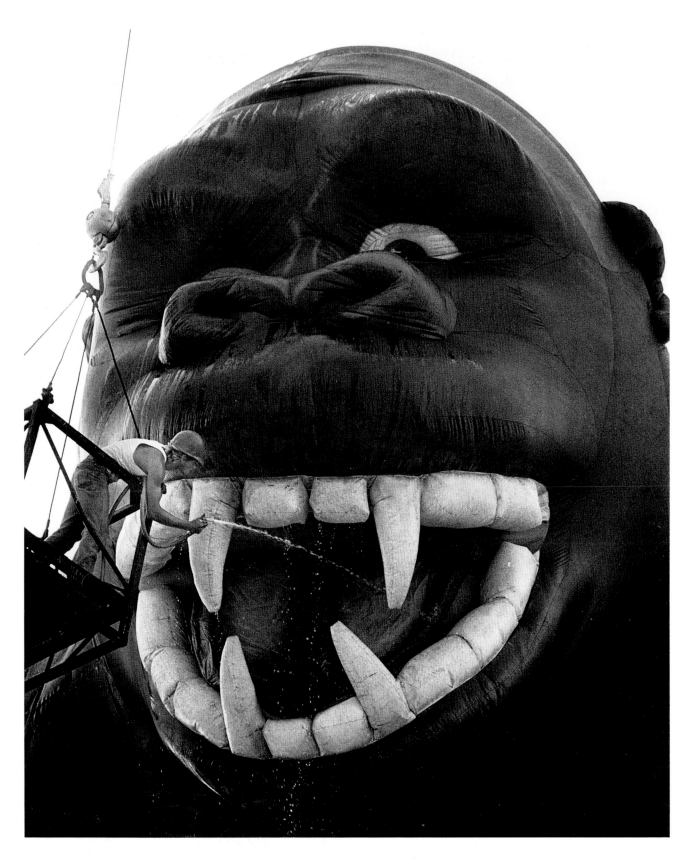

Fresh from his triumph atop the Empire State Building in New York, the giant inflatable King Kong visits the dentist before appearing at a promotional event in downtown San Diego. *September, 1984.* (Vince Compagnone)

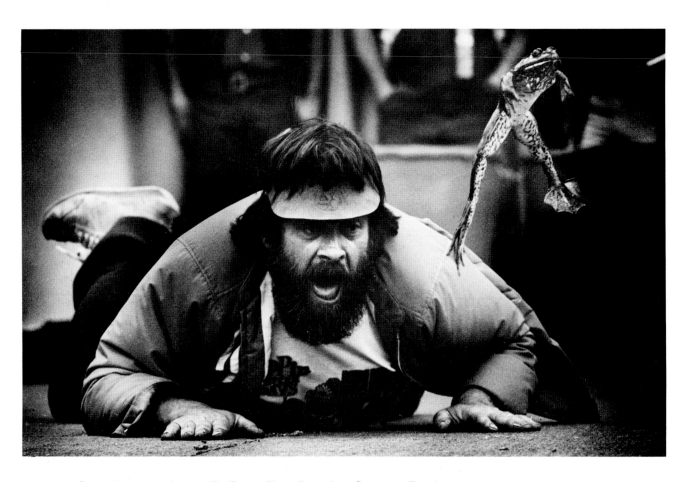

At the annual Angel's Camp Frog Jumping Contest, Danny
Matasci cheers on his champion E. Davey Croakett, holder
of the record at 20 feet 3 inches. *May, 1981.*
(Bob Chamberlin)

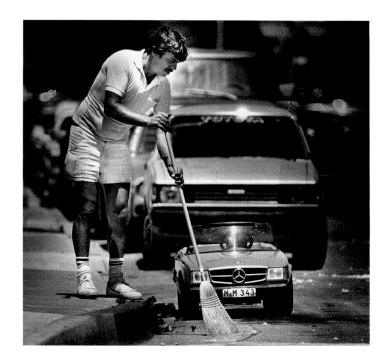

Neatness counts in Newport Beach, even
when the Mercedes Benz is only one-fifth
life-size and pedal-powered. *August, 1985.*
(Ken Hively)

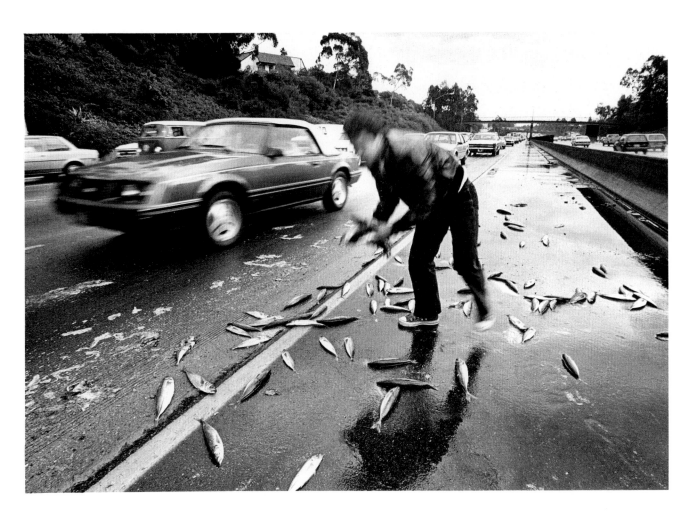

A fish story is what Arturo Velasco had to tell his friends
after picking up handfuls of seafood on the Santa Monica
Freeway near Crenshaw Boulevard one morning. Highway
Patrol officers guessed that the mysterious bonanza was part
of a load that fell off a restaurant supply truck.
December, 1984. (Marsha Traeger)

FOLLOWING PAGES
Too much snow apparently frightened away the skiers from
this stretch of Route 395 near Lake Crowley in Mono
County. *February, 1980.* (George Rose)

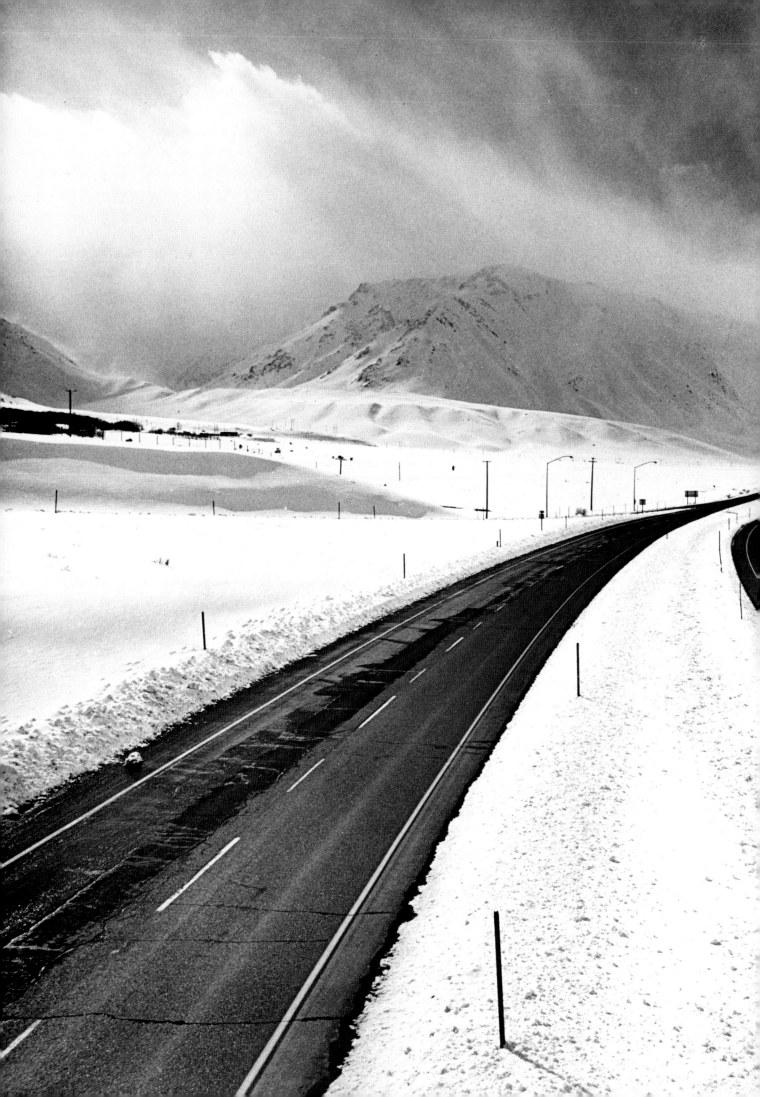

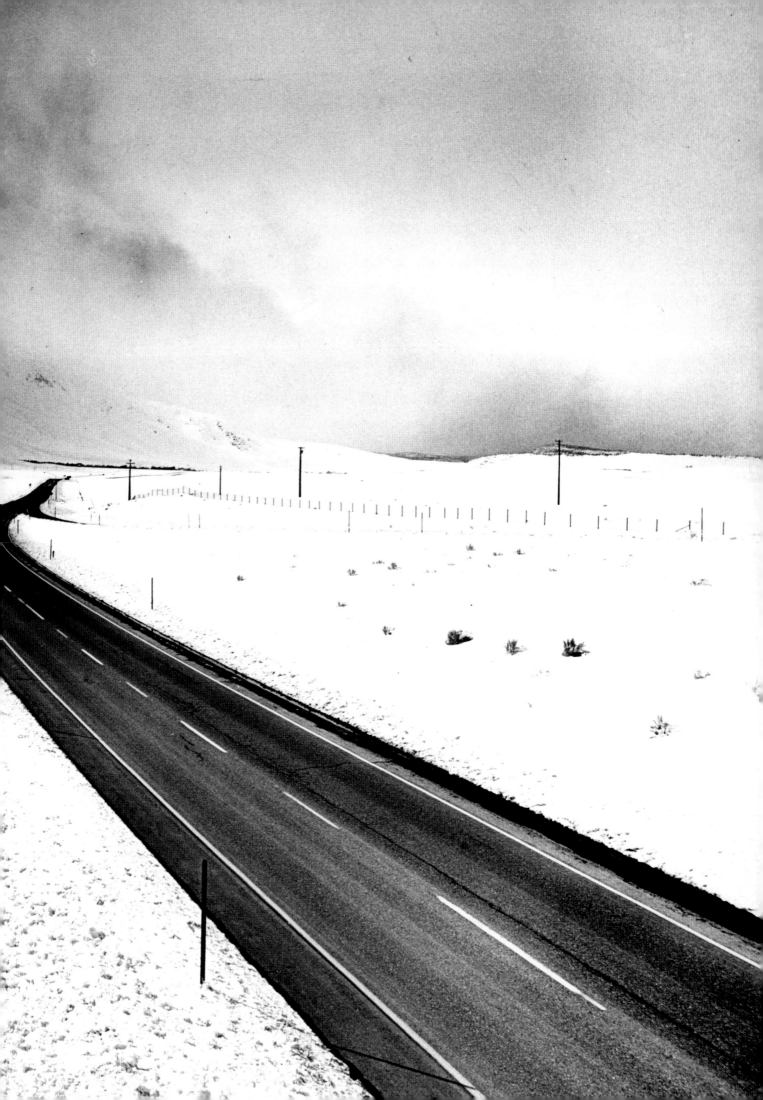

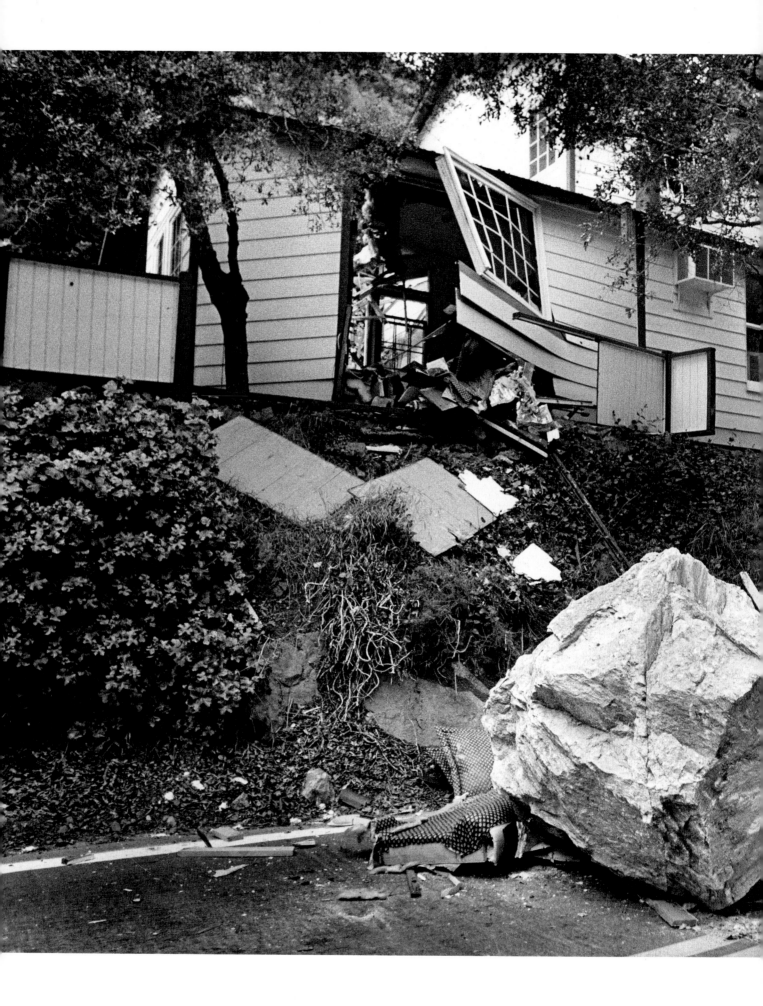

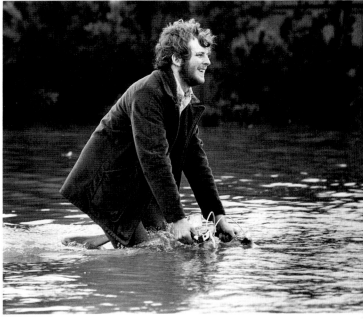

Aquacycling became a new sport for Jim Buchmiller of Costa Mesa as Orange County was hit with the worst flooding in 22 years. *March, 1983.* (Christine Cotter)

No one was home when a four-ton boulder rumbled down Silverado Canyon in Orange County and tore through this residence. *May, 1983.* (Christine Cotter)

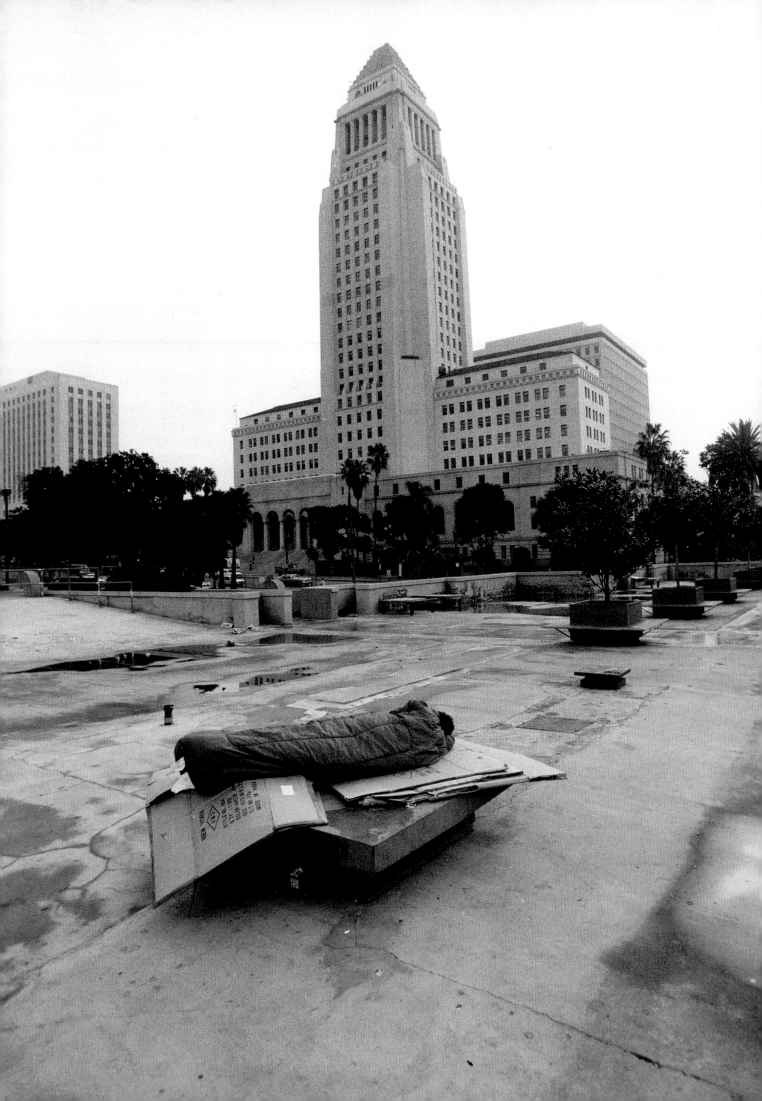

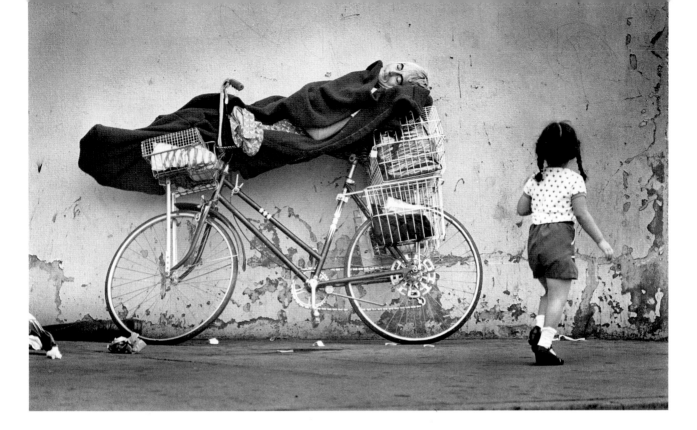

Not a circus act but a derelict woman, balanced precariously for sleep atop a bicycle parked at Ninth and Figueroa. A passing child barely takes notice. *November, 1983.* (Ken Hively)

One of the fine picture essays by *Times* staff photographers was on the homeless men and women who populate downtown Los Angeles. Ken Lubas found some of these people living in cardboard boxes they had somewhere rounded up and assembled, virtually on the doorstep of City Hall, every night. *December, 1984.*

A better life is advertised but unavailable to a homeless woman who sleeps on a downtown bus bench, her belongings stacked in boxes. *April, 1981.* (Ken Hively)

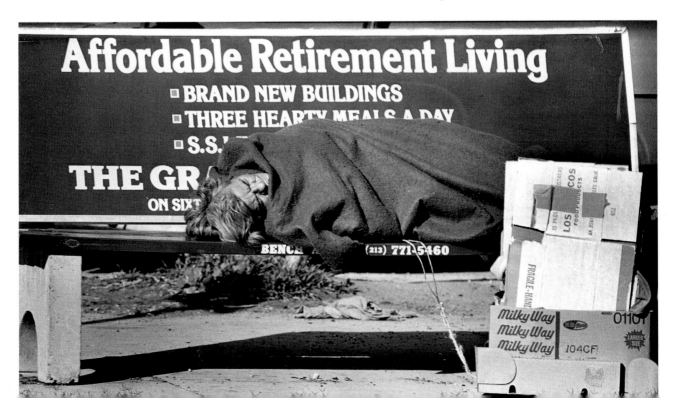

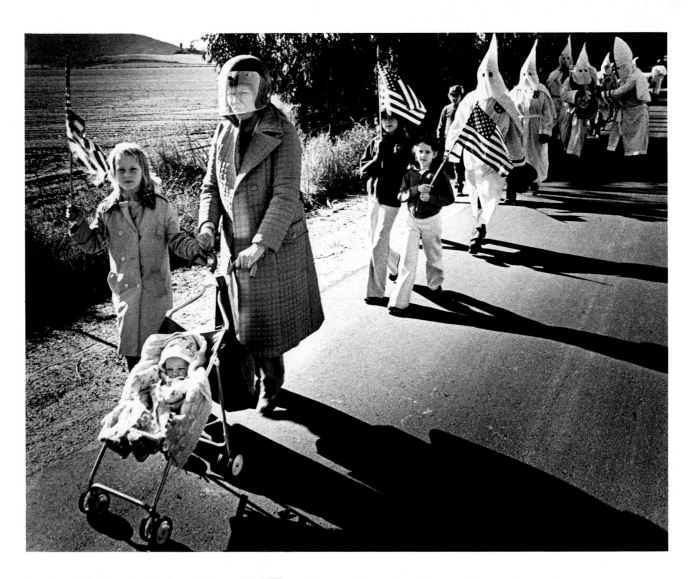

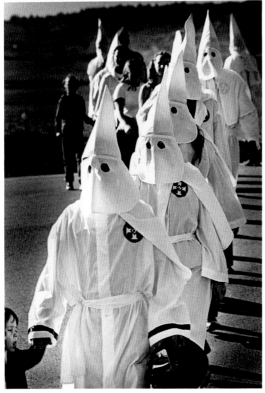

Two views of racism on the march: a riot-helmeted mother leads a parade of Ku Klux Klan members and their families to a demonstration at the San Pasqual Battlefield State Historical Park. *January, 1980.* (Dave Gatley)

At a Ku Klux Klan rally in an Oceanside park, a man was severely beaten with baseball bats and soda bottles after fighting broke out between the 30-member group and onlookers. The rally had been announced as a peaceful demonstration, but the Klan members showed up carrying shields and wearing helmets and hockey masks. *March, 1980.* (Dave Gatley)

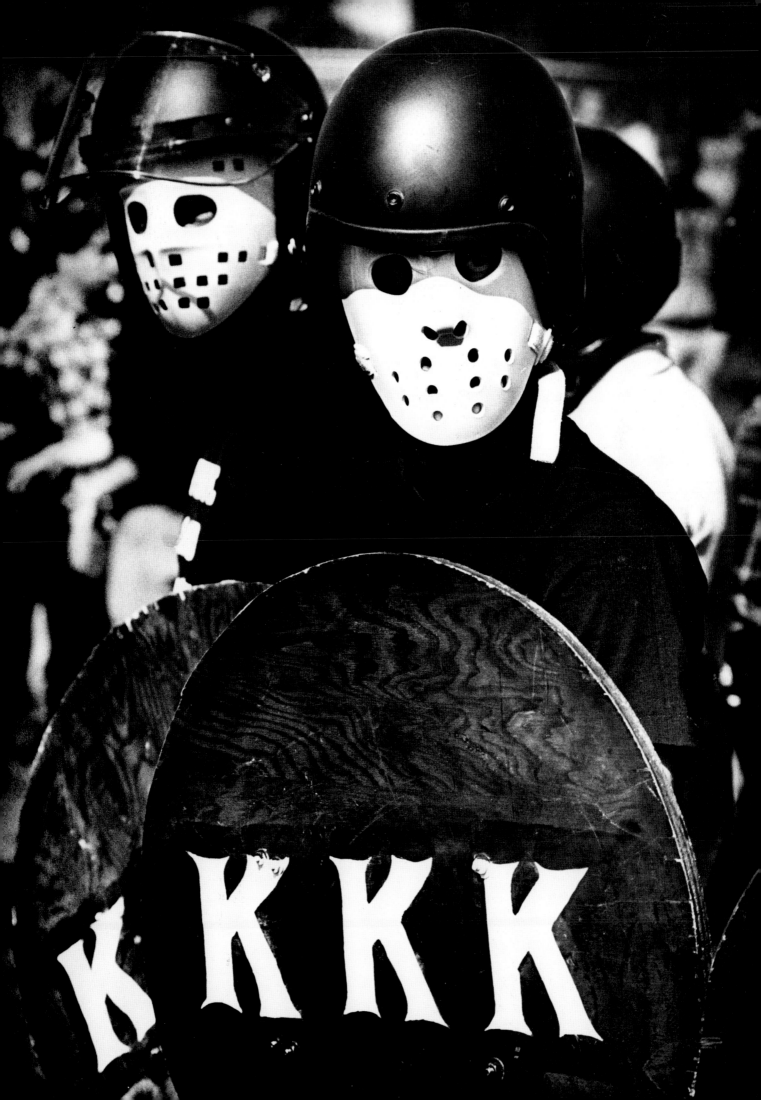

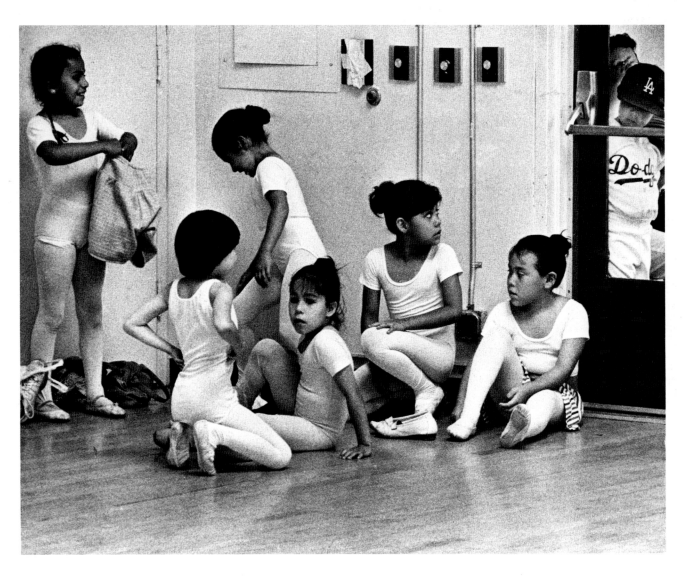

A future Dodger, five-year-old Joey Vargas peers in at his sister Jennifer, nearest the door, and other dancers as they prepare for a ballet class. *June, 1986.* (Ken Lubas)

Two former UCLA stars mix it up under the basket in an NBA game at San Diego. *November, 1983.* (Vince Compagnone)

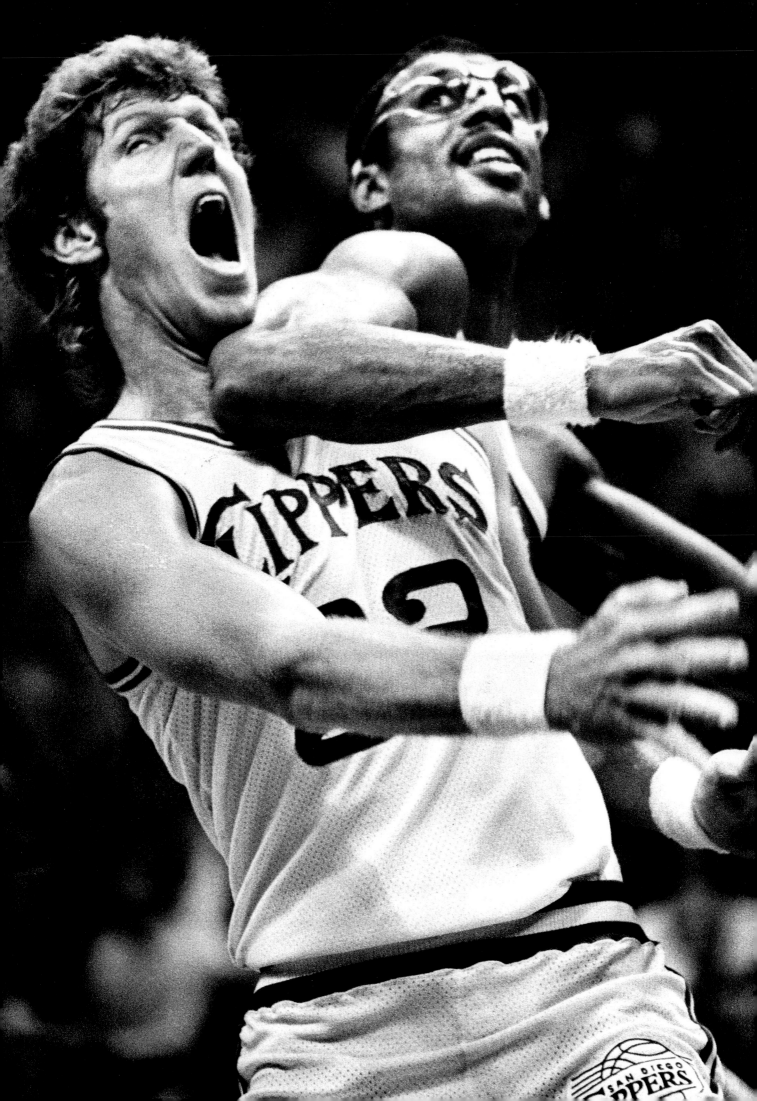

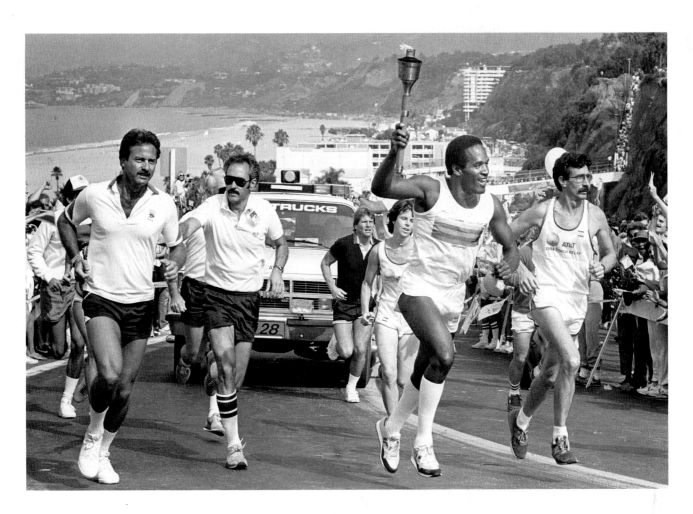

On the eighty-second day after it arrived in the United States at New York, the Olympic torch was carried up the Santa Monica incline in Los Angeles by O. J. Simpson, among the last in a long series of runners who had brought it across the continent. The Los Angeles Olympic Organizing Committee, headed by Peter V. Ueberroth, was criticized by some for charging $3,000 for each segment of the run, though the money went to charity. Criticism dimmed as the drama of the opening ceremonies approached. *July, 1984.* (Marsha Traeger)

1960 Olympic decathlon winner Rafer Johnson took the torch from Gina Hemphill, granddaughter of the great Jesse Owens, hero of the 1936 Berlin Olympics, and carried it up a steep flight of steps under the central arch of the Los Angeles Coliseum to fire the huge Olympic flare that would burn for 16 days and nights during the games. *July, 1984.* (Jayne Kamin)

OVERLEAF

A crowd of 92,655 spectators cheered the 7,800 competitors from 140 nations as President Reagan in the press box officially declared the XXIII Olympiad open. Hollywood producer David Wolper orchestrated the 200-minute-long opening ceremonies which included, in addition to the athletes, some 12,000 participants, 2,500 pigeons, 1,065 balloons and 84 baby grand pianos—a spectacle reported to cost $5 million. *July, 1984.* (Ken Hively)

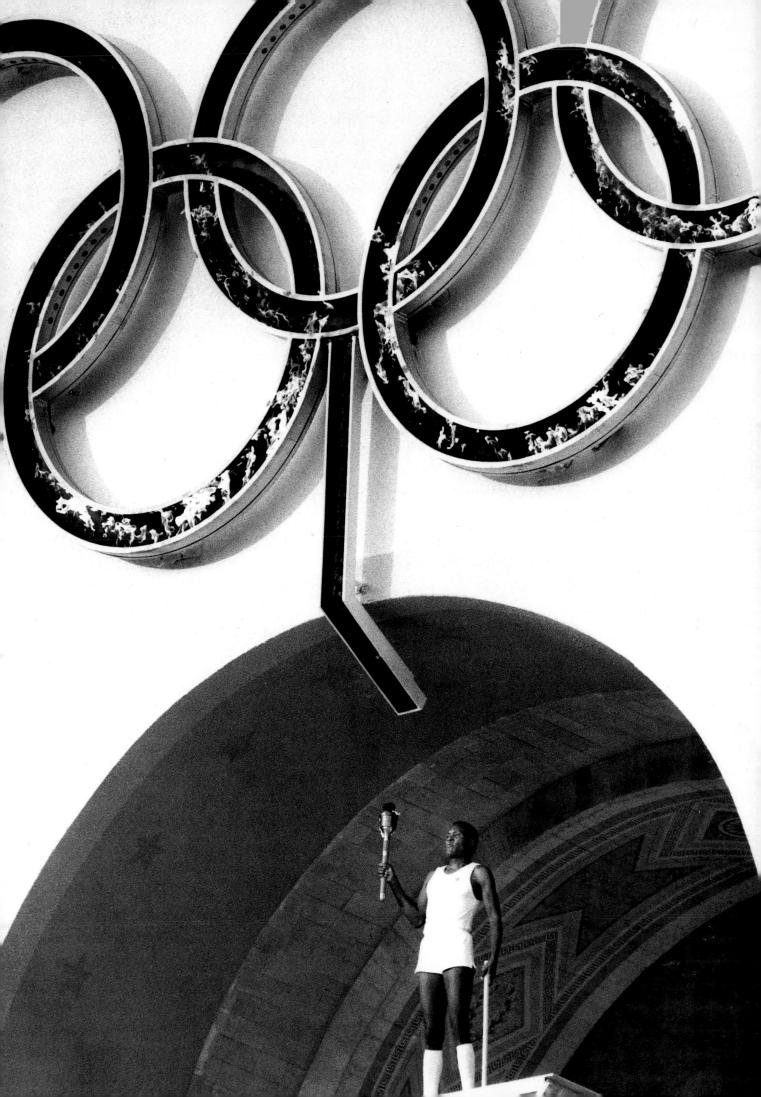

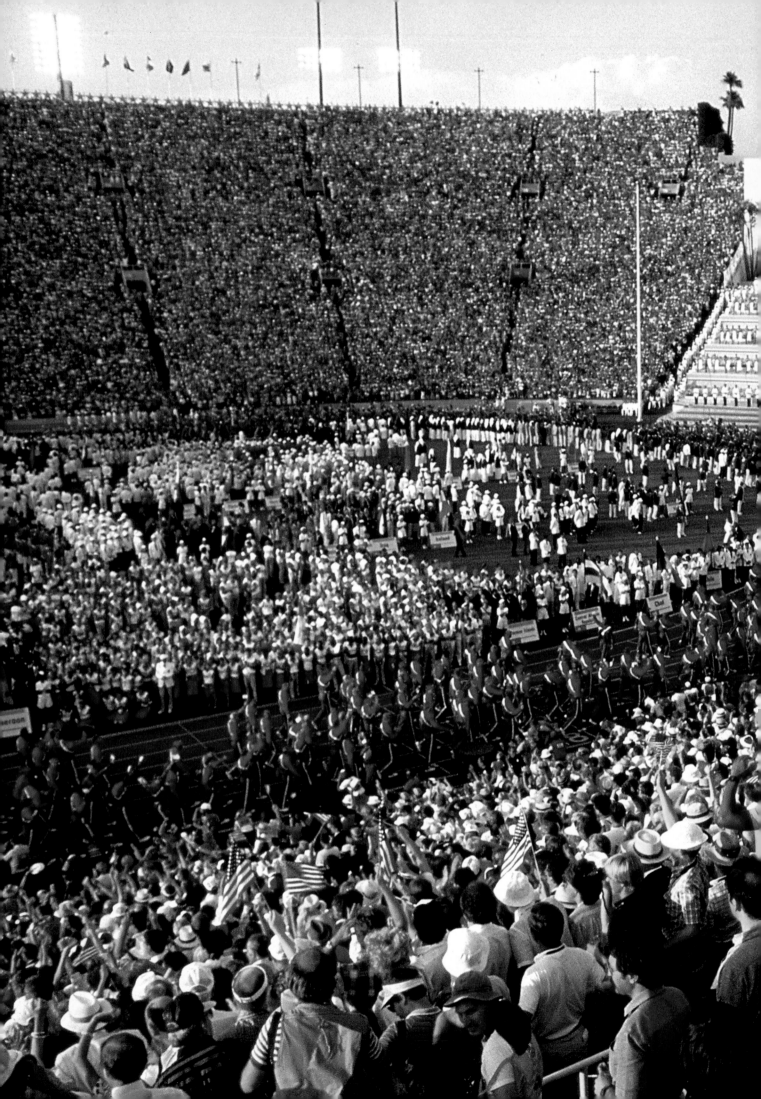

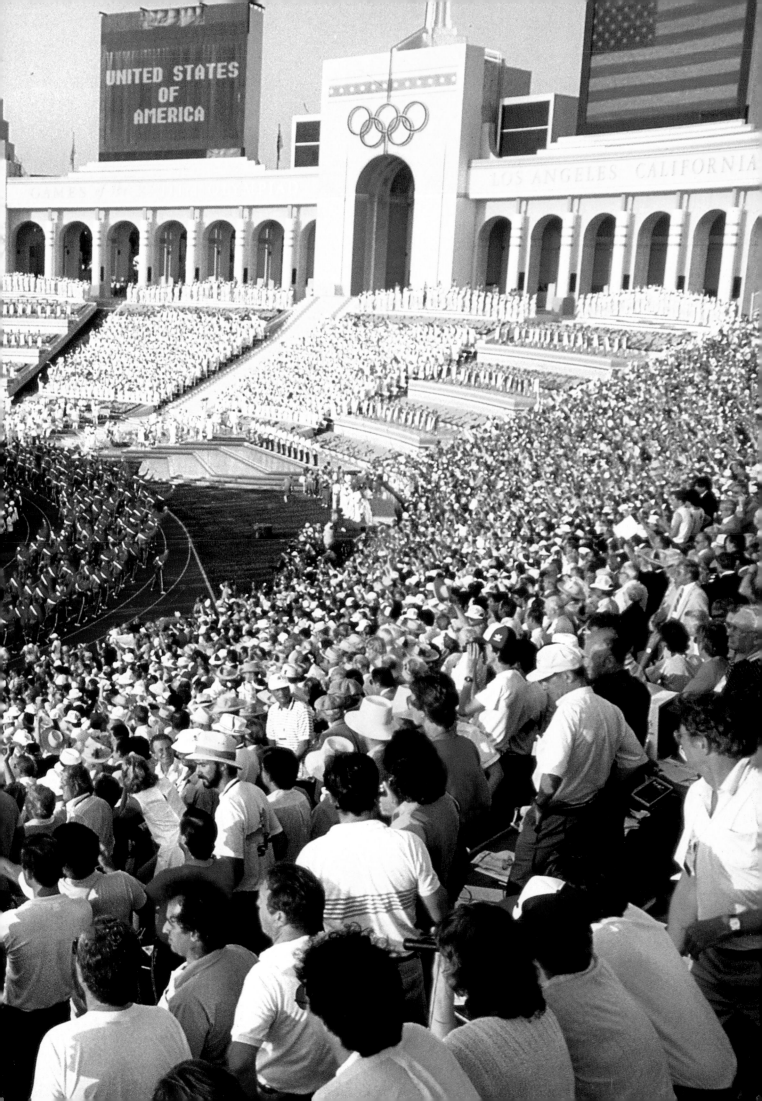

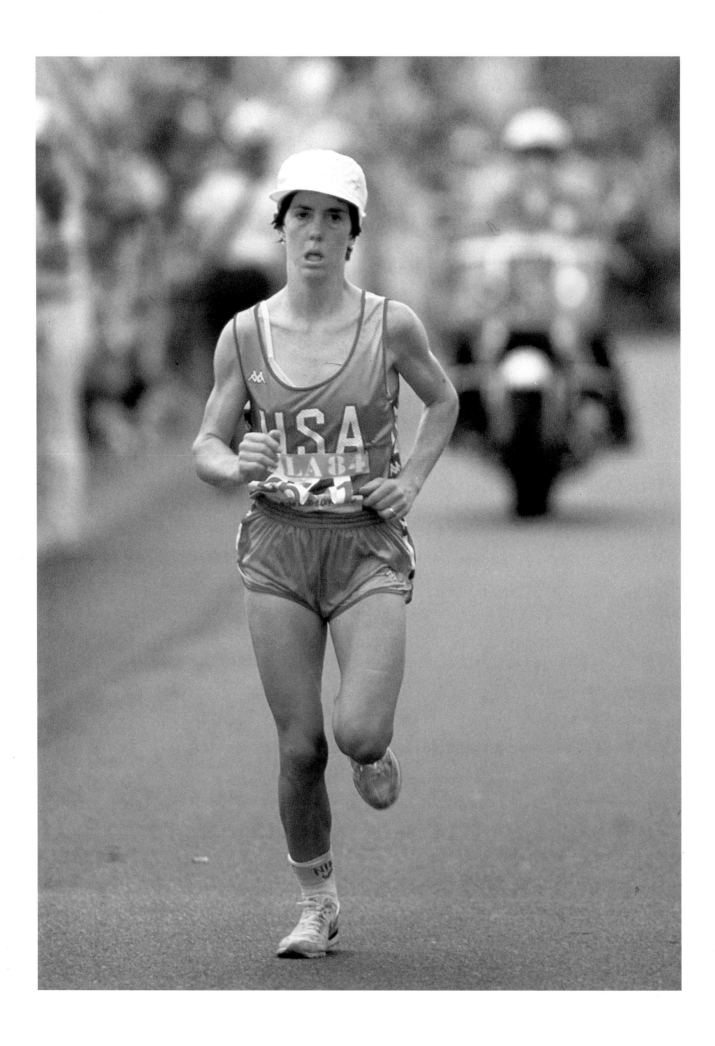

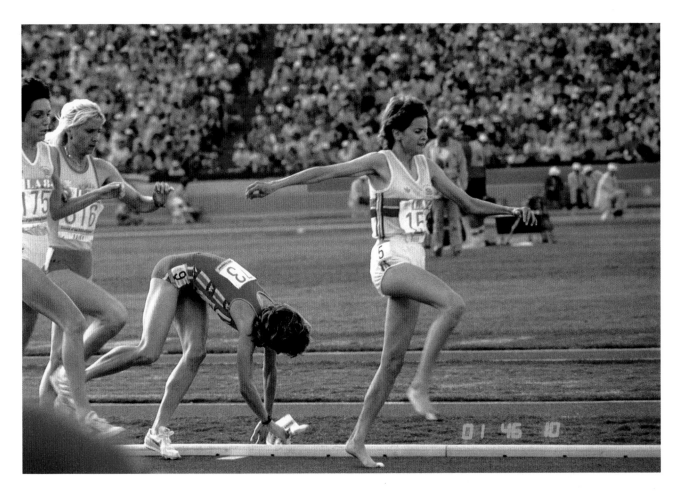

One of the heartbreaking moments in the games was the tragic trip and fall of Mary Decker in the 3,000 meters. A good bet to win, Decker was running second to England's Zola Budd (who runs barefoot) when she accidentally spiked Budd in the heel, stumbled, and fell into the infield, wracked with pain from a pulled left hip muscle. Umpires later ruled that there had been no foul. The race was won by Romania's Maricica Puica, who had the best time of the year at that distance and would have been hard to beat in any case. *August, 1984.* (Copyright 1984 Hiram Clawson/ Los Angeles Times)

Joan Benoit won the first women's marathon ever run in the Olympic games, leading the race from the third mile and beating Norway's Greta Waitz by nearly a minute and a half. Rosa Mota of Portugal was third in the field of 50 women who started the race, with 44 finishing. Long distance races for women had been banned after several runners in an 800-meter race in 1928 collapsed; the marathon of 1984 was a signal victory for equal rights in athletics. *August, 1984.* (Larry Bessell/Los Angeles Times)

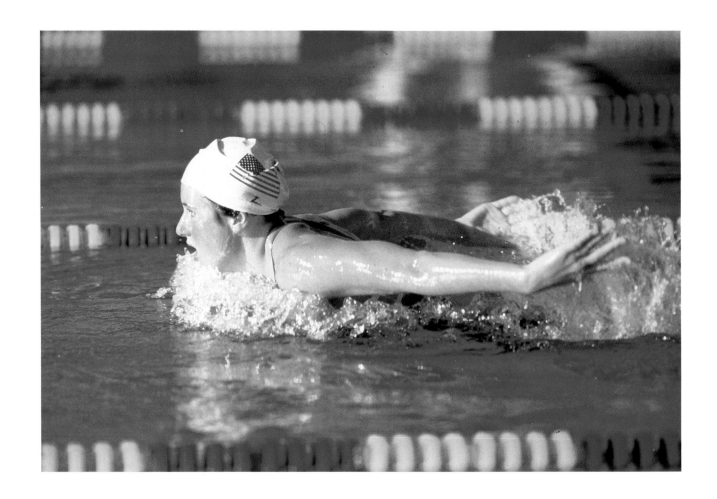

Mary T. Meagher was considered by some the Old Lady of U.S. swimming because as a 15-year-old she had been ready for the 1980 Olympic games in Moscow, at the time holding world records in both the 100- and 200-meter butterfly. Four years later, in trials for 1984, the 19-year-old had been upset in the 100, and, though she won the 200, it was well off her world record time. But the competitor in Meagher came to the fore and she won three gold medals—in the 100, 200, and women's medley relay. *July, 1984.* (Con Keyes)

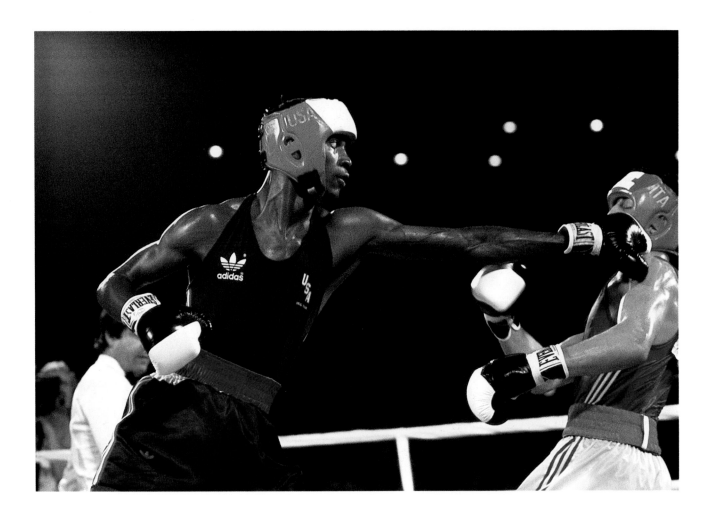

Mark Breland, the class of the world in the welterweight division, proved true to form as he made his way effectively through his division with three less than thrilling wins and three superior victories. Speculation was that even with boxers from Cuba and the Soviet Union in the competition Breland would have come out on top, bringing into the Olympics his amateur record of 104 wins against one loss. *July, 1984.* (Skeeter Hagler/Los Angeles Times)

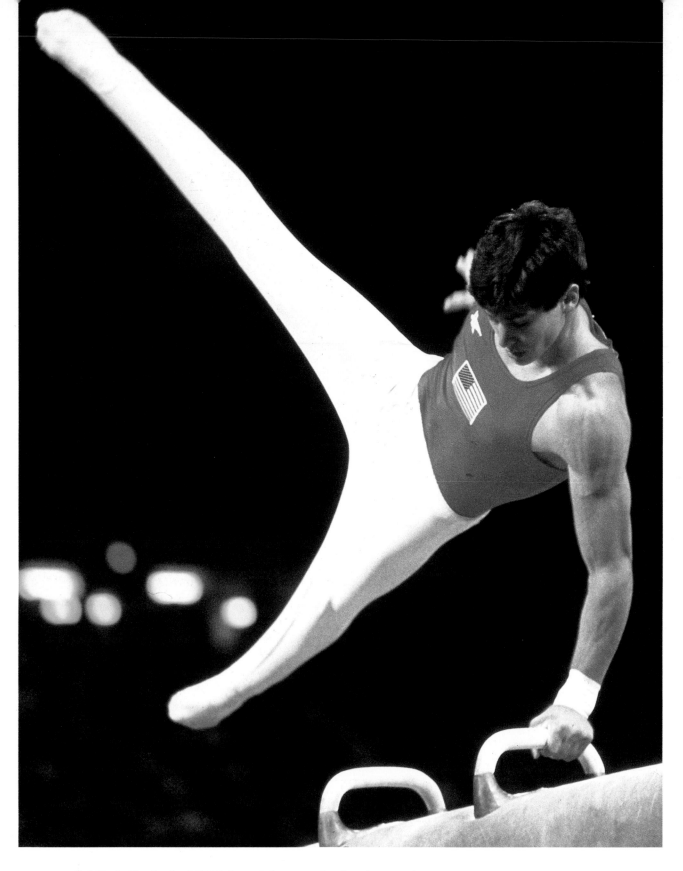

Mitch Gaylord of UCLA took bronzes in the rings and parallel bars, and a silver in the vault to help teammates Bart Conner, Tim Daggett, and Peter Vidmar win the team championships from favored China. *July, 1984.* (Gary Friedman)

Greg Louganis performs an inward 1½ somersault as he wins the 10-meter platform event, achieving a first time ever score over 700 points. Louganis also won the springboard competition, a rare double in a field of increasing specialization. *August, 1984.* (Con Keyes)

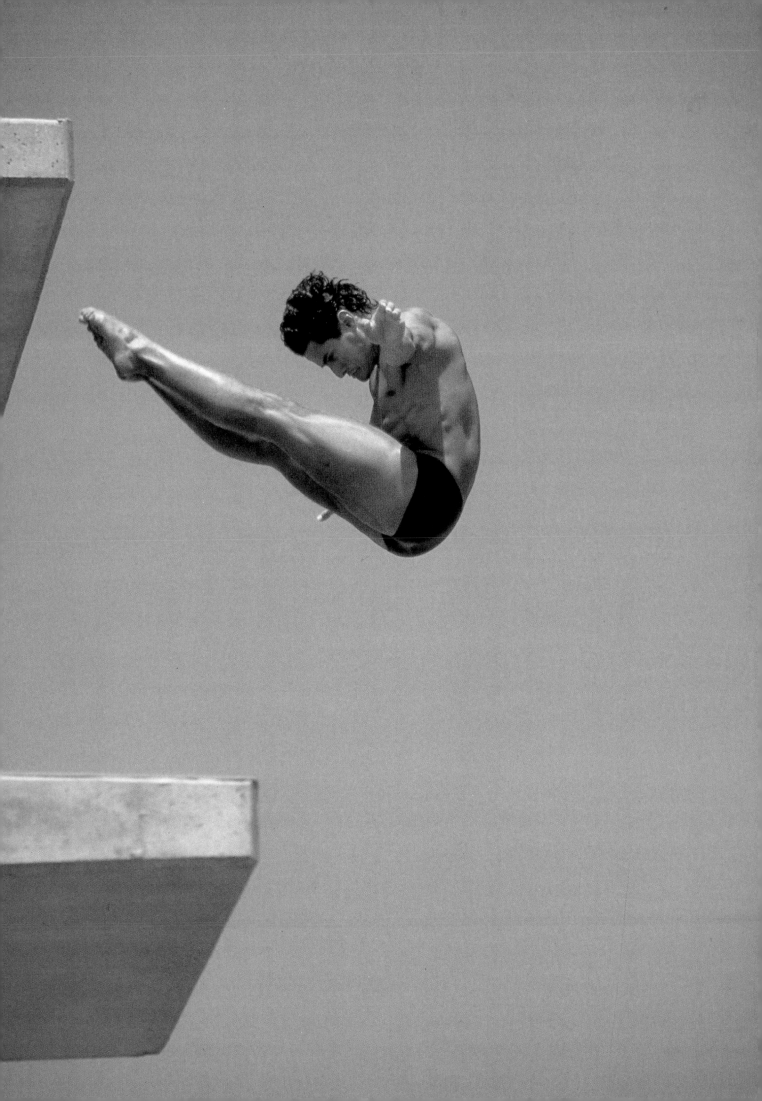

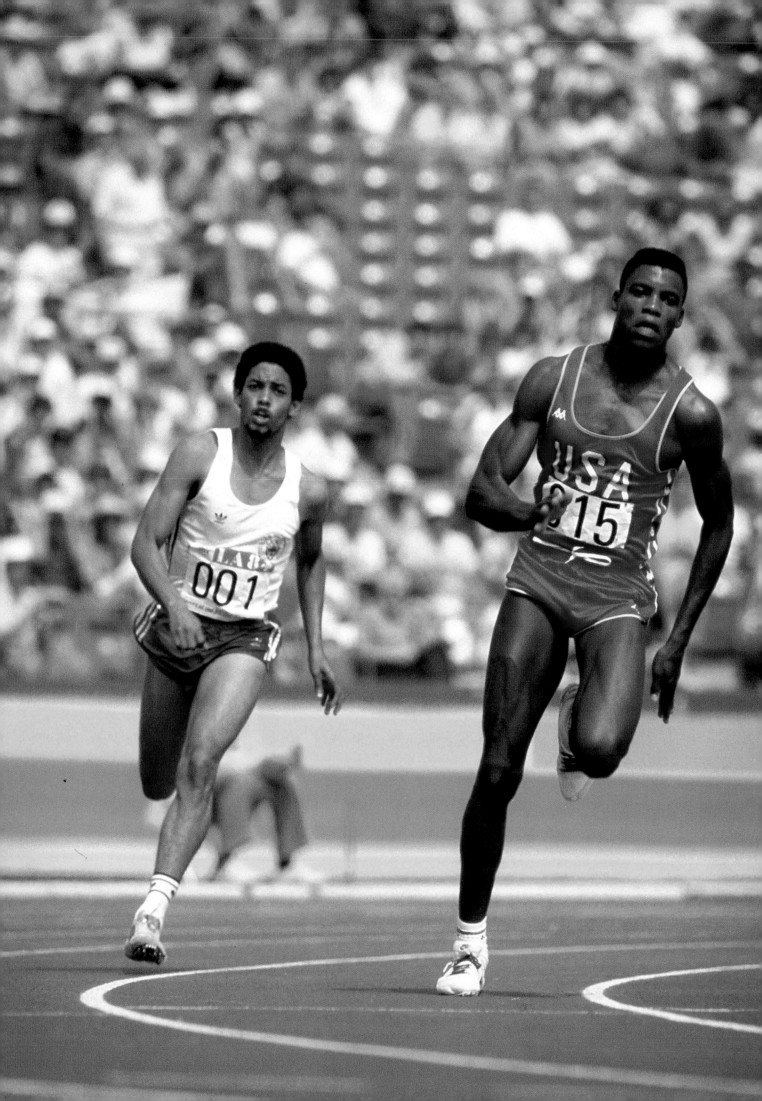

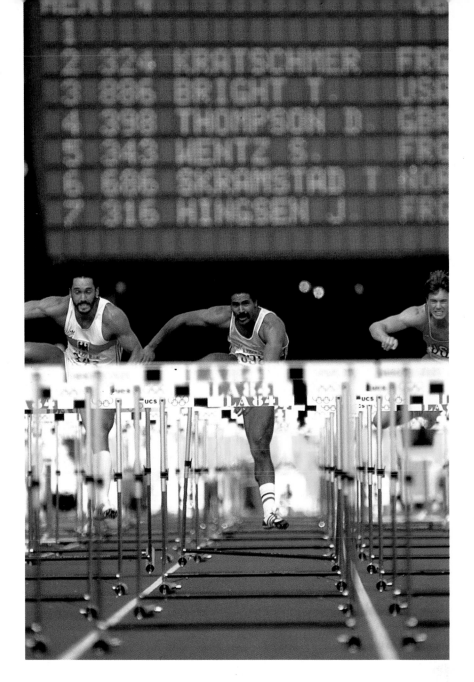

Britain's Daley Thompson matched Bob Mathias's three-decade-old record by winning a second consecutive Olympic decathlon title. Winner of every major decathlon competition since 1978, Thompson indicated after the 1984 games that he would be competing in Korea in 1988, when he would be thirty years old. *August, 1984.* (Jayne Kamin)

Carl Lewis did what was predicted of him and took gold medals in each event that he entered, setting a world record with his teammates in the 400-meter relay with a total time of 37.83 seconds, Lewis's anchor leg having been run in 8.94. In imitation of Jesse Owens, Lewis took his other medals in the 100- and 200-meter sprints, and in the long jump with a leap of 28 feet ½ inch. *August, 1984.* (Anacleto Rapping)

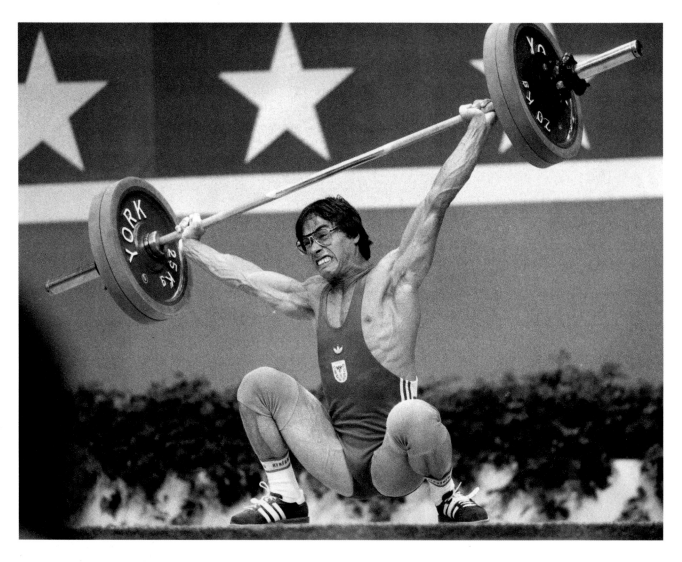

Gregor Bialowas of Austria fails in his attempt to snatch 358 pounds and puts himself out of medal range in the lightweight division, which was won by Chinese lifter Yao Jingyuan. With the absence of the world class Bulgarian and East German weightlifters, China won four gold medals and two silvers in the lighter events; the U.S. took a silver and bronze in the heavyweight classes. *August, 1984.* (Tom Kelsey)

Mary Lou Retton became the media star of the 1984 games with her chunky little body, pixie personality, and dazzling smile. Beneath the 16-year-old's bubbly charm however was a steel-ribbed determination. Retton threw two perfect 10s in the vault to edge out Romanian gymnast Ecaterina Szabo, who was leading the all-around competition, by five-hundredths of a point. *August, 1984.* (Tony Barnard)

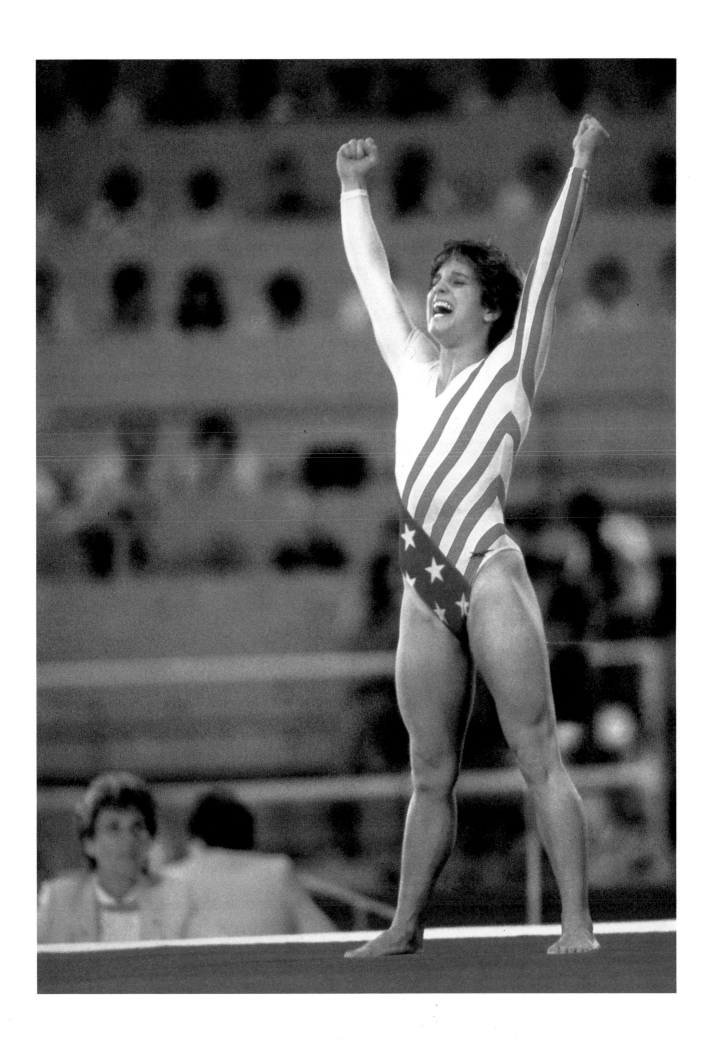

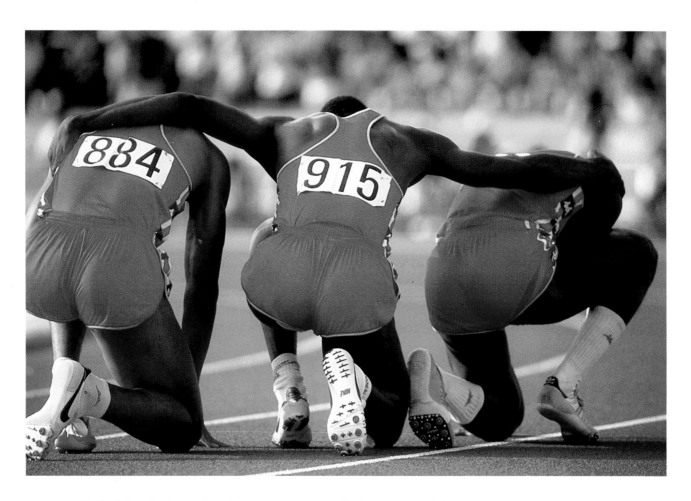

Carl Lewis *(center)* embraces teammates Kirk Baptiste *(left)* and Thomas Jefferson after the trio swept the 200 meters, the first such win in the event since 1956. Lewis's time of 19.80 seconds broke Tommie Smith's 1968 Olympic record. *August, 1984.* (Jayne Kamin)

Connie Carpenter-Phinney *(center)* and Rebecca Twigg *(left)* finished first and second in the 49 mile road race for women, the first women's event in Olympic cycling and the first American win in the sport since 1912. The men made up for lost time with three individual golds, two silvers, a bronze, and two team medals. *July, 1984.* (Jayne Kamin)

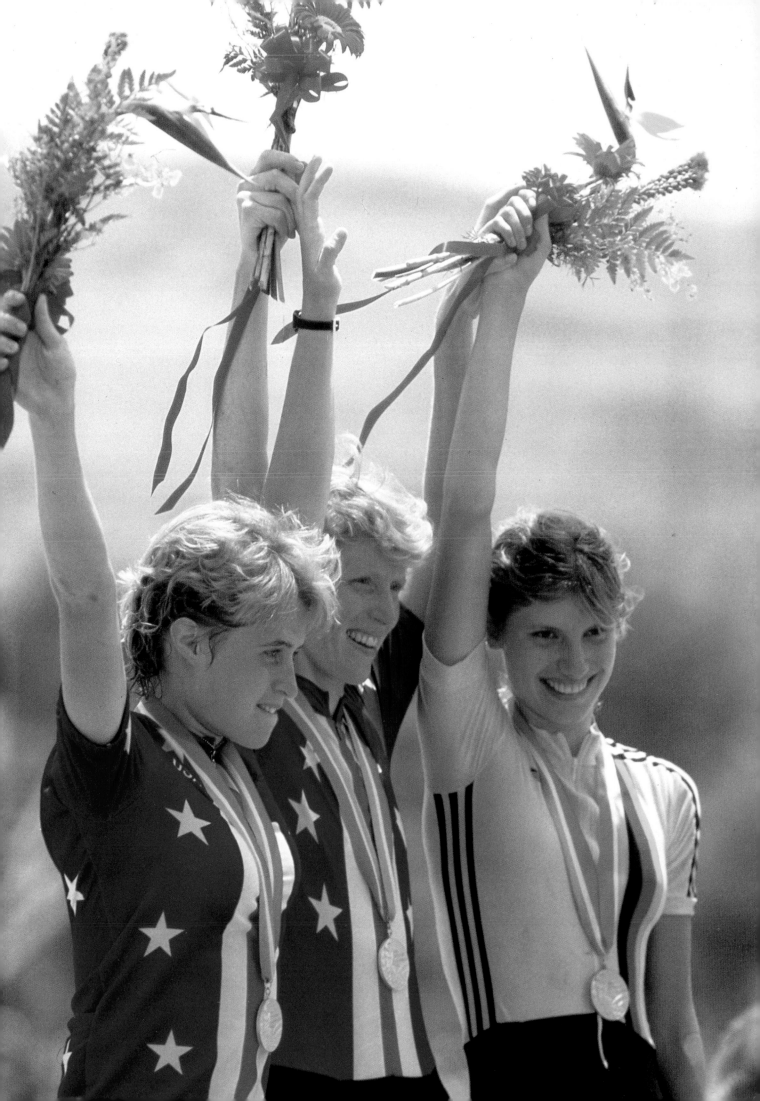

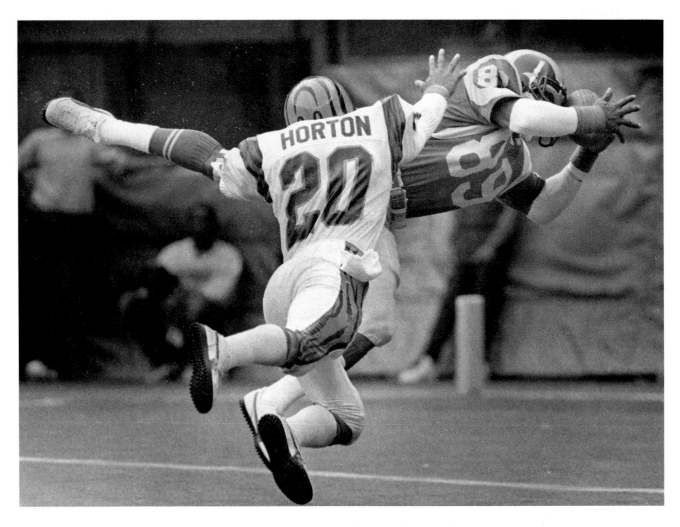

Ram receiver Ron Brown makes a leaping touchdown catch of a Jeff Kemp 52-yard pass to beat the Bengals 24–14. *September, 1984.* (Christine Cotter)

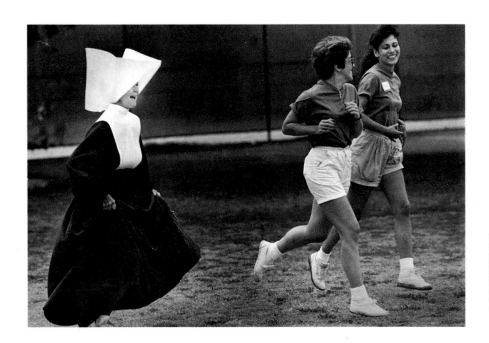

Hampered by her habit, a nun races to catch up with jogging sisters. *September, 1986.* (Ellen Jaskol)

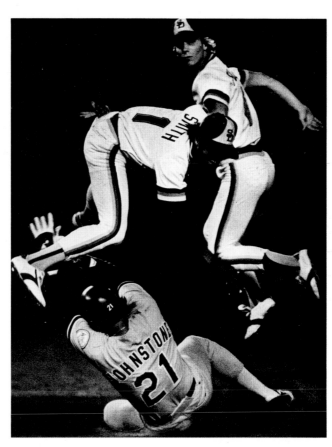

Ozzie Smith, in his last Padre season, goes airborne to turn the double play. *1981*. (John McDonough)

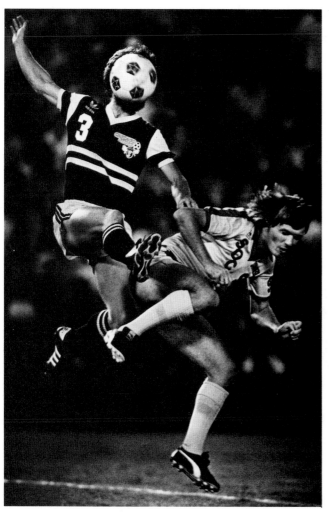

A Chicago Sting player uses his head in a game against the San Diego Sockers. *1981*. (John McDonough)

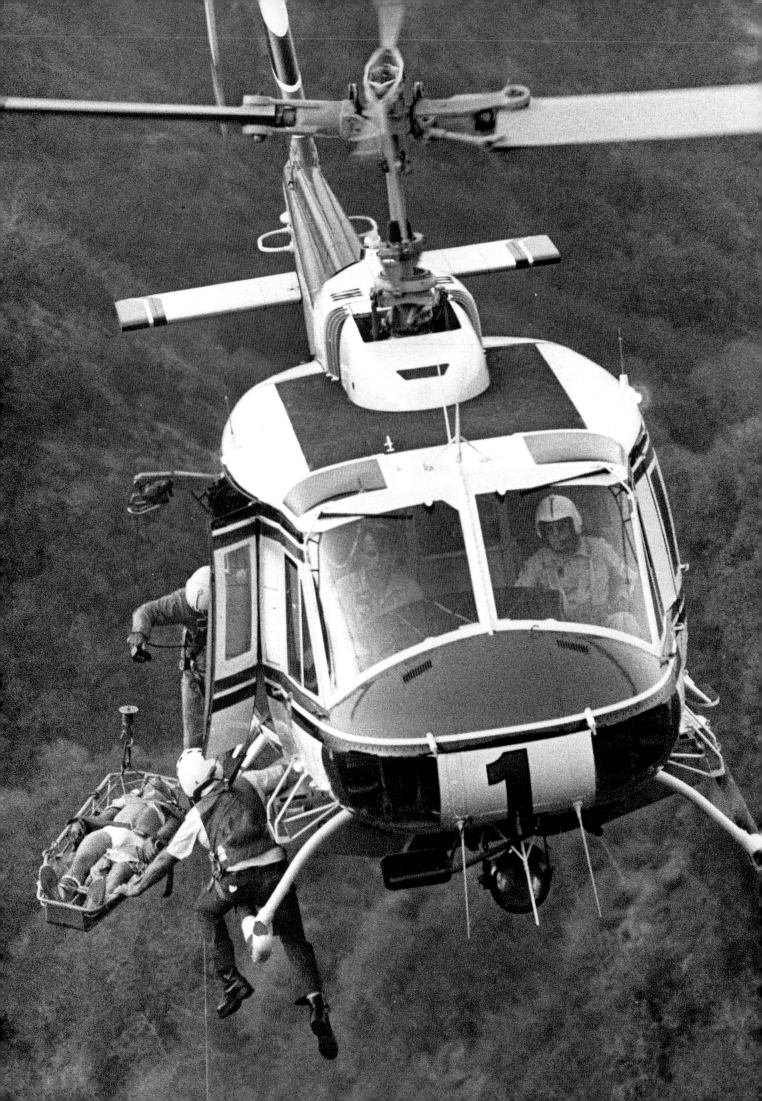

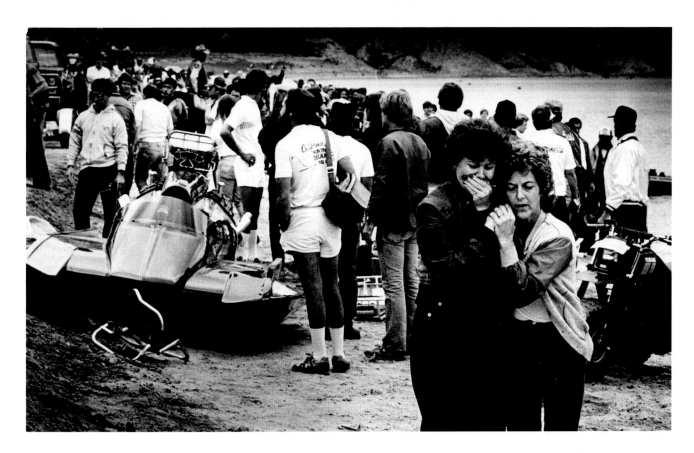

No rescue was possible when a drag boat on Irvine Lake went out of control and ran ashore, killing a nine-year-old Burbank girl and injuring two other persons. Racing on the lake was permanently suspended. *1985*. (Thomas Kelsey)

A Los Angeles Fire Department helicopter airlifts a man injured when a jeep in which he was riding ran off Mulholland Drive above the Encino Reservoir. *October, 1984*. (Joe Vitti)

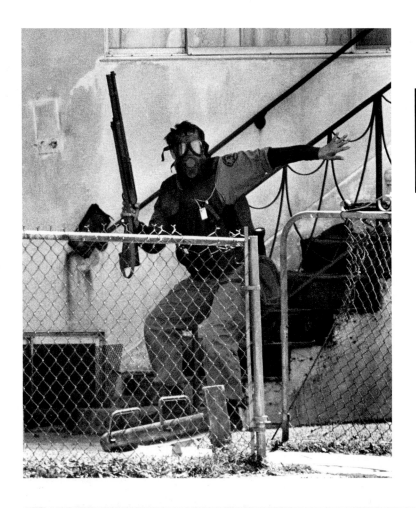

An **LAPD SWAT** team member motions others away from a house under siege and occupied by a heavily armed and dangerous fugitive. *April, 1984.* (Lori Shepler)

Without apparent explanation or cause, a man was shot to death at a roadside stand in El Salvador where similar mysterious killings have taken place. *April, 1981.* (Bob Chamberlin)

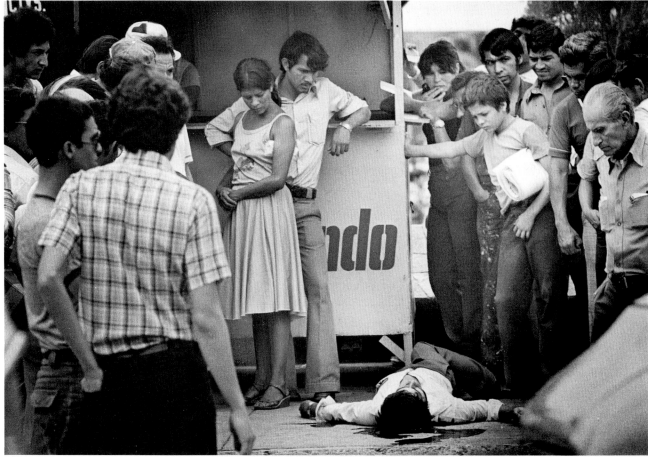

Not a holdup but a hoax, this threatening scene was observed by photographer Dave Gatley, who radioed Chula Vista police and kept the car under observation for six miles until it was pulled over by officers. The two occupants, men in their twenties, had apparently only been fooling around with a plastic gun; no charges were filed. *December, 1985.*

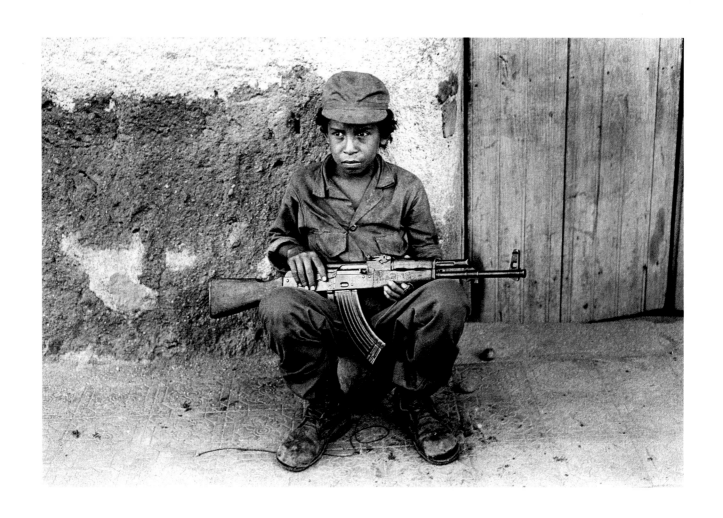

In Nicaragua, a Sandinista militiaman, age 15, stands guard duty. *September, 1985.* (Iris Schneider)

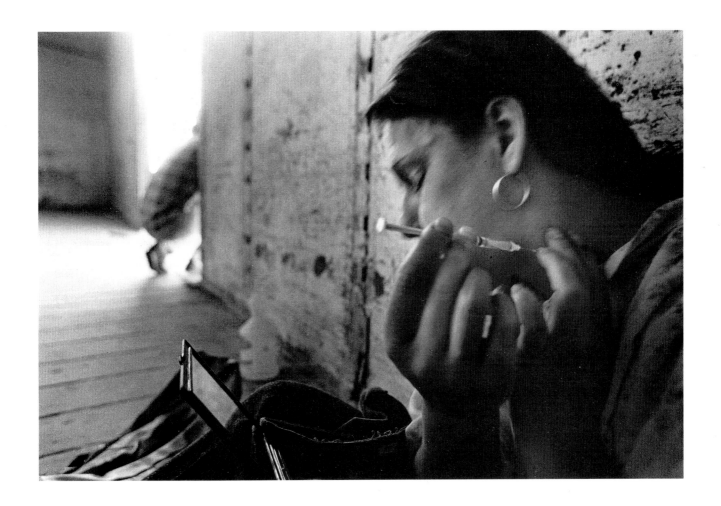

Hiding in a railroad boxcar at Calexico, a girl injects herself with heroin as a companion guards the door. The extensive use of drugs in Imperial County was said to be due in part to the proximity of Mexico, poverty, unemployment, and the oppressive summer heat. *January, 1986.* (Don Bartletti)

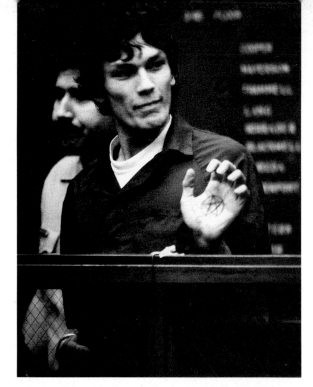

Richard Ramirez, the suspected Nightstalker murderer, displays a satanic cult symbol on his palm as he is led from court. *October, 1985.* (Tony Barnard)

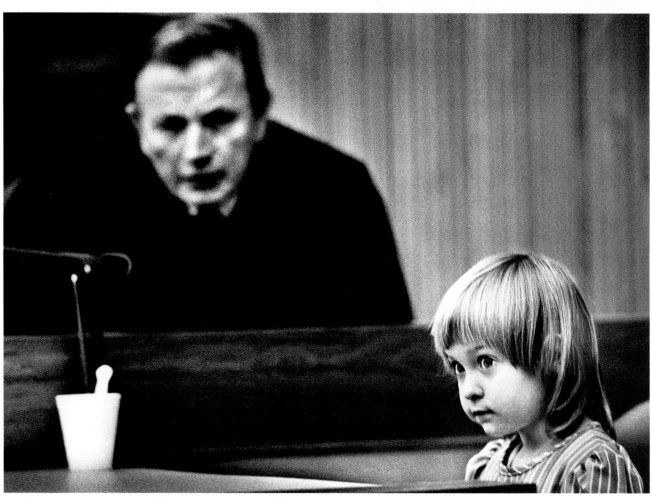

Three-year-old Amanda Conklin looks out at a crowded Van Nuys courtroom as Judge Melvin B. Grover questions her in a case in which her father was accused of murdering her mother. *January, 1985.* (Al Seib)

A tiny refugee from fear peers out the door of a secret shelter set up for battered women and their children. *1982.* (Kari Rene Hall)

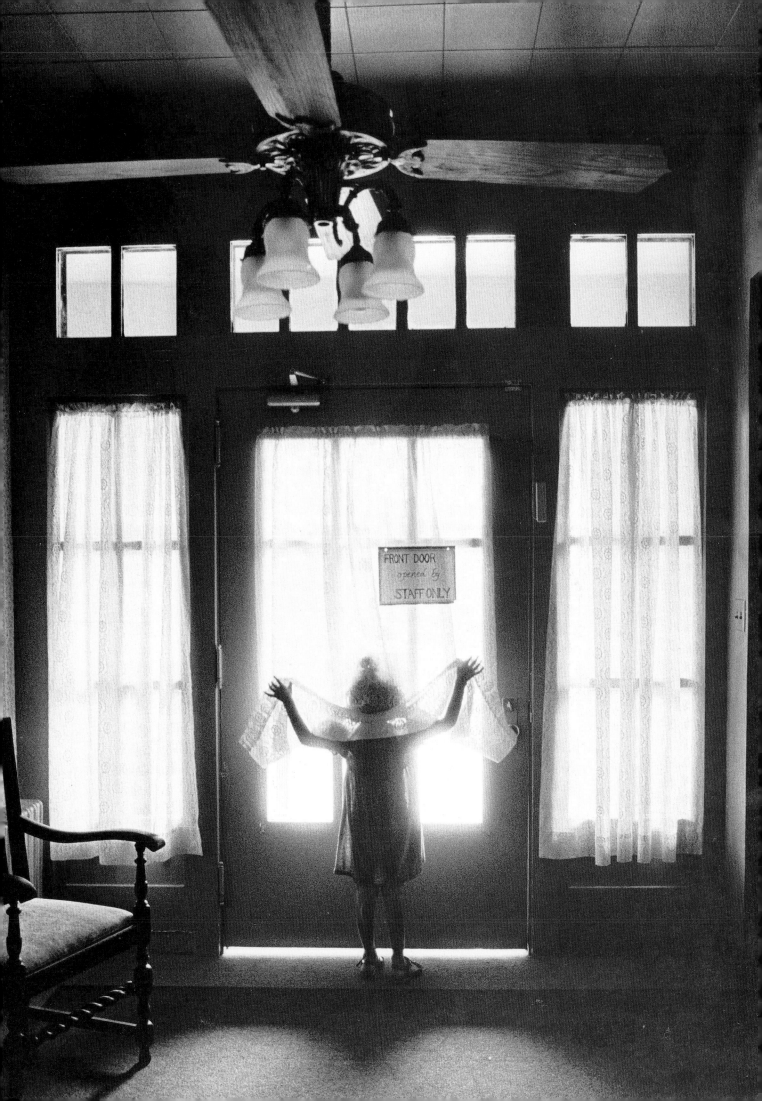

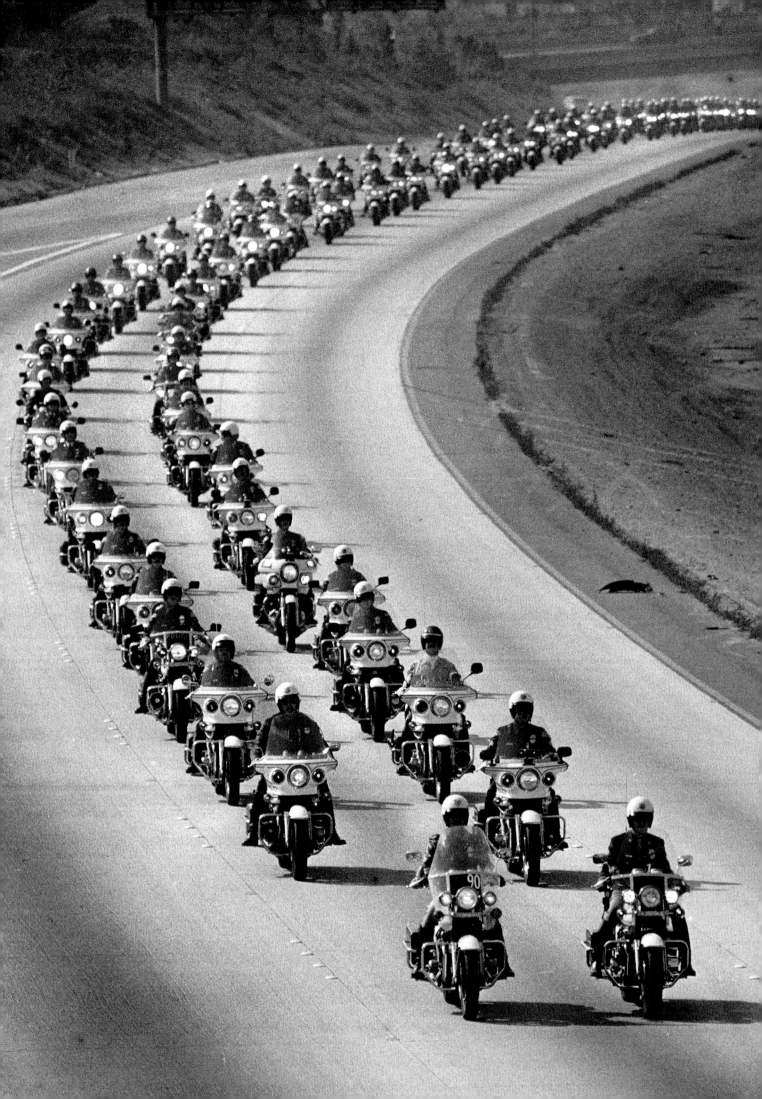

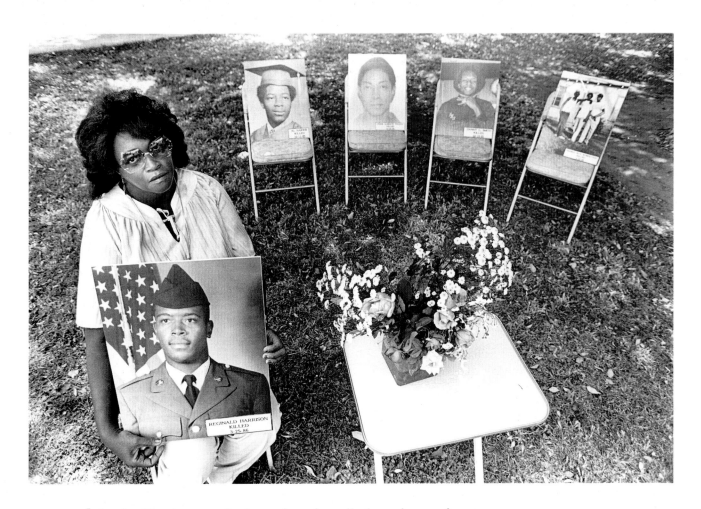

Lenita Harrison, an Inglewood mother, displays photos of
her son Reginald, who was shot to death by police. She
participated in a rally sponsored by the Equal Rights
Congress, a Chicago-based group, which protested that
seven unarmed men had been killed by police gunfire in the
previous year. *June, 1986.* (Iris Schneider)

A grim procession down the 118 Freeway
marks the funeral of a police officer killed in
the line of duty. *November, 1985.* (Joe Vitti)

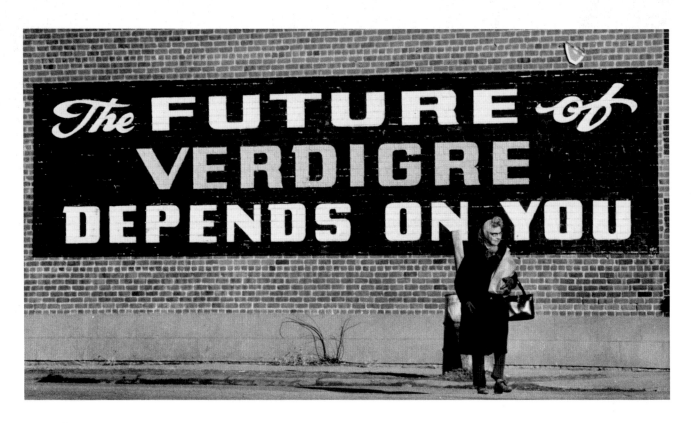

From a wide-ranging story on America's troubled farmlands comes this haunting picture made in a small town in northeast Nebraska. *February, 1985.* (Jose Galvez)

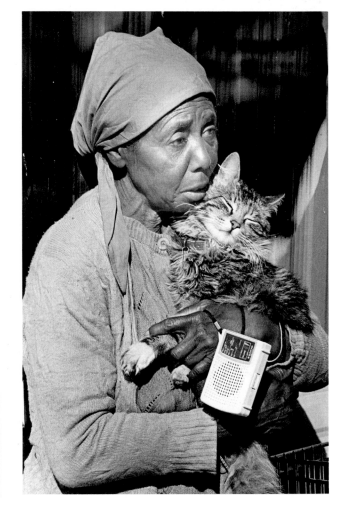

Ellen Oliver, 61, with her cat Pam, will look for a home on the streets after having been evicted by police from her "home" in Justiceville, where she had lived for six months with the cat and three dogs. *May, 1985.* (Ken Lubas)

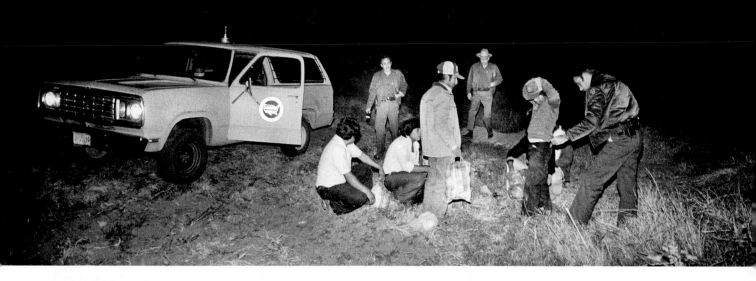

Spotted by infrared telescopes from a helicopter, a group of illegal aliens is apprehended in the predawn by Border Patrol officers in a field on the U.S. side of the Tijuana River. *November, 1981.* (Barbara S. Martin)

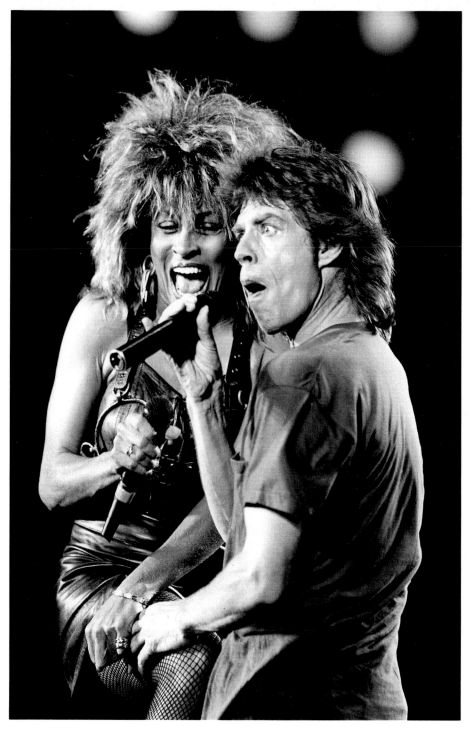

Tina Turner and Mick Jagger perform at JFK Stadium in Philadelphia to raise money for famine relief in Africa. *July, 1985.* (Don Bartletti)

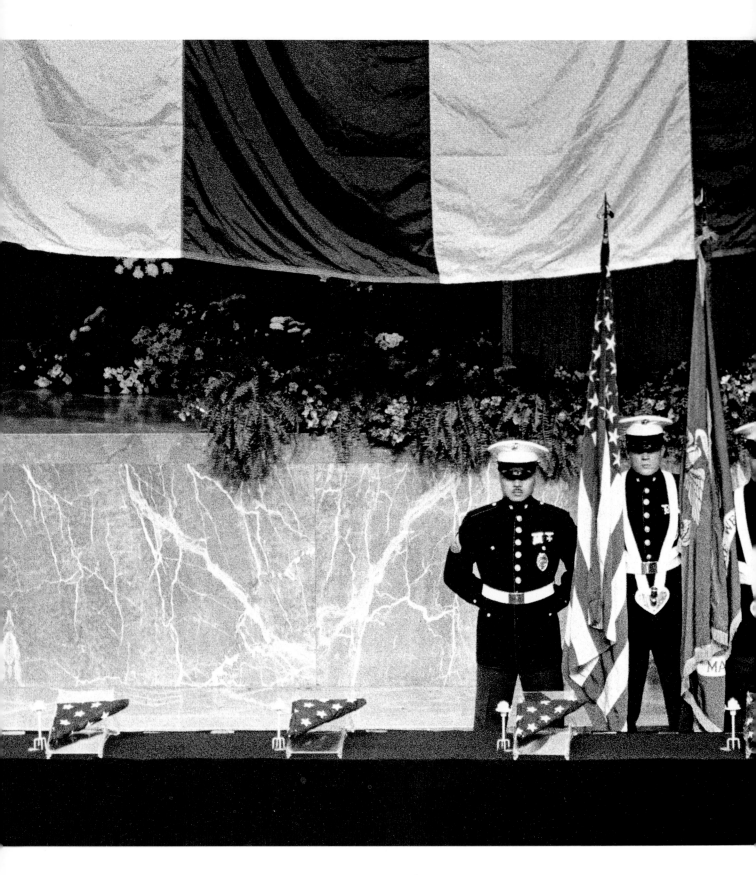

A Marine Corps honor guard at Crystal Cathedral services stands over folded flags in memory of the seven astronauts who died in the space shuttle *Challenger. February, 1986.* (Gail Fisher)

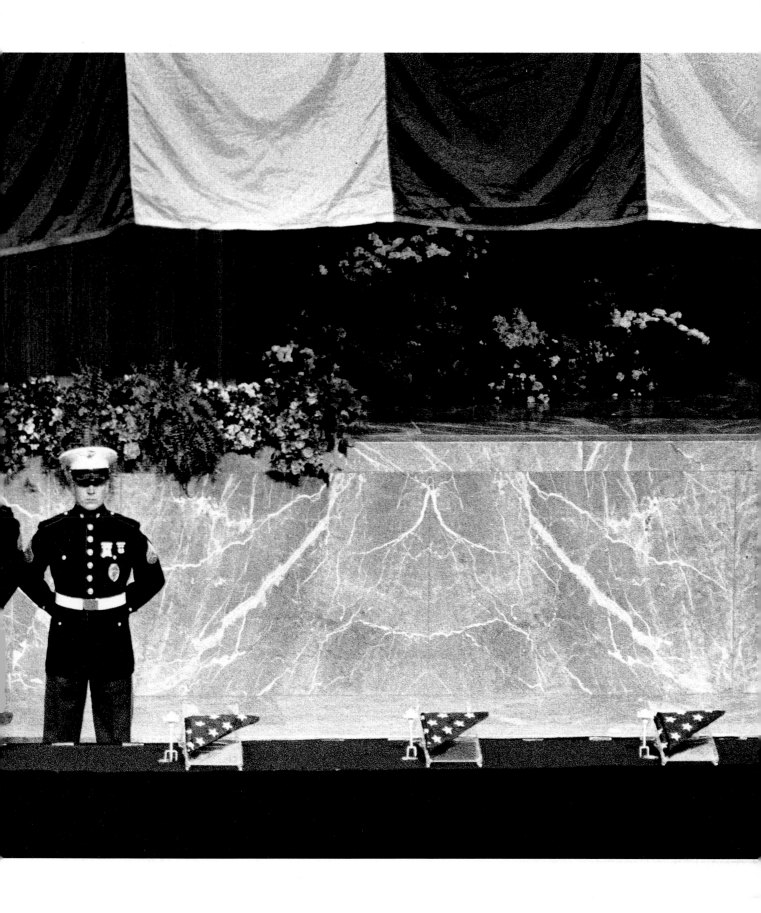

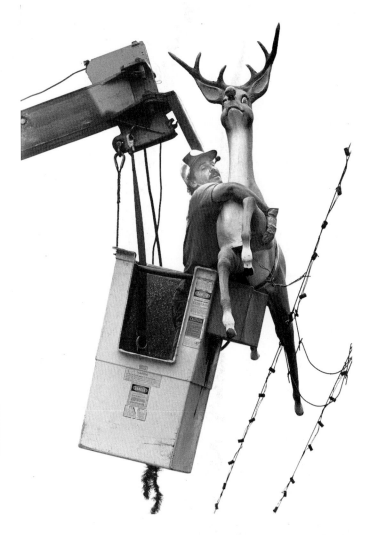

Rudolph takes a ride to his temporary home on a Christmas display at San Diego's Balboa Park. *November, 1982.* (Vince Campagnone)

Buffaloed by two strange men with numbers on their fronts, a bison hightails it across the path of the Catalina Marathon. *March, 1981.* (Kari Rene Hall)

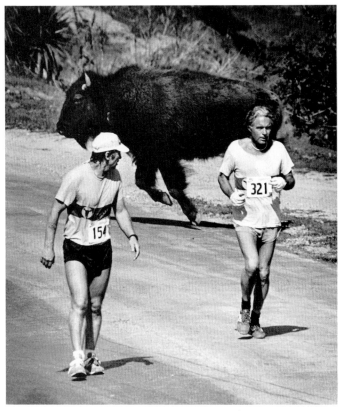

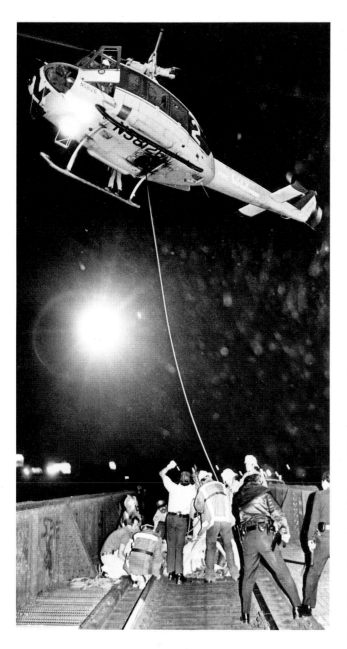

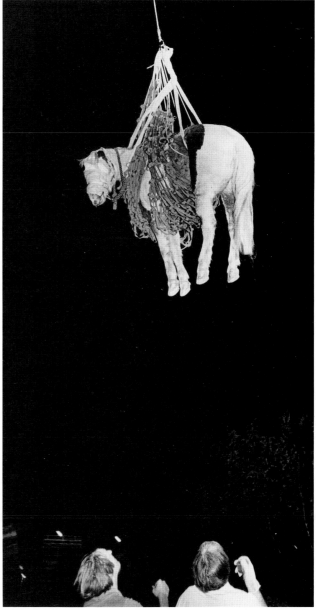

Heigh-ho, Silver is the cry as an LAFD helicopter rescues a horse from a railway overpass. *1984.* (Mike Meadows)

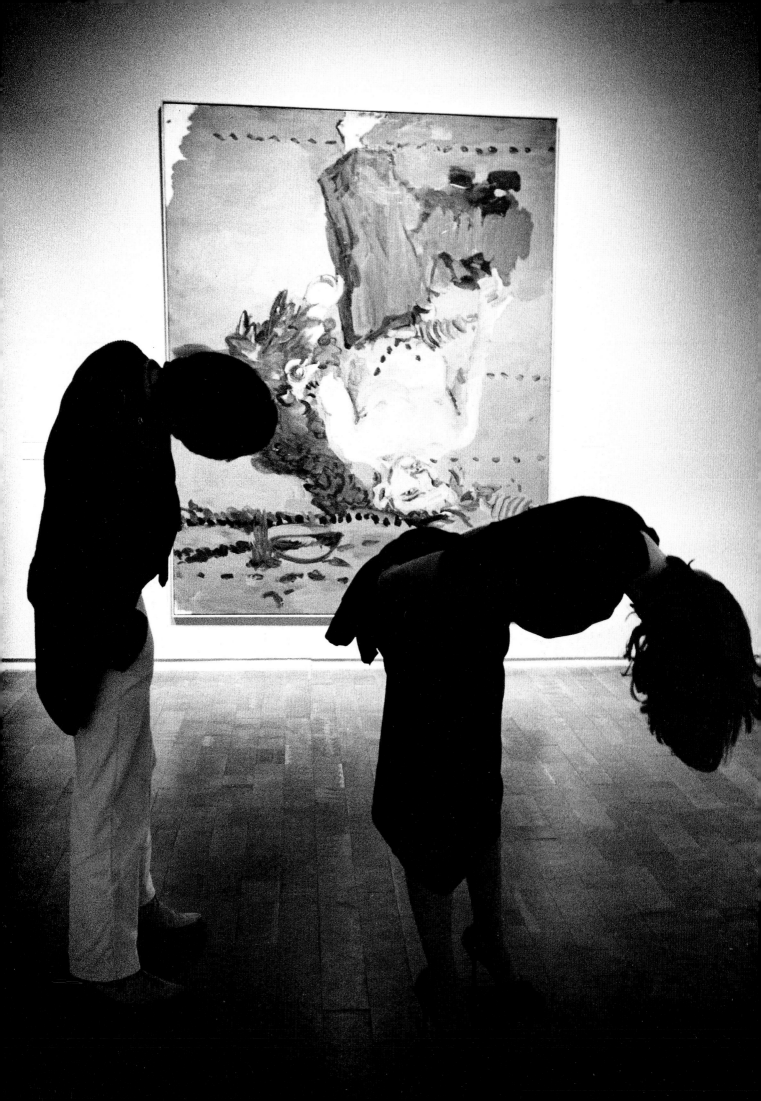

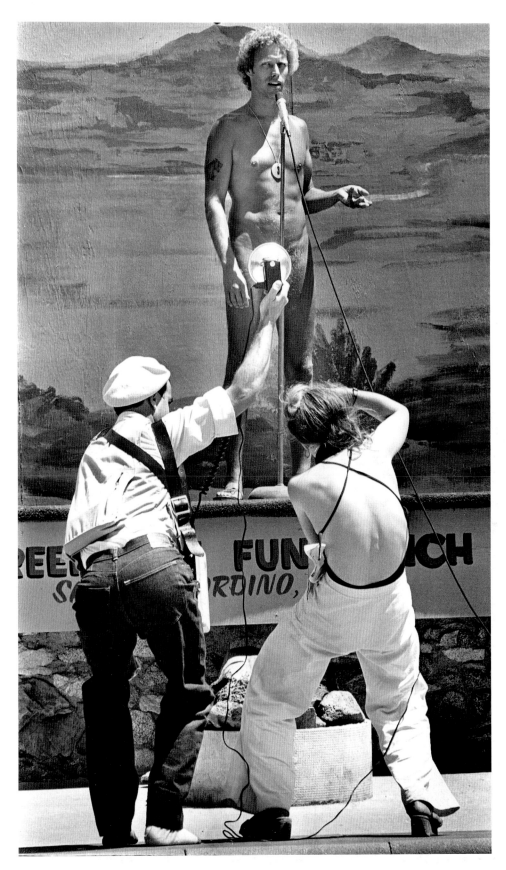

Jerry Kinley leaves no doubt about which end is up as he competes for the Mr. Nude International–U.S.A. title. *July, 1980.* (Ken Hively)

Which end is up puzzles viewers of a painting by Georg Baselitz at the Newport Harbor Art Museum. The artist paints subjects upside down to concentrate on form rather than content. *September, 1984.* (Kari Rene Hall)

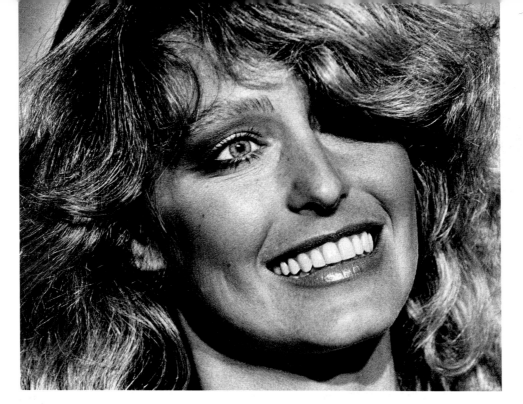

Stars at the Academy Awards in April, 1979,
included Farrah Fawcett. (George Rose)

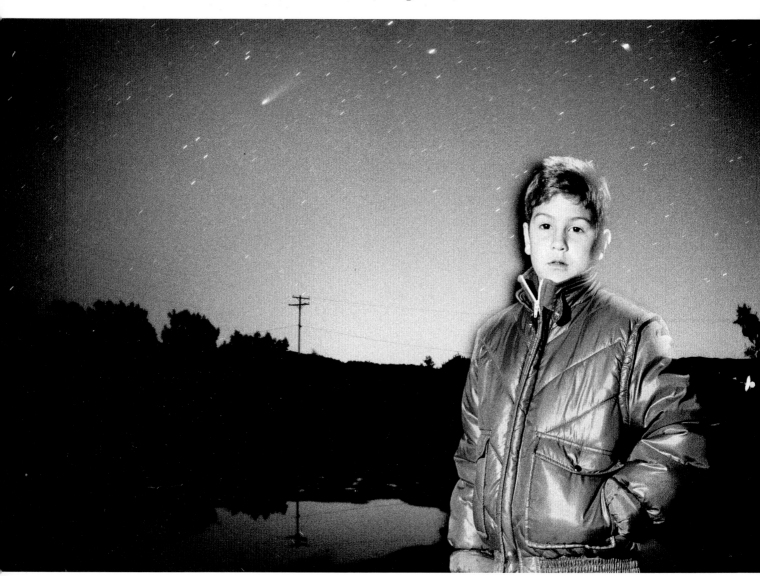

Stars at night surrounded Halley's Comet, which nine-year-
old Jay Bartletti of Vista got up at 4:00 A.M. to view.
March, 1986. (Don Bartletti)

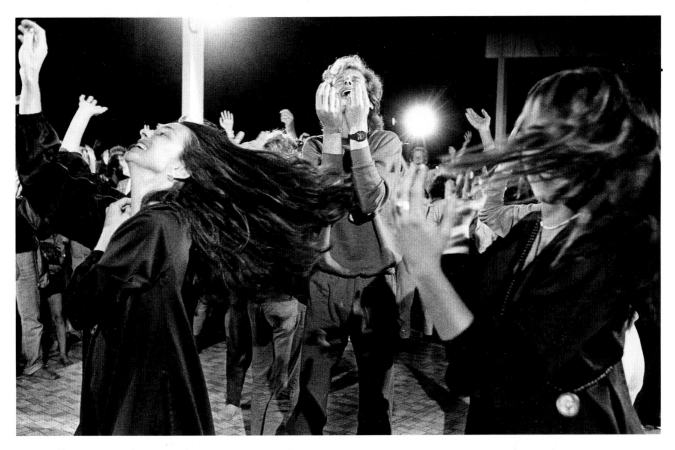

Energy accumulates as followers of the Bhagwan Shree Rajneesh celebrate Sannyasin at Darshan in singing and dancing. *July, 1983.* (Marsha Traeger)

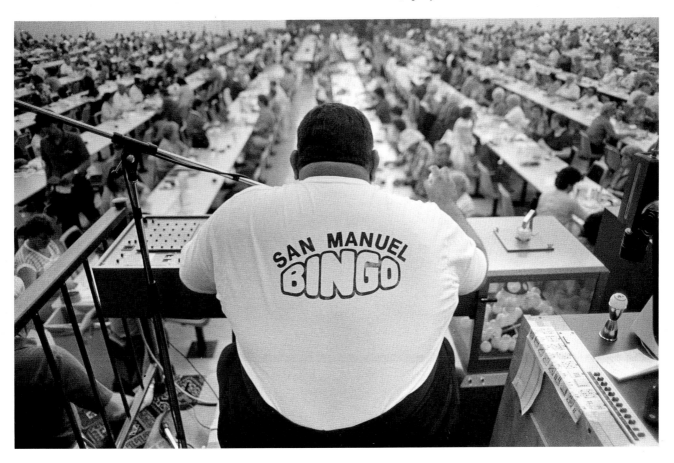

Calm prevails as Jess Jaurique calls the numbers in the San Manuel bingo hall. *October, 1986.* (Steve Dykes)

Picture perfect, famous photographer Richard Avedon poses
before a giant enlargement of one of his portraits of
Westerners at the Amon Carter Museum in Fort Worth,
Texas. *September, 1985*. (Kari Rene Hall)

Sylvester Stallone looms larger than ever on a billboard for
the film "Cobra" as artist Pietro Palladni works in his
Burbank studio. *1986*. (Joe Vitti)

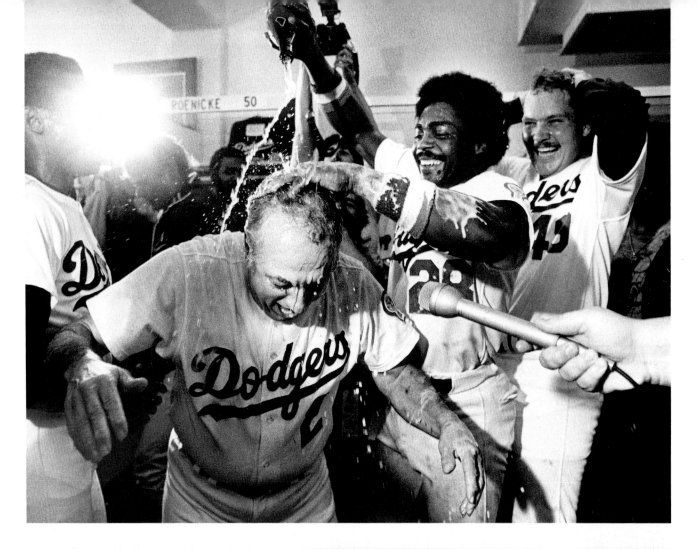

The Dodgers celebrate their divisional title win over the Houston Astros by dousing manager Tommy Lasorda. *October, 1981.* (Jayne Kamin)

An octet of Grammy awards fills the arms of Michael Jackson. *February, 1984.* (Ken Hively)

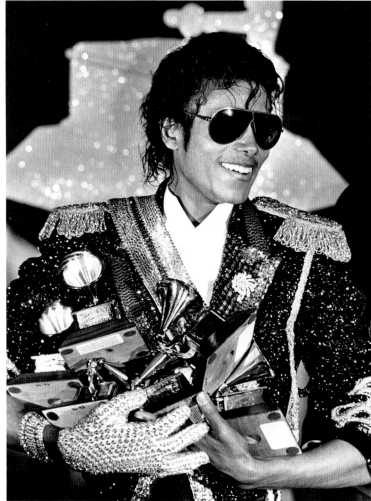

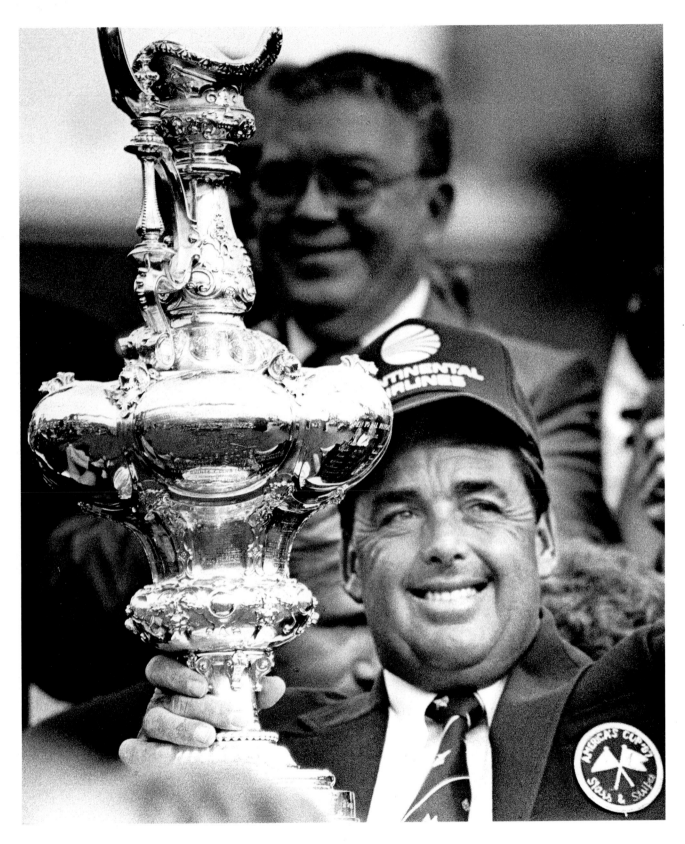

Triumphant skipper Dennis Conner shows off the America's Cup, which he brought back from Australia to homecoming celebrations in San Diego. *February, 1987*. (Bob Grieser)

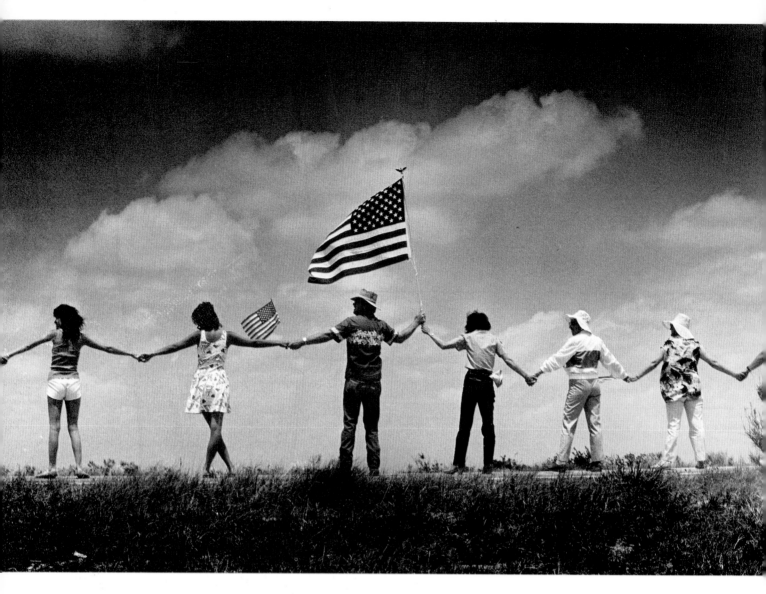

Hands Across America spanned the continent to fight hunger in the nation. Here are participants at Santa Fe, New Mexico. *May, 1986*. (Bernie Boston)

The helping hands of Sister Antonia, a former Beverly Hills housewife, minister to prisoners at the penitentiary in Tijuana, Mexico, where she is known as the White Angel. *October, 1983*. (Dave Gatley)

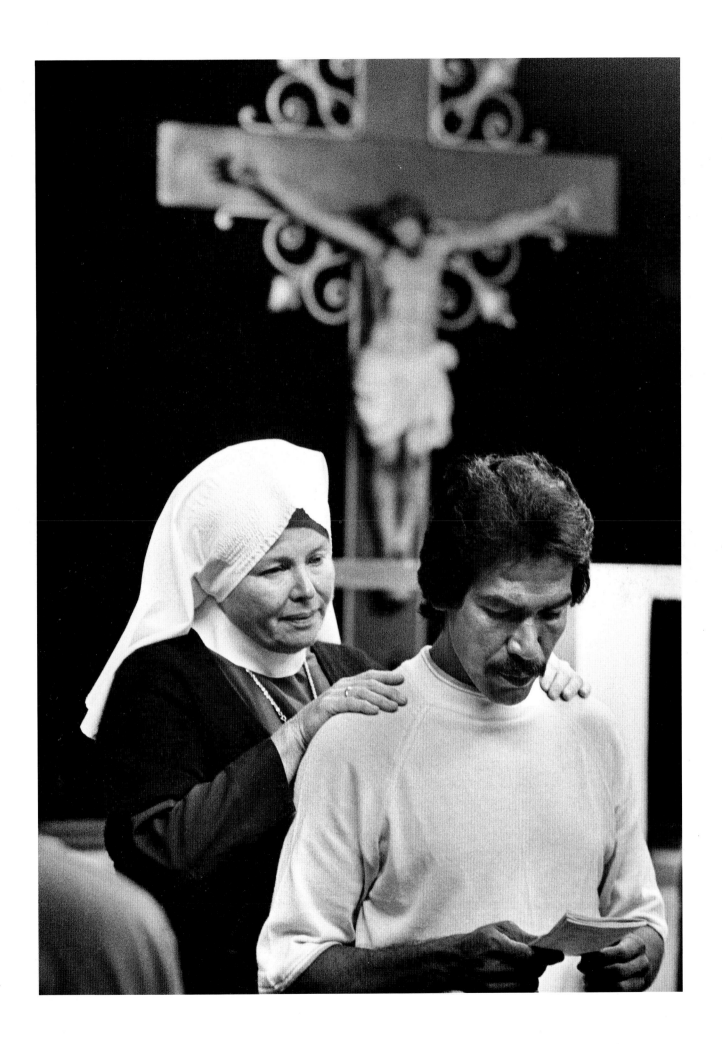

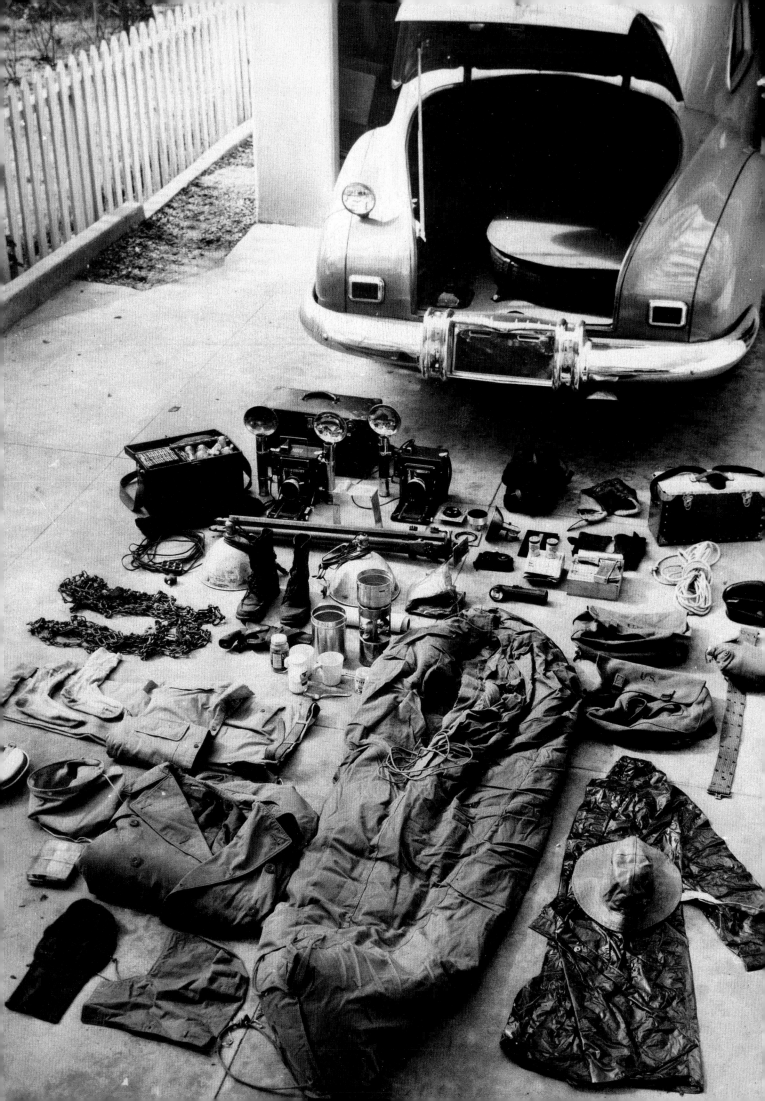

From the Photographer's Angle
by Iris Schneider

"I take pictures because they help me to see the world," says staff photographer Rosemary Kaul, with the *Times* since 1983. "I'm curious—I'm interested in showing what people are like, or what they're doing. It's like doing a case study on people. I don't think I would ever experience the world this intensely by doing anything else. And if I see something that's really interesting or fun, or really tragic, corrupt, or awful—and can communicate that—it's the best thing I can do."

As newspaper photographers we don't earn a fortune; most of us are in it because we love what we do. In fact, we sometimes can't believe that we actually get paid for it. Not that we don't work hard. But on a good day, we have the best of both worlds: we're sent to the eye of the hurricane, and we get to leave the scene before it gets boring. But then there are the bad days when it feels as if we're still working back in the 1930s—assigned to shoot criminal trials, society parties, and pictures of cute kids, cute animals, and cute kids with cute animals. The diversity keeps us going.

"What always amazes me is the contrast in what we do," says Jayne Kamin, who photographs everything but has excelled as a "sports shooter" at the *Times* since 1980. "One morning I spend in the emergency room of a county hospital with a homeless man who has an infected foot that hasn't been looked at for a month, and then that evening I go to a Beverly Hills party to shoot very wealthy people who'll do anything for you because you might get their picture in the paper."

In the early 30s and 40s, photojournalism was pretty cut and dried. Photographers covered society balls, and celebrity benefits, and now and then shot human interest, or "feature" art—such as the little old lady who had sewn 10,000 buttons on her dress. But the bread and butter work was at crime scenes, accidents, and in the courts. They shot divorcées (if they were pretty), car crashes and train wrecks (if they were big), and court proceedings or trials (if they were scandalous). And they often were.

Sensationalism ruled the front page.

The photographers were sometimes called "buttonpushers," or "lens louses," but whatever they were called their purpose in those days was clear: shoot what the reporter or editor tells you, don't ask questions, and get the picture back before deadline. Given the situations they encountered, the slow speed film, and the bulky equipment they carried, it was a lot harder to be creative, and it is a tribute to their skills that so many strong images of that era remain.

In the days when Paul Calvert was covering events for the *Times*, a good press photographer didn't leave home without a trunkful of gear. Here is his kit for 1947.

At the *Times*, as at most of the nation's newspapers in those days, women in the darkroom were even rarer than women in the newsroom. Maxine Reams was hired in 1943 as the first female photographer, but until 1956 when Mary Frampton was hired to shoot features, men like John Malmin, Art Rogers, Bruce Cox, Bill Murphy, and Richard Oliver made up the main staff.

"Those older guys had a much more precise timing for 'the moment' than we do today," says Patrick Downs, with the *Times* since 1981. "They came back with two frames and had the picture. With our motorized equipment, we sometimes shoot five rolls and have to look for the shot."

News photography has gone through many changes, but the image of the news photographer is still evolving. "Photographers were really looked down on before World War II. They were an appendage of the reporter," says Bill Murphy, hired by the *Times* in 1940.

"We were always trying to upgrade ourselves to be on a par with writers. For example, I always wore a shirt with French cuffs and cuff links. Can you imagine it? I'd come into the photo office, very carefully put my cuff links on the counter, roll up my sleeves, and try to keep my tie out of the developer."

These were photographers who lugged heavy Speed Graphic cameras and trunklike cases loaded with 4 by 5 inch filmholders, and who used flash powder before flashbulbs were available in the late 40s.

John Malmin remembers the days of flash powder. "If there were two photographers in a room who had to shoot with flash, the first one got the picture," he says. "The second one got the smoke."

But when the smoke cleared, these photographers showed Los Angeles the best and worst of itself.

There were six daily newspapers and competition was intense. Art Rogers, who started working at the *Times* in 1939, at sixteen, remembers the wrath of a scooped editor. "The editors would raise hell if you didn't have as good a picture as the guy on the other paper." And, often, photographers would be called upon to put a slant in their pictures. In murder cases, for example, no one gave a thought whether suspects might be innocent or guilty. "Hell," says Rogers, "if we had a murderer, even someone accused of

murder, we'd stick the flash down low to throw the shadow up in his face and make him look sinister. You could editorialize a hell of a lot with a camera."

As newspapers grew in respectability, however, photography and its power to communicate also gained respect.

The impact that *Life* magazine made on the American public from its inception in the mid-1930s helped develop a new breed of photographer: a "photojournalist" who could use a camera just as a writer could record impressions with words. *Life*'s photographers (which, interestingly, included men *and* women) influenced a whole new generation of young photojournalists, and they continue to do so. "We are all living under the legacy of W. Eugene Smith and the work he created," says Downs.

In conversations with today's young news photographers, a seriousness of purpose comes through. The ethics and morality of what we do—including concerns with the privacy of the individual, the power of our medium, and how these issues and our assignments mesh with our personal needs and ambitions—are often subjects for long, rambling discussions with our colleagues. These concerns did not grow in a vacuum, but rather, along with the growth of journalism.

Some trace these changes to the Watergate era. Others cite the war in Vietnam and what it showed us we could do with our cameras. "Vietnam was the first war that stimulated a strong social reaction and a tide of commentary at home," says Downs. "Those photographers were asking serious questions and portraying situations that could not easily be depicted in words. They used their cameras as microscopes to examine things that were causing upheavals both abroad and at home. They ended up documenting some very important issues."

On the good days, we like to think we still are.

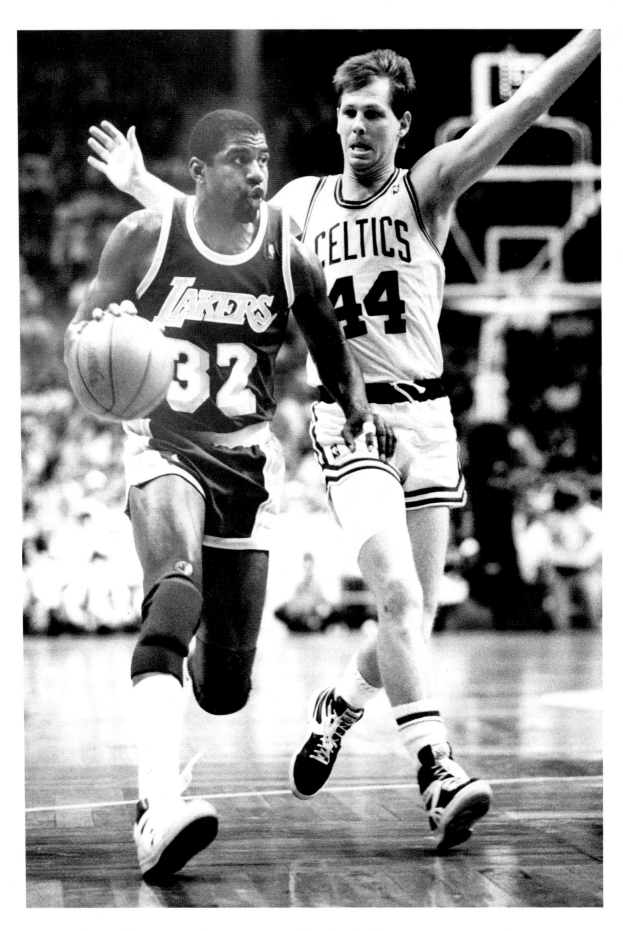

Magic Johnson puffs past Danny Ainge in the Boston
Garden as the Lakers prepared to return home to clinch the
1986–87 NBA Championship Final four games to two.
June, 1987. (Al Seib)